THANK YOU

First and foremost, I need to thank my Mom, Dad and Step-Dad. Your lifetime of unconditional love and support gave me the confidence to pursue my dreams. The values you taught me are at the heart of Go Media's success. Norman Rockwell couldn't paint a more idyllic childhood as mine.

Go Media wouldn't be what it is today without the talent and work ethic of my partners Wilson and Jeff. This book does not do them justice. You guys inspire me daily.

Go Media was built by a team of dedicated and talented people. Thanks to my staff past and present who've been on this fantastical journey with me: Sean, Zoe, Chris, Jason, Diann, Oliver, Adam W., Adam L., Heather M., Dave T., Dave R., Kim, Marissa, Sarah, Heather S., Simon and Carly.

CONTRIBUTORS

I want to thank my many contributors, who took time out of their hectic schedules to answer my many questions and send me amazing artwork. This book would be incomplete without their hard earned wisdom and talents.

QUEZ MEDIA MARKETING
Jose Vasquez
quezmedia.com

MOOSYLVANIA
Norty Cohen
moosylvania.com

KIWI CREATIVE
Jen Lombardi
kiwicreative.net

BURLESQUE OF NORTH AMERICA
Mike Davis
Wes Winship
burlesqueofnorthamerica.com

BLUE STAR DESIGN
Julia Briggs
bluestar-design.com

DKNG STUDIOS
Dan Kuhlken
Nathan Goldman
dkngstudios.com

STUDIO GRAPHIQUE, INC.
Rachel Downey
designwithdirection.com

SPARKBOX
Ben Callahan
seesparkbox.com

WIER / STEWART
Alex Wier
Daniel Stewart
wierstewart.com

FASTSPOT
Tracey Halvorsen
fastspot.com

HARRISON & CO
Chris Harrison
harrisonandco.com

ELEPHANT IN THE ROOM
Chad Cheek
elephantintheroom.com

LICATA & TOEREK
Sharon Toerek
www.completecounsel.com

FINE CITIZEN
Phil Wilson
finecitizens.com

THE KDU
David Gensler
davidgensler.com

KELLEY GREEN WEB
Jenny Kelley
kelleygreenweb.com

It's amazing to find a career that you love so much that it hardly feels like work.
— JEN LOMBARDI, KIWI CREATIVE

Hello. My name is William A. Beachy. I'm president of Go Media, Inc. This book is about how I built and run Go Media, a graphic design firm headquartered in Cleveland Ohio. I hope that the information in this book will help you build your design firm. Or perhaps you simply want to improve the way you work as a freelancer. Or, if you run an internal design department of a larger company, there is loads of information in here that will help you do that too. You may also be reading this book for inspiration—people often tell me they're inspired by my story. If you're reading this for a good laugh—I've included a lot of mistakes.

As I write this book, I'm going to share with you the principles by which I live my life and run my company. It's important to me and I decided to include it because I believe that the principles by which you live your life determine the outcome of any business. It is fundamental to how I've gotten to where I am and is the backbone of our corporate culture at Go Media. So, let me jump right in:

Failure is fundamental to success. Failure is a good thing, perhaps the best of things. Learn to embrace it. When you're failing, it means you're trying something that you don't know how to do. That's a great thing. And if you failed, then you're probably in some discomfort or pain. I think

being in pain or discomfort is when we learn fastest: Hand caught in a bear trap? Hair on fire? Business out of money? If you find yourself in any of these uncomfortable situations, I promise you'll be learning—fast. I'll answer how I opened a bear trap; how I extinguished a fire and how I made money.

When I was in middle school I was a member of the ski club. Each week, after my friends and I had finished skiing, we would swap stories as we rode home on the bus. We didn't focus on what we had done right, instead we told glorified stories about how many times and in what painful ways we had fallen down. We believed that if we weren't falling down, then we weren't pushing ourselves. And if we weren't pushing ourselves, then we weren't learning. We considered a trip skiing without at least falling once as a failure. In our minds, falling down was fundamental to improving.

> **A few months of pain and misery can be turned into a lifetime of much wiser decisions.**
>
> **TRACEY HALVORSEN, FASTSPOT**

So, let's not plan to fail. Let's plan very hard to succeed. But if we DO fail, let's not beat ourselves up too much. Otherwise you might be afraid to fail again. And failure causes discomfort, discomfort leads to rapid learning, and the knowledge gained from failing is what leads us to success.

Having run off on that tangent, let me bring it neatly back to this book. It might suck. It's the first book I've ever written. Failure is an option, though I hope you'll enjoy the book. I'm going to do two things here.

First, I'm going to tell you my story—many small stories. It will start with me clinging to my mother's leg, crying as she leaves me in my first art class and it will end with me as a partner and president of a successful 14-person design firm. And second, just in case I'm not as smart as I think I am, I'm going to interview other owners of successful design firms. For good measure I'll throw in some cool designs because I know you're probably a visual person.

A quick disclaimer about the content in this book: what works for me may not work for you. What works in today's business environment may not work in tomorrow's. Life is impermanent. Don't ever assume that what you read in a book (like this one) is the end-all-be-all of how to do things. You are a unique flower. You are going to have strengths and weaknesses that I don't. So, as you're reading my stories and trying out my business ideas, if they don't work—throw them out. Experiment fast, find what works and stick with that. Throw everything else out. Sometimes it takes two or three attempts at something before it finally works. But giving it a go, despite feeling like it's not working and throwing it out is still a good approach to business. When you try something and end up throwing it out, you're giving your brain a chance to rest and reflect on what you did. And by throwing it out you get to start fresh the next time you attempt it. Naturally you'll do it a little different the second and third time around. On one of those attempts you just might get it right. I prefer this strategy to trying something despite feeling like it's not working but sticking with it for years regardless of the fact that you're having constant difficulties with it.

The beginning. My parents are artistic. My father is an architect and my mother is constantly engaging in one artistic hobby or another—watercolors, basket-weaving, cutting out colorful fish from foam to decorate her travel agency. It was probably my parents who first got me started drawing. I can't recall exactly when it began. What I do recall is a giant

box of crayons. Now, I'm not talking about a 64-piece cardboard box of Crayolas, but a giant wooden box the size of a dresser drawer. I'm guessing there were at least 300 crayons in there. It was the center of my life. I spent most of my childhood laying on the floor drawing. When I was drawing I was always calm and happy. I would dream up some story in my head about giant robots battling for control of the world and then I'd draw it. I truly believed that this is what children all over the world were doing. It was my favorite activity.

> When I was in school and shared my project, the class actually stood and applauded, sealing the deal that design was my path.

RACHEL DOWNEY, STUDIO GRAPHIQUE, INC.

When I was five years old, my mother enrolled me in classes at the Cleveland Museum of Art. When she dropped me off at class the very first time I began to cry hysterically. The class was full of older kids and adults that I didn't know. I clung to her leg as she tried to leave. With the help of a few teachers they were able to pry me off her and she escaped. I don't remember what happened during that first day in art class, but I do also remember her coming to pick me up. It was just like when she dropped me off, except in reverse. I started to cry hysterically and fought with all my might to stay in the class. I clung to the door frame as she tried to drag me out. With the help of a few teachers, they were able to pry me loose and I was forced to go home.

The point is that I started drawing when I was very young. I'm sure I didn't know it at the time, but those early art classes were developing the

skills that would lead to my success as a designer. When young designers ask me if they should learn how to draw I'm emphatic: Yes. Absolutely.

Drawing is designing. Drawing trains your brain how to see. When you're drawing, you're dealing with layout, composition, contrast, and frequently, storytelling. You're also honing your ability to convert three-dimensional objects onto a two-dimensional surface. If you're not drawing from life, in essence you're constructing 3D objects in your mind, then interpreting them and drawing them in 2D on paper or on the computer screen. These are all skills integral to being a successful designer.

Lemonade Stand. Great, I'm an artist. So, why should you be reading a business book by me? It's not because I have a degree in business, because I don't. When I was 11 years old, a friend had a Macintosh IIc. He had a few games—your basic shoot-em-up or bomb-em style games. While I enjoyed the classic action games, my favorite on his computer was called "Lemonade Stand." The concept of the game was simple. You were given a weather report and you had to decide how much lemonade to make and at what price to sell it. The goal, obviously, was to maximize your profits. I'm not sure why, but I was fascinated by this game. I played it for hours. This was the very beginning of my entrepreneurial life adventure. For some reason, business was my second passion in life after art. While I don't have a business degree, it's just something I have been interested in my entire life.

My earliest businesses revolved around the acquisition of candy. In middle school I would buy candy in bulk at the store and sell it to my school friends for a profit. Then I would promptly eat all my profits by buying more candy.

When I was 13, I started a lawn mowing service for my neighbors. I designed a flyer and put one in every mailbox on my street. I got two

regular customers. Once a week they would leave $7 in an envelope on their front porch. I would push my family's lawnmower up the street, mow their lawn and collect my pay—which I promptly spent on candy. I don't recall having to buy any gasoline for the mower. I'm sure my supportive parents took care of that. If only I didn't have to pay for my overhead today!

While I was in college, during one summer recess I started an asphalt sealcoating business. I called it Beachy Blacktop. My friends tease me to this day about that name. But it was a huge success, my first real taste of that. I learned that summer that you can make lots more money by running your own business than you can working for someone else's.

It's less complicated than you might think. At your local big-box hardware store they sell five-gallon buckets of a nasty petroleum product called sealcoat, a black liquid about the thickness of paint. Its purpose is to seal up the little cracks in asphalt to prevent further cracking, prolonging the life of a driveway. You spread it on using a push-broom or squeegee. It feels a lot like painting a driveway. Using the same marketing approach as my lawn mowing service, I designed a flyer, included a short paragraph explaining that I was on break from school and was sealcoating driveways to earn college money. After the very first day passing out flyers—done on foot walking house-to-house, I had three messages on my answering machine asking for a quote. I could hardly believe it! My business had immediate traction.

Having an immediate response to my marketing is what I would call "being on the fish." I've heard that when you go fishing, 90% of the fish hang out in 10% of the lake. So, when I fish, if I'm not getting bites, I don't wait around. I move until I get an immediate response. My business experiences are very similar. If you have a business concept, market it, and if you don't get an immediate response, you're not "on the fish."

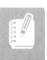

You need to either move to a different market or change your idea. It's very exciting when you are "on this fish." I've had several experiences in business over the years when things took off instantly. My sealcoating business was the first time that happened.

I would pass out flyers on Monday which brought in enough business to keep me busy for the rest of the week. I'd drive to the hardware store, load up 20–30 gallons of sealer and drive, rear end of my car hanging low, to my customer's house. I would sweep off their driveway with a broom, mix up the sealcoat, pour it onto the driveway and spread it around. I could seal three driveways in a day if I worked really fast, but typically I was doing two. I was clearing a profit between $100 and $250 per driveway! A few years earlier it would take me two weeks to earn $250 working at my local grocery store. Now I was earning up to $500 in a single day!

I understood why homeowners were willing to pay me to perform this service. It was nasty work. The sealcoat got everywhere. It smelled terrible and if it touched your skin it caused serious irritation. Your skin would turn red and itch like heck. My legs looked like they had a bad case of poison ivy. There was so much tar on my work pants that if I took them off they would stand up on their own. Not only that, I was doing this work in the middle of the summer. Imagine doing manual labor all day long in the summer heat while standing on a large black surface. I'm pretty sure the sealcoat fumes are carcinogenic. It wasn't pleasant work.

But the business aspect of this summer experience was awesome! I was bringing in money so easily and so fast that I immediately started reinvesting in my little enterprise. I bought a gas powered weed whacker, leaf blower, a garden hose, specialty crack filler, asphalt tamper and all sorts of gear to keep me clean. With these new tools I could work faster and do a better job. My clients came home to a pristine driveway! I would

BEACHY B
BLACKTOP

PROTECT YOUR DRIVEWAY!!
I CAN FILL CRACKS AND SEAL
YOUR DRIVEWAY FOR LESS!

My Name is William Beachy and I am an Ohio State University student. I am working my way through college by tarring driveways. Being a one man operation I can seal your driveway for much less than any one else. My work is at a professional level although my cost is not.

''REMEMBER'' Winter will soon be here! The only way to protect your blacktop drive from the cracking effects of freezing water is to seal it today! Call:

932-3703

trim the entire drive, remove any weeds, blow it clean, fill all the cracks, repair damaged spots, then apply the sealcoat to make it black and shiny. Looking back now, I can see that my instincts to reinvest in my company and improve the quality of the service I provided to my customers came quite naturally.

There were larger companies that offered this service, but I think one reason I was successful was because I had a good story. I wasn't a big corporation. I was a local kid raising money for college. A good story is a critical piece to selling your business. When I did see a competing company leaving someone a quote in their mailbox, I would hang out until they left. It might have been illegal, but I would run up to the house, remove their quote from the mailbox and read it. I'd write my own competing quote, making sure to undercut them by a few bucks. I would put both quotes back in the mailbox and wait for a phone call. How could a homeowner resist saving money while also supporting a local kid who's working to earn money for college?

I want to be frank with you about my business education. I don't have one. That is to say, I don't have a formal business degree from a college. I did earn an A+ in both economics classes I took at Ohio State. More recently I attended AIGA's Business Perspectives for Creative Leader's course at Yale. That was an intensive week-long business course geared toward leaders in creative industries. I was also a participant in the Goldman Sachs 10,000 Small Businesses program. That was a five-month course on entrepreneurship and business management. Additionally, I read a ton of books and articles.

But my classes really don't add up to much formal education. At the end of the day, I would have to say my business education is based on more "street smarts" than "book smarts." I just went out and did it. I've always been fascinated by business. When someone is talking business, my ears

perk right up! My mom always told me I was an "experiential learner." I'm a jump-in-the-lake-then-learn-how-to-swim kind of guy. I've been throwing myself into the business deep-end my entire life. I wouldn't say what I've accomplished is remarkable, but it's enough that I feel I have something to share with you (young designers and entrepreneurs). I certainly wish I had all the wisdom put forth in this book 15 years ago. I would have saved myself much pain and suffering.

How do we define success? Before I tell you all I can to help you be a successful designer, we should take a moment to define success. After all, if your idea of success does not match mine, then I may steer you in the wrong direction.

Sustainable. Success means sustainable. First, your business, whether you're a freelancer or a 500-person firm, must be sustainable. Now, I'm not talking about the "green," leave-no-carbon-footprint "sustainable." I'm talking about keep-the-lights-on-and-eating-Ramen-Noodles "sustainable." But you have to make enough money to afford to live and pay your bills. This is the number one rule in business. And when you're building your business, sometimes this is the only monetary success you'll have to hang your hat on.

When Go Media was just two guys— Wilson Revehl (my first partner) and myself, times were tough. A typical work week for us included 14-hour days, grumpy clients and a frigid office. We often had little or no profits to show for our hard work. We had two mantras we would repeat: "Still in business" and "One day smarter." That's what we could say we accomplished. We weren't successful, but we were sustaining.

Not to oversimplify things, but you haven't failed until you go out of business. So, staying in business is everything. It doesn't have to be pretty or comfortable. You don't need a fancy office or a catering service to

bring you lunch. Staying in business means you have electric for your computer and a working phone line. If your idea of being in business means that you have fancy desks, embroidered shirts and a big neon sign, you need to adjust your expectations because things may get tough—very tough. And when they take away your neon sign, If you think you need it to be in business, then you'll probably quit.

And while it may be uncomfortable, staying in business affords you an opportunity—to learn. The second Mantra Wilson and I repeated, "One day smarter," was because even though we were not necessarily successful financially, we were at least learning. We believed that today's hard-fought lessons would equal tomorrow's successes. That belief kept us going through the tough years. And since we stayed in business, those hard-fought lessons did turn into success, but it started with sustainability.

Profitable. Success means profitable. Sustainability being the first step, at some point you're going to need to see a return on your hard work. If you never see a profit, then eventually you'll wear out.

This is an important mental perspective to take on—that you deserve to profit. You deserve to live well. You deserve to be able to afford health insurance, a new computer and maybe even one of those fancy Wacom Cintiq Pen Displays.

Why is that so important? When you're working for someone else, you negotiate once a year what you're worth—your salary. Once that's been established, you work as much or as little as you need to, because your pay is set. When you are your own boss you set what you're worth on a daily basis. You do this by telling a customer what you'll charge for a project. But you also do it when they call you with a ton of unexpected changes, and in a hundred other ways each day. The question is—how are you spending your time, and are you being paid for it?

If you don't accept the perspective of "YOU DESERVE TO BE PROF-ITABLE," then you'll probably give it away.

When I first started freelancing I was charging $100 for a gig poster that to draw would take me three days! It was usually some complicated illustration like a cow firing a shotgun over a barn because it was a country band whose name was "Shoot the Moon." I spent approximately 30 hours on those kind of projects. That works out to under four dollars an hour! In fact, Wilson and I calculated our income during those first few years and it regularly came out to about that much, below minimum wage.

Why did I price myself so cheaply? Because my own self-worth was so low. I didn't think I was worth more than that. It's truly amazing what you can get just because you BELIEVE IT. At the time, I had friends telling me that I should be doubling or tripling my rates. I thought they were absolutely crazy. Nobody would pay me triple what I was charging. As it turns out, they were right. I think our rates today are at least quadruple what they used to be.

You deserve to be profitable. First you have to believe it. Here is a quick way to figure out how to BE profitable:

THE PROFITABILITY EQUATION

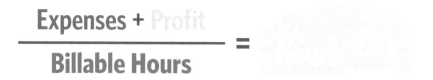

$$\frac{\text{Expenses} + \text{Profit}}{\text{Billable Hours}} =$$

First, you have to do a budget. What does it cost you to be in business? For this equation, let's assume we're dealing with a one-month timeframe. Most of your expenses are billed monthly, so this should cover

most things. Your budget will include things like electricity, internet service, phone line, advertising, your salary (yes, you get to decide what to pay yourself), heat, and office supplies. That's your monthly operating expense. That's what you have to earn to break even. Next we get to decide on the profit you want to make. You simply add how much you want the company to profit to the operating expenses. This is the total that you need to bring in each month.

Now, how do you figure out how much to charge to accomplish that goal?

Simple, you need to figure out how many hours you can bill your clients each month. A safe bet is about four hours a day per employee. This may not seem like much, but remember all the things you have to do each day—answer phone calls, write estimates/proposals, design advertising, deal with freelancers, invoice customers, email files to the printer, etc. At the end of the day, you'll see that four hours a day of billable time is a reasonable goal. Now we multiply that times five to get 20 hours a week times 4.3 (average weeks in a month) to get 86 billable hours per month.

The last step is to divide the total you need to earn by the billable hours you can work.

Just for conversation sake, let's throw some numbers in here and see how it turns out. Let's assume you're one person working out of your apartment. Your overhead is relatively low and you want to pay yourself $3,000 a month. Let's also assume you want your company to profit $2,000 a month for growth. And let's assume all your expenses (less your salary) add up to $1,500 a month. That brings your grand total to $6,500. That divided by 86 = $75/hour.

That's a long way from the $4/hour I was charging.

Simply writing out a math equation on a piece of paper won't make you

profitable. Writing down a salary of $90K in this equation will not make it come true. But this is a handy little way to think through what you're charging, how many hours you're working, and if you're not profitable—why. Suffice it to say that being profitable is one part of my definition of success.

Relevant (Doing work that you care about). Success means that you are doing relevant work. This is highly subjective and you'll have to decide for yourself what that might be. Steve Jobs told Apple's designers that they were changing the world through better product design. If you're a designer for Greenpeace, perhaps you hope that your designs will save the whales. For me, relevance is a bit more pedestrian. At Go Media we hope that our designs will dramatically improve the businesses of our clients, and the experiences of their customers. Our jobs become doubly rewarding if our client happens to be an animal shelter or a social program for impoverished South African communities. Relevant for you may also simply mean that you're working for a cool shoe company. You may want to take a second or two to define for yourself what this means and keep it in mind when planning your business.

I'll admit that when Go Media got started, we weren't too concerned about the relevance of our work. We just wanted to keep the lights on. But as soon as we made a little money and had some freedom to steer our company in one direction or another, we definitely pursued work

that we were passionate about—even if that meant steeply discounting our rates or working for free.

Respect (Receiving recognition from your peers). Success is getting a little R-E-S-P-E-C-T. Whatever you're doing in life, you want to know that your peers have respect for your work. As a graphic designer and owner of a firm, getting respect boils down to two things. First, the quality of your design work needs to be good. This book will not teach you how to be a better designer; you'll have to learn that somewhere else. Second, you need to be working on respectable projects. In other words, you don't want to be stuck designing cover art for porn DVDs. I did not build my company doing smutty design work; I won't recommend it in this book.

Happiness (You enjoy your job). Success is Happiness. There is really no point in being in business if you're not happy. I'm a big believer in the concept that "work" and "fun" are not mutually exclusive. I do believe that you can work hard, make lots of money and enjoy the process. Finding happiness is very important to me in my business. As our founding fathers phrased it—the "pursuit of happiness" is really the important takeaway here.

When you're happy, work isn't a chore. When you're happy, living with less isn't so bad. When you're happy, having a setback isn't the worst thing in the world. You have to find happiness in your work. The nice thing is, this is YOUR business. If something is making you unhappy, you can change it! Crappy client? Fire them! Crappy employee? Fire them! Uncomfortable office furniture? Buy new!

I went through many long stretches of time when building and running Go Media was miserable. I'm not going to pretend like being a free-lancer or building a design firm is a bed of roses. Improving my situation and finding happiness were things I always worked on. And today I can proudly say that I love coming to work every day. I love my office, staff,

and for the most part, love my clients! So, happiness would definitely be another part of my definition of success.

Yes, Success, Let's Get Started! (Hold your horses!) Now that I've finished defining success, you should take note of a few items that were not on my list. I did include profitable, but I did not include rich. Owning your own design firm will not necessarily make you rich. I'm sorry. If you're only opening a design firm for money, I'm afraid you'll most likely fail. Business takes too long and is too difficult to maintain if you're only in it for the almighty dollar. You won't inspire your employees or your clients. If your heart is not in it, when times get tough, you'll probably quit and your business will fail. I also didn't list short work days or lots of vacation. Ask anyone who owns a business if they work more or less than a typical nine-to-five workday and they'll almost always tell you: more. If they say less, I'm guessing maybe they won't be in business much longer.

So, before you dive into your new business venture, let's take a moment to look at some myths about owning your own business. I don't mean to be discouraging you—I'm really not. But I believe that if you have a good idea of what being in business is REALLY like, then you'll be more likely to succeed once you get started.

MYTHS ABOUT OWNING YOUR OWN COMPANY

Myth #1: I can make my own hours. While this is technically true, the reality is that you are at the mercy of your clients and your employees. When I started Go Media I was frequently sleeping in till noon, then working till 1:00 a.m. I would also take a long lunch and have a one-hour nap in the middle of the day. I loved the flexibility of those early days. But as my company grew, I soon had an entire staff working with me. As the owner I had to set the standard. It wasn't feasible for me to start the work day at noon or disappear in the middle of the day to take a

nap. Not only that, but as the company grew I had more meetings with the staff and clients. So again, my schedule was being forced upon me based on the needs of the business. If a client asks for a meeting at 8:00 a.m., I say: "Yes sir, no problem. I'll see you at 8:00!" Today Go Media's official work hours are 10:00 a.m.–6:00 p.m., close to "corporate" hours. A number of the staff members work 9:00–5:00 or 8:00–4:00. The point is, that if your business is your priority, then it's the needs of the business that dictate your hours, not the other way around.

BRIEFLY DESCRIBE HOW YOUR COMPANY GOT STARTED?

Humanbrand was started mostly out of revenge against previous bosses that had fired me. It was the cliche: "I can do this better" thing.

DAVID GENSLER, THE KDU

Myth #2: I can work fewer hours because I have employees! When you own a business you actually work MORE hours than when you're an employee. There are simply too many demands on a young business owner to work fewer than 40 hours a week. Plus, your staff will only work as hard as the owner does. Your staff expects you to be the most passionate and hardest-working person in the company. If you're not, then your staff will lose respect for you, slack off, and soon your business will be failing.

Myth #3: I'm going to be rich. While this is certainly a possibility that we all hope for, it's best if you not start with this assumption. When deciding on a business, ask yourself: "Would I still want to build this business even if I only made a livable wage?" If the answer is yes, then you're probably on the right track.

In my experience of watching why people start businesses, they tend to fall into one of two extremes: they are only in it for the money or they are completely in it for the passion. For instance, I can recall a shop opening up near my house when I was young. The entire store was filled with jester dolls. They were high-end plush dolls with ceramic heads. They were cool. The person running the store was obviously extremely passionate about these dolls, but I couldn't imagine how my suburb could possibly have enough people also passionate about jester dolls to support a business! And this was before the internet (yes, I'm old), so it wasn't even like the owner of the store could supplement his income with internet sales. So, this brick-and-mortar location had to sell enough dolls in one community to support the business. Obviously, that store was out of business within one year. It's rather easy to fall into the passionate end of starting a business. If you're passionate about something, it's easy to assume that others are also share your passion. Just because I love jester dolls, everyone else on the planet must love jester dolls, right? Wrong. Do yourself a favor and do a little research before you race ahead with your passion project. It doesn't have to be complicated research, just go ask your friends. Walk out on the street and take a poll. Or even take a look at your competitors. Is ANYONE getting rich in your market? Is there a big company making money in your market, with your product? If your only competitors are a bunch of little mom-and-pop shops, then it's likely that that's all the market can bear. So you should be prepared to be happy with a little mom-and-pop shop.

Now, I certainly don't want to dissuade anyone from following a business idea that is their passion. Having passion is a major part of success in business. You have to have it! But the more realistic your perspective on success is, the more likely you'll stick with it if you're struggling. Understanding the limitations of your market will also force you to be more intuitive. By polling potential customers and looking at what your competitors are doing, it should force you to think about how you can do

it differently. How can you create an innovative business model that sells to your market in a better way?

Conversely, you're probably in just as bad a position if you're only in a business for the money. In that case, you've probably already selected a business for its high-earning potential. But even when you're getting into a business that seems on the surface like it has great get-rich-quick potential, that's rarely the case. If it was that easy, competitors would be flooding the market. The window of opportunity for those types of situations is far and few between. You need to always assume there is going to be serious work that goes into a business. And if you have no passion for a business, there will be a moment when you realize: "This business is not going to be an overnight success. Now I'm stuck doing this work I'm not passionate about. Crap." That's when you'll quit.

I heard a successful business mogul once say that he doesn't enter into any new business unless he knows he can lose money at it for at least the first five years. I loved that concept. It fit with my ideas about what it meant to be a business owner. It certainly isn't about getting rich quick. First, I know that it takes a long time to figure out how to run a business. It takes time to reach your market. It takes time to hone your advertising message. Giving yourself five years allows you the necessary time to figure those things out. Second, it gives you the right financial perspective before you start. If you're starting a business with financial projections that require you to make money in the first six months or you'll be out of business, then you're really putting yourself in a pressure filled situation. It's better if you assume the worst-case-scenario financially for your business then figure out how to stay in business for several years despite dire financial projections. Doing this type of exercise will force you to ask yourself what expenses are necessities and those you can live without. Lastly, it helps you make decisions based on a long timeline. If your back is against the wall financially, it's easy to make bad decisions for your company that may save it for today while jeopardizing the future.

There are businesses that can be built with a short lifespan in mind. Many serial entrepreneurs will build businesses with the plan of selling them quickly. That's not really my area of expertise, so I won't be teaching you how to do that. If you're interested in that business model, you should read a different book. However, when you build a successful business right—which is what I'm here to teach you—you'll have no shortage of buyers.

In 2006, Go Media was invited to a presentation given by a highly successful mergers and acquisitions firm. The partners and I were not planning to sell Go Media, but we were curious, so Jeff Finley (our third partner) and I decided to attend. The presentation was held at Cleveland's fanciest hotel, the Ritz-Carlton. When we arrived we were surprised at the lavish accommodations. There was a continental breakfast like nothing I had seen before. Exotic fruits were piled high, elaborate pastries and no less than six varieties of coffee were available. There were only about 12 people attending other than Jeff and myself. Everyone there other than us were much older. We felt completely out of place. The two presenters were dressed in fancy suits with shiny gold cufflinks. They passed out glossy three-inch-thick binders of information and workbooks on how and why to sell your business. They pitched their services with extreme passion. It was flattering to be in this fancy situation and having these skilled professionals working so hard to persuade us to sell our company. At one point one of the other business owners asked us: "What the heck do you guys do? I need to tell my son to get into that!" Eventually the mergers and acquisitions head took us aside and told us point-blank how much money he felt he could sell our business for. It was a big number, much bigger than we had expected. Obviously, we didn't sell, but the point is that we had built a good business. And because we made the right decisions for the company's long-term success, we had built value.

WHAT SURPRISED YOU ABOUT OWNING YOUR OWN COMPANY?

You spend an extraordinary amount of time on unbillable work. I write blogs, go on speaking engagements, attend networking events and tweet up a storm. I hardly ever see an immediate return on this stuff, but I know I'm building the foundation for a great business in the future.
— JEN LOMBARDI, KIWI CREATIVE

Between writing newsletters, working with our employees, updating our website, answering emails, helping set up shows or clean up our gallery, there are days when I barely even get to crack open an Illustrator file or uncap a pen.
— MIKE DAVIS, BURLESQUE OF NORTH AMERICA

The business side seems like a never-ending necessary and tedious list of tasks. The creative part of the business is fun and easy, but it's such a small portion of the whole thing.
— DAN KUHLKEN, DKNG STUDIOS

The sense of responsibility for your employees is definitely heavy—but worth it.
— TRACEY HALVORSEN, FASTSPOT

I had dreamed that trucks of money would be dropped off each day! No one told me the delicate art of client management and the maze of legalities and potential pitfalls.
— DAVID GENSLER, THE KDU

I didn't expect was the shear volume of things I needed to learn to be an effective business owner. I also learned that you really never stop learning. Every day is about overcoming challenges and building upon lessons learned from every engagement.
— PHIL WILSON, FINE CITIZENS

Myth #4: I can pay myself whatever I want. Obviously, your payroll as owner is an expense to the company. It must be budgeted just like anything else. If you pay yourself too much, you'll soon find yourself broke. So, for the benefit of the business, it's important that you pay yourself as little as possible. At Go Media there have been many years where the partners paid their employees more than we paid ourselves. Occasionally when we've fallen on extremely hard times, the partners have skipped payroll so we had enough cash to pay everyone else.

Right about now you may be thinking: "Sheesh, owning your own company doesn't sound that good at all." Before I talk you out of it, let me give you the reasons why I started my own company, and why I encourage you to do the same.

WHY IT'S WORTH IT:

Reason #1: You'll learn a lot. In my opinion this is the #1 reason why you should start your own business. Even if you fail miserably, you're going to learn a ton. Forcing yourself to consider all aspects of a business will teach you things you could never learn in a classroom or while working for someone else. Even if you decide being an owner is not for you after you've been in business for awhile, you'll greatly improve your value to any future employer. Being able to sell yourself as someone who knows the ins-and-outs of sales, marketing, invoicing, project management and everything else you learned is going to put you ahead of your peers.

Reason #2: Life's short. It will be an adventure with potential highs and lows. Pursuing something with potential risk and reward is the kind of thing that makes life worth living. I promise you'll never be laying on your deathbed thinking: "Man. I never should have tried to start my own company." But you may regret it if you don't try. Life's short—have an adventure!

Reason #3: You have the opportunity. Building a design firm is low risk. Unlike many businesses, you don't need a lot of startup capital. All you really need is a computer, internet and a phone. That's about it. You should appreciate the unique opportunity you have when striking out on your own.

Reason #4: You just might succeed. If you do succeed, your life will be transformed. Even if you are only successful enough to make a living wage, your life will still be changed forever. Working for yourself is a completely different experience than working for someone else. Knowing you are self-sufficient feels amazing.

Reason #5: Ownership has its privileges. Feeling proud of a job well done is enhanced even more when you know it was done for your own company—conceived, sold, managed and completed by you and your staff. That's ownership.

Reason #6: You won't be alone. This is more about why you should build a firm if you're already freelancing. If you are a solo freelancer working from home, you may find that you spend most of each day alone. I did this for several years when I was getting started—it sucked. At one point I got a part-time job at Starbucks just so I could get out of my apartment and interact with people. Obviously, when you build a company you'll have coworkers.

Reason #7: Coworkers will inspire you and push you. It's easy to get settled into a particular thought or design style when it's just you. When you are part of a team you'll get pushed and pulled in directions you never imagined. It won't always be comfortable, but it's the spice that makes running your business worth it.

Reason #8: If you love what you do you'll never work a day in your life. The vast majority of your waking life is spent at work. If you have an opportunity

to improve how much you enjoy your work, then you owe it to yourself to give it a try. Owning your own business may just be that opportunity.

Reason #9: Respect. Even if your business sucks, or even if your business fails, having been a business owner garners a lot of respect. People, particularly Americans, have a deep respect for business owners. They understand that you took a risk and pursued your dream. Again, even if you fail, there is a level of respect people will give you for having had the balls to put it on the line, and that feels good.

Reason #10: Perks. Owning a business has its perks. There are traditional perks like vendors of your company that try to buy your loyalty with gifts like baseball tickets and steak dinners. There are also financial perks like tax deductions for running expenses through your company. Then there are perks like setting up a gym in your office for your staff, or having access to all your company's hardware and software for use on personal projects. There are a lot of nice little things that come along with owning a company.

EDUCATIONAL BACKGROUND OF OWNERS

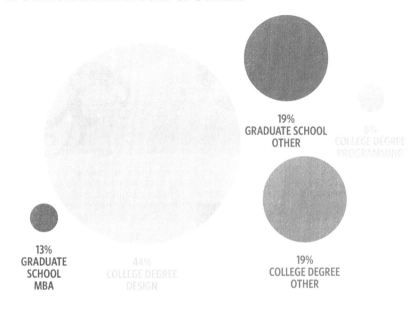

19%
GRADUATE SCHOOL
OTHER

6%
COLLEGE DEGREE
PROGRAMMING

13%
GRADUATE
SCHOOL
MBA

44%
COLLEGE DEGREE
DESIGN

19%
COLLEGE DEGREE
OTHER

YEARS UNTIL FINANCIAL SUCCESS

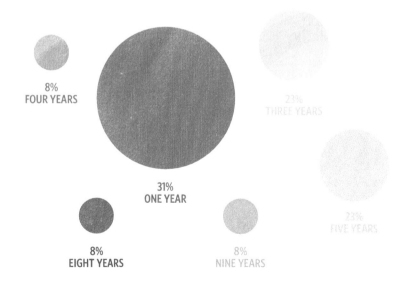

8%
FOUR YEARS

23%
THREE YEARS

31%
ONE YEAR

23%
FIVE YEARS

8%
EIGHT YEARS

8%
NINE YEARS

Nothing will teach you how to fight a lion like being thrown right in the lion's den.
— MIKE DAVIS, BURLESQUE OF NORTH AMERICA

How do I get started? Many people have asked how to get started in business. You'll notice that the start of this book talks a lot about the possibility of failure. For me, accepting failure is a big part of getting started. The decision to start a business can be very scary. If you feel like you MUST succeed, then it's easy to think about all the ways you might fail and what a horrible impact that might have on your life. The more you focus on those things, the more crippled with fear you'll become. The result is that you don't even start.

I like to disarm my fears of failure by accepting it. OK. I'm going to fail. How bad will it REALLY be? Have you never failed at something before? Heck no! You've probably failed regularly throughout your life at one thing or another. And here you are—still standing. Failing at business isn't like playing Russian roulette or going to war. It's only money. If you fail, nobody dies. Your loved ones, if they truly love you, will continue to love you despite any failure. You can always get a new "day job." Life will go on. And let's not forget the things you'll learn. You don't lose that just because the business goes under. You get to keep that knowledge.

Who says that staying in your corporate job is a safer move than starting your own business? Businesses fail all the time. People get laid off and

fired every day. If a business has a major downturn and is running out of money, who do you think gets laid off first—the owners or the employees? And even if you're a great employee for what seems like a huge rock-solid company, do you really know what's going on behind the scenes? Enron looked like a very strong company just before it collapsed and thousands of people lost their jobs and life savings. Bernie Madoff was a highly respected investment broker just before his Ponzi scheme collapsed.

I trust myself more than I trust others. Perhaps you too should have a little bit more respect for yourself, and not put so much faith in others. You CAN DO IT!

Focus on one thing. A great technique I use to overcome fears, deal with large projects or tackle a super-busy week is to focus on one thing at a time. What's that old saying—How do you climb to the top of the mountain? One step at a time.

If you think about absolutely everything you need to accomplish to build a successful design firm your head may explode. At the very least you're going to stress yourself out and find it hard to get anything done. Instead, focus like a laser on one thing and forget the rest.

Sometimes I will have this happen to me during a particularly stressful work week. I might have new projects dropped into my lap, some clients may suddenly give me feedback and there may also be important things I need to get done around the office. I will start to feel an inability to focus. My brain will start pinging back-and-forth between what I should be working on. I'll be worrying about the things I'm not working on. I'll start on one thing, then suddenly stop and decide something else is more important and switch tasks. The whole time I'll feel panic: like there's something else I'm forgetting.

When you're facing a crazy-busy schedule or an overwhelmingly large project, here are the steps to manage it:

Step One: Make a list. Make a list of everything you have to do. I used to do this with pen and paper, but now I use Outlook's Tasks list. However you do it, you can't accomplish this in your head! Give yourself all the time you need to create this list. Write down every actionable item, big and small. You'll find that just getting this to-do list out of your head will provide immediate relief.

Step Two: Prioritize your list. What's important? What has an immediate deadline? What can we put off till next week? This may be somewhat subjective. Keep in mind the difference between "urgent" and "important." A client's request that you send them a logo is urgent. It FEELS important because there is a waiting customer, but will it help you grow your business or finish your project? No. It's not important. When prioritizing your to-do's, give priority to important things. In the long run, it's the important things that will bring you success, not urgent things.

 a. Delegate things to others if possible.

 b. Warn people if you'll be missing any deadlines.

Step Three: FOCUS. OK, now that you've got your list and prioritized everything, you need to pick that top item and focus, focus, focus! Clear your mind of all the other tasks on your list. You cannot be in two places at once or do two things at once. Worrying about the other items on your list won't help you get them or anything else done. Stop thinking about them and pour your energy into that task at the top of your list. And do an amazing job at it.

In my experience, once I let myself focus on one thing and get to work, I suddenly feel better. And the moment I finish that first task, suddenly the rest of the list doesn't feel overwhelming. The satisfaction of completing the first thing on my list gives me a rush of positive energy that pours over onto the second item on my list. Getting that first item done is the key.

I have a memory from a movie that helps reminds me of this principle. The movie was *City Slickers*. Jack Palance plays Curly, the wise old cowboy who is leading the cattle drive. At one point he imparts the secret of life to the depressed Mitch (Billy Crystal). He says: "The secret to life is... one thing. Just one thing. You stick to that and the rest don't mean shit." I love that. When you're stressed, just remember the secret to life: one thing. Focus on one thing. The rest don't mean shit.

Do you have what it takes? If you're on the fence about whether to go out on your own and start a design firm, you may be asking yourself: "Do I have what it takes to build a company?" I know that when I was getting started I had wild misconceptions about what comprised a successful businessperson. The stereotype in my mind was something out of a Hollywood movie. I imagined a fat, red-faced bald guy smoking a short cigar and banging his fist on his desk as he yelled at some poor underling who cringed in fear. I was bald, but that was about the only similarity I shared with this image I had in my mind. I thought I had to be mean. I thought employees wouldn't work very hard for me unless I was a bit of a jerk. I also thought I had to be a bit of a shyster—looking to take advantage of my clients and grab a quick buck whenever possible. At least, that's what I thought I had to do to be successful.

What I found once I got into business was very different from what I thought it would be like. Yes, there were jerks out there for sure, but more frequently I was meeting very successful business owners who were extremely friendly. They weren't angry and they didn't yell. And as a busi-

ness owner, I recognized that I preferred to buy from nice vendors. I also dealt with some shysters who took advantage of me. Can you guess how many times I called them back for more service? You guessed it—none. In fact, sometimes in business it feels like a love-fest. Everyone is working so hard to be nice to each other that it's all compliments and smiles.

What I've read in books like *Good to Great* and *The Millionaire Next Door* is that it's not the larger-than-life characters who win at business. It's more frequently the soft-spoken, mild-mannered, hardworking frugal guy that eventually comes out on top. It's not about your ability to push people around that makes you successful. It's more about putting your company, employees and clients first. And you don't really have to be strong or dynamic to do that. It does take hard work. I won't dispel that stereotype. It's going to take long hours. But then again, if it's your company, the hard work doesn't really feel like hard work. But the financial ride can be bumpy. I would mostly be concerned if you're in a situation where you have extensive family or financial obligations.

The emotions of starting a business. When I started my business I felt like a fraud. My intentions were pure, but I didn't really know what my customers expected. I hadn't worked in a professional design firm prior to starting my company. I knew less than nothing. Nobody taught me how to run a design firm. What are people expecting to pay? How do they expect to pay me? When a project is done how do they expect to get their files? Or do they even expect to get the files? Maybe they assume I'm going to handle the printing and they never need to get the files. I didn't know. I literally felt like I was pretending to be a design firm. I'm a big believer in the fake-it-till-you-make-it philosophy. In essence, you don't really know what you're doing, but you're going to do it anyway. You're going to fake it. All that really matters is that you're going to get started and try your best. You'll have to trust yourself to figure it out over time.

Much of what you'll be doing building your design business is going to feel awkward and unfamiliar. I just wanted to mention this briefly so you'll know you're not alone when you're feeling it. And sometimes knowing "OK, this is natural" is all you need to know to feel better about something you're going through. In fact, sometimes not knowing what you're supposed to be doing can be an asset. It's like cheating off someone else's test. You may get their right answers right, but you're also going to get their wrong answers wrong. If nobody has told you how to do something, you may figure out a new way, perhaps a better way to do things. I attribute much of what makes Go Media successful to the fact that we aren't following any design firm blueprint. We've invented much of how we run our company. And even as we learn how other firms run their companies, we try not to let ourselves get pigeonholed into a traditional way of doing things. Of course, we've also discovered that many of the traditional ways of running a design firm are, in fact, the best way to handle things.

Having no boss can also have an emotional impact on you. Naturally, you probably assume that life is better without a boss, but having a boss is not all bad. They pressure you to show up to work on time. Whether you realize it or not, you want that. You want someone to hold you accountable. That way you do show up to work on time, and feel good about yourself. A boss will also step in and handle it if a coworker is harassing you. When you have a question, the boss will answer it for you. When you don't feel like working, they'll motivate you. But when you are the boss, the emotional impact of that can be negative as well as positive. You're going to have to motivate yourself to get out of bed in the morning. You're going to have to motivate yourself to work hard all day. You're going to have to find answers to your own questions. And you'll have to learn how to communicate well with others and resolve conflicts.

Finding a rhythm. When I first started my business it didn't go smoothly. I can't recall specifics, but I'm sure I probably overslept in the mornings,

FAMILIA XXVI

There's no place like
home.

There's no place like OUR hom

Since 1986, Familia has been instrumental in h
more than 35,000 families from around the corn
around the world find a home-away-from-home a
Ronald McDonald House of Cleveland (RMH). Th
he support and generosity of our loyal patrons, Fa
ontinues to provide substantial funding for the ma
sential services of RMH.

June 5, 2012, RMH entered a new era of care by
ing ground on a 20,000 square foot expansion.
ing will add 17 additional rooms to the current
at the House. Last year, nearly 700 families had
ther accommodations because the House had
. With this addition, we hope to fulfill the dre
ble to accommodate nearly all families who se
n from the cyclone of stress which accompan
lness and medical treatment. We are confide
munity will help us rise to the challenge of
ndertaking. We hope you and your guests
very special afternoon of fashion and
wship as we celebrate the shining future of RMH.

You are Invited

Familia XXVI
Saturday, October 6, 2012

Executive Caterers at Landerhaven
RSVP by September 21, 2012

A benefit for the
Ronald McDonald House of Cleveland

10:30 a.m. DOORS OPEN
raffle and fabulous emerald silent auction

11:30 a.m. FASHION SHOW
featuring your favorite local personalities
in partnership with Dillard's

12:00 p.m. LUNCH

Honorary Hostess
Wilma Smith of Fox 8 - WJW TV

then worked too late at night. I'm sure I didn't shave and wear a tie every day. It took me a solid year before I started to find a good rhythm. But I felt better when I dressed nicely and put my shoes on before walking from my bedroom to my "office" (ten feet away). I did enjoy a nap late in the afternoon, but even that became a regular part of my routine and it helped me work late into the night. With each passing day I got more comfortable dealing with customers, giving quotes, collecting payments and delivering finished products. Finding your rhythm will largely come over time and with repetition. By the time I had been doing it for three years, it became second nature. I knew exactly what I was doing and what customers expected. Take it easy on yourself if you're in your third month and struggling with the day-to-day routine. It just takes time.

Here are a few tips to help you get into a good work rhythm:

- Schedule meetings first thing in the morning so you're forced to get out of bed and dress nicely.

- Get dressed. Even if you're working from your own house and won't be meeting with any clients. Being dressed nicely and putting on your shoes will prepare you mentally for work. If you're still wearing your pajamas you'll probably find it harder to concentrate on work.

- Get to bed on time. In my experience, the difficulty with getting up in the morning is mostly about having not gotten to bed on time the night before. If you focus on going to bed, the getting up part won't be nearly so difficult.

- Use a calendar to schedule your daily tasks. For instance: from 1:00 p.m.–2:00 p.m. create a list of prospective customers; from 2:00 p.m.–3:00 p.m. eat lunch; and from 3:00 p.m.–5:00 p.m. call potential customers to set up meetings.

WERE THERE ANY KEY MOMENTS OR STRATEGIES TO YOUR SURVIVAL IN THE EARLY YEARS?

We kept our overhead low, we cared deeply about creating quality work, we were (and still are) brutally honest with our clients. They hire us for our expertise, not just to say, "Yes!" Also, we struggled until we specialized. Find one thing that you can do better than anyone and focus on that.
— BEN CALLAHAN, SPARKBOX

Getting a 50% deposit on any job is crucial. This will help you avoid a death blow if some jackleg refuses to pay you.
— ALEX WIER, WIER / STEWART

Ask everyone you know (including other design agencies) for help and advice—with everything. People really will share information, if you ask.
— JULIA BRIGGS, BLUE STAR DESIGN

Stay flexible and be bold and relentless. I sometimes took the relentless thing to extremes and developed sorta of hard-ass reputation, but ultimately it was about winning and in the business world, you either win or you fail - there is no grey zone and no room for error.
— DAVID GENSLER, THE KDU

What got us through the oft dreaded early years was an absolute "never quit" mentality. Regardless of the challenges, we would band together, work through the night, do whatever it took and just get things done. I am extremely proud of what we accomplished with relatively little.
— PHIL WILSON, FINE CITIZENS

• Treat your internal work in the same way you treat client work. Give it deadlines, put it in your schedule and make it a priority.

KEYS TO SURVIVAL IN YOUR EARLY YEARS

This is a very important section. While it is short, don't underestimate its value. Reread it many times if needed.

Be frugal. This is the most important facet of success during your early years in business. It's easy to spend money when you're first starting a business. You're probably riding an emotional wave that makes spending effortless—you're excited! You want hats, and signage and a vehicle wrap and shirts and new equipment and new software; heck, a hot-air balloon would make an awesome marketing tool.

> Keep your costs really low at first, work from home, make your computer equipment and software last as long as possible. Think twice before you spend a lot on fixed overheads—rent, wages etc.

CHRIS HARRISON, HARRISON & CO.

But what's the only thing that can truly put you out of business? Running out of money! Protect it carefully!

Let's look at a hypothetical case where someone is starting a design firm. Let's see how easy it will be to spend money.

Bob decides to start his design firm. He goes to the bank, family and friends, who all give him loans. He quits his day job at Go Media to

start Bob's Design Haus. He designs a logo. He pays someone else to build his website because he doesn't have the time to do it himself ($15K). He orders business cards, letterhead, envelopes, embroidered shirts and hats ($5K)! He needs an office so he buys a small warehouse and rehabs it into a chic industrial space ($350K). It's his new business, so he should definitely buy all the latest Apple computers and Adobe software ($20K). Oh! And his business needs a fancy sign ($12K). Advertising ($5K), Server ($4K),and on and on. Bob has already spent $411,000 and he hasn't sold a single thing!

The point being that you can spend yourself into failure instantly. It's easy.

Ask yourself: what is the absolute minimum I can spend and be a legitimate business? Before you buy ANYTHING ask yourself: do I REALLY need this? Or is there some other way I can get by without spending this money?

Now, let's consider how I started Go Media. My first office was a bedroom in my dad's house ($0—thanks dad!). My computer was left over from college ($0). The software was also left over from college and had been bought with a student discount ($0). To advertise, I volunteered my time designing gig posters for a local bar with the agreement that I got to tag each flyer with my company information ($0). I built my own website ($0). I designed and printed 4x6-inch flyers that I distributed around Cleveland ($250).

Don't quit your day job. Regarding Bob's day job that he quit in the above hypothetical: if you have a day job and are considering starting a design firm —DON'T QUIT YOUR DAY JOB. Hold onto that day job as long as possible. That's income. That's your first client! They might be a bad low-paying client, but they're still your only source of income. Go

to your day job, then work on your business at night. Spend as much income from your day job as possible on your business. When you start landing clients, do that work at night and on the weekends. You should only quit your day job when you're so slammed with work from your business that it justifies quitting.

Oh, and if you feel like you don't have the energy to work on your own business after you've worked a full day at your regular job, you might seriously consider how committed you are to building your own company. Starting a new business l requires well more than eight hours a day.

DID YOU WORK FOR A DESIGN FIRM BEFORE YOU STARTED YOUR OWN?

I definitely did and I think everyone should. You have to learn the ropes and do your time—and best to do that on someone else's dime. It's especially great if you can work somewhere that just sucks really bad— learning what "not to do" is way more valuable than reading all those biz books about what "to do."

TRACEY HALVORSEN, FASTSPOT

The closer eye you keep on your expenses, the longer you will stay in business. The longer you get to stay in business, the more time you'll have to figure things out. Keeping your day job gives you an opportunity to build momentum and cash flow before you take the "leap."

Stay positive. Go Media was not an overnight success. Money was terribly tight for at least the first five years. In those early years Wilson and I didn't have a lot to "hang our hat on" regarding financial success. But

we had a mantra we would repeat whenever we were depressed or faced a setback: "Still in business and one day smarter." Remember that as long as you are in business, you're being successful. And so long as you're learning, given enough time, you'll eventually figure it out. At least, that's what we believed and it was good to regularly remind ourselves of that by focusing on the positive.

Have fun. Even when you're broke and struggling, you can find ways to have fun. It is your business after all. Sleep in once in a while, take a nap, go to a baseball game in the middle of the day, design a wacky marketing campaign that your boss at your previous job would have never agreed to put out. Yes, you need to work hard and be responsible. But you also need to stop and smell a few roses along the way. If you land a big client, celebrate! Take your friends out for pizza and beer. If you finish a month where you're "in-the-black," grill steaks! If you hire a new employee, play a practical joke on them. Wrap their entire desk in plastic. Keep a smile on your face. The more ways you find to enjoy your business, the less likely you'll want to bail out when times get tough.

Should I write a business plan? A lot of people ask me if they should write a business plan before starting a business. My answer is yes, but don't over-think it. Writing a plan is a great way to get your brain to start thinking about all aspects of your business. If you don't write a business plan, it might not occur to you to consider how much money you have to pay to Social Security as part of your payroll and you might not consider what will happen if your company scales up quickly. Maybe your office is only big enough for two employees. What happens if you suddenly need to grow in year two? You should be thinking about where you expect your business to go, and develop plans for that.

BUT—and here's the important part. A business will rarely go as planned, so it's important to not get tunnel vision. When things start to

go in directions you weren't expecting, you need to be agile and flexible. You need to be able to identify opportunities and run with them. Also, you need to recognize quickly when something isn't working and make a dramatic change if necessary, and quickly.

I suggest writing the plan because it's an important learning tool. By mapping it out, you're setting goals and expectations. These are benchmarks that will allow you to make comparisons. You should invest real energy on it, but don't spend six months scrutinizing every last detail. It's crucial to realize that a plan is not a fortunetelling device. It's much easier to PROJECT five million dollars in sales than it is to EARN five million dollars in sales. Don't take out massive loans in anticipation of earnings that are only forecast in your business plan.

I'm not teaching you how to write a business plan in this book, but I will share with you a few parts of one that are absolutely critical.

Company Story: Who are you? What do you do? What makes you different? Who is your ideal customer? What problem are you solving for them? All of this needs to be communicated in a simple story. People love stories. People remember stories. How compelling is yours?

Simply telling a customer "We're a design firm that does branding, print design and web development," is not enough. You've only categorized your business. You've given them no reason to hire you over any other design firm. Here's Go Media's story: concise and compelling.

Go Media was started by illustrators. While we all had degrees in design, our background was drawing. In the first six years of the company we didn't care about making money. We only took on projects that were highly artistic. We lived on Ramen Noodles and worked insane hours designing apparel, gig posters and marketing for the entertainment industry. Our uniquely artistic design style led to incredible demand from

NEW 007 EXHIBIT
EXQUISITELY EVIL: 50 YEARS OF BOND VILLAINS

HOME > EXHIBITION & EXPERIENCES

EXHIBITION & EXPERIENCES

Welcome to the shadowy world of espionage! No matter what motives bring you here...leave your preconceptions behind. See the tradecraft of espionage through the stories of individuals and their missions, tools, and techniques. Galleries include:

IN THE EXHIBITION

- COVERS & LEGENDS
- SCHOOL FOR SPIES
- THE SECRET HISTORY OF HISTORY
- FROM BALLROOM TO BATTLEFIELD
- SPIES AMONG US
- EXQUISITELY EVIL: 50 YEARS OF BOND VILLAINS
- THE 21ST CENTURY

COVERS & LEGENDS

Adopt a cover identity, memorize specific details about it, and learn first-hand the importance of keeping your "cover."

LEARN MORE

SPY EXPERIENCES

Operation Spy
Think of it as a live action spy adventure. Only you're the spy. This one-hour, adrenaline-fueled mission is no exhibit. Don't screw up!

LEARN MORE

Spy in the City
You've qualified for the mission. Now see the city as a spy by taking a GPS-guided tour of DC and its neighborhoods. It's your chance to explore the spy capital of the world.

LEARN MORE

Spy City Tours
Washington, DC. Cradle of democracy. Stomping ground of politicians. Home to more than 10,000 spies, and some of the most notorious cases in the history of covertness.

LEARN MORE

FROM THE COLLECTION

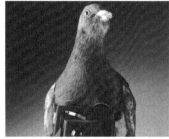

Pigeon Camera

VIEW COLLECTION HIGHLIGHTS

IN THE EXHIBITION

EXQUISITELY EVIL: 50 YEARS OF BOND VILLAINS

INTERACTIVE SPY EXPERIENCES

ABOUT THE COLLECTION

ARGO EXPOSED

TRAVELING EXHIBIT

Plan A Visit
Information is everything. Customize your own classified spy itinerary.

LEARN MORE

TAKE A
VIRTUAL TOUR

SPY STORE
All the Spy You Can Buy! Free Shipping on Orders $25+.

SHOP NOW

MULTIMEDIA GALLERY
Explore our media library of exhibit images, exclusive interviews with real spies, and lectures from our Museum historians.

RECENTLY RECRUITED AGENTS

Follow @IntlSpyMuseum 3,500 followers | Like | Oh 335,000 people like this.

INTERNATIONAL SPY MUSEUM

CONTACT US
800 F Street, NW
Washington, DC
20004
P: 202.EYE.SPYU
E: info@spymuseum.org
© 2013 International Spy Museum | Privacy Policy

STAY CONNECTED
Facebook | SpyBlog
Twitter | SpyCast
Flickr | Foursquare
YouTube | Newsletter

MUSEUM HOURS
Open Everyday
9 AM – 7 PM

SPY | PLAN A VISIT | EXHIBITION & EXPERIENCES | EDUCATION & PROGRAMS | SHOP SPY | ABOUT THE MUSEUM | BUY TICKETS

HOME > PLAN A VISIT

PLAN A VISIT

Umbrellas are pistols, dead rats are microphones, femme fatales are men fatales. Gain access to a wild world of gadgets, weapons, bugs, cameras, vehicles, and spy tech that defies classification.

UPCOMING MISSIONS

AUG 14 — Global Terrorism, Espionage and Cybersecurity Monthly Update
12:00 pm

INSIDER INTEL
THE SPY PHOTO THAT FOOLED US ALL
July 9, 2013

OPEN TODAY FROM 9AM–7PM
Buy Tickets | Where to Stay
Getting Here | Event Calendar

Team Building Special Offer

EXHIBITION & EXPERIENCES
Operation Spy | Covers & Legends | School for Spies

RECENTLY RECRUITED AGENTS

CONTACT US — 800 F Street, NW, Washington, DC 20004
STAY CONNECTED
MUSEUM HOURS
9 AM – 7 PM

corporate America. In turn, their needs led us to put together a robust team of web developers. That gave us the technical skills to back up the creativity of our designs. Today, 80% of our work is web development. One constant with Go Media has been our passion for professionalism. While artists are known for being emotional and unreliable, Go Media's creative team takes great pride in delivering every project on time, on budget, with a smile on our faces.

That's it. That's Go Media's story in less than one minute. That's commonly referred to as your elevator pitch. Write yours, memorize it, tell it with passion. Make sure that it's short and compelling. Nobody wants to hear you drone on for an hour. Your story should communicate your value proposition.

Value Proposition: What value do you provide for your customers? When it comes to establishing this, the golden standard is what's known as "resonating focus." Specifically, three key points, two of differentiation and one of parity. The simple fact is that people can't remember everything. Your potential customers only have a mental capacity to walk away and remember about three things about your company. If you give them 20, they will get to choose what they remember. But if you only give them three, and hammer away on your company's three key value propositions, they walk away remembering what you want them to.

Here are the three key points I want customers to know about Go Media:

1. We're very artistic/creative (point of differentiation)

2. We're technically proficient (point of parity)

3. We're professional (point of differentiation)

Do you think they got that from our story?

Obviously, the two points of differentiation make perfect sense—this is why we're different. But you might be asking, what's the whole point of parity? Research shows that in addition to wanting to know why you're different from your competitors, customers typically have some nagging fear about a company or product. Your point of parity is to dispel your customer's primary concern.

In Go Media's case, if someone is looking to hire a firm to do web development work, they might worry: "Are a bunch of illustrators the right team for coding my website?" We address that concern with a point of parity: "...we have put together a robust team of web developers. Today, 80% of the work we do is web development." That's a compelling statement of parity.

How do you know what concerns your customers (or potential customers) might have about your company? ASK THEM! I probably won't say it enough in this book, but customer feedback is one of the most important concerns for your company. Every time a client hires us we ask them: "If you could use only three words to describe why you hired Go Media, what would they be?" We keep a database of these words. Over time a pattern has emerged. We know exactly why customers hire us and we know exactly how to sell ourselves to new customers.

Similarly, you could ask your potential customers: "Do you have any concerns about hiring our company?"

About three years ago we were losing a lot of web development projects. We started asking our clients: "Why didn't you hire us?" From those questions we realized that our web development proposals appeared to be weak on Search Engine Optimization (SEO). The funny or sad thing was that we were extremely strong on SEO—stronger than our competition. But we didn't include a section on SEO in our proposals,

so the customers didn't know about that strength. Only through asking questions did we realize we needed to add a beefy section to our web development proposals that talked about all the ways we ensure SEO on the websites we build.

Define your market. To whom are you selling? At first, you may be thinking: "Anyone who will pay me." That's fine. You're certainly not going

> Have a targeted client market. It took us a long time to realize that being generalists wasn't the best approach for us. Once you focus into a particular market, you gain specific and valuable expertise, you can find clients easier, and you know how to spend your marketing dollars. This translates to greater knowledge, greater value and a strong referral network.
>
> **RACHEL DOWNEY, STUDIO GRAPHIQUE, INC.**

to be turning down work. But who exactly are you pursuing? If you say "everyone," it's the same as saying "no one." You must decide exactly who your market is. Are you selling to Fortune 500 companies or startups? Are you focusing on a specific industry? Are you targeting a specific location or region?

When you define a profile of your ideal customer, you will understand them and all your marketing and communications should be targeted for

this particular market. Does the value proposition you might make to a startup make sense for a Fortune 500 company? Probably not. If you're selling to a startup, price is probably going to be their biggest concern. A Fortune 500 company might not care at all about price. If you walk in the door and the first words out of your mouth are: "I'm really cheap!" you might lose the job to a company that walks in the door and says: "We're the most creative!"

By selecting a target market it gives you the opportunity to figure out exactly what they want to hear to sell them. By the time you're done giving your elevator pitch, your target customer will be thinking: "Wow, this company is EXACTLY what I've been looking for."

Once you've defined your target market, do some research on it. It's amazing the amount of free information you can get from the U.S. Census Bureau (http://www.census.gov/) and the U.S. Bureau of Labor Statistics (http://www.bls.gov/). Questions to ask include: How many companies are there in your targeted region? Can you figure out how much money they spend on the services you offer? This is not always going to be easy. You will have to make some educated guesses. For instance, maybe you want to sell design services to car dealerships. The U.S. Census Bureau lets you know that there are 100 car dealerships in your city. You try to find one that is about average in size. Then you pretend to be a college student writing a paper on how car dealerships market. Ask the owner if he would be willing to help you with some annual figures— what do they spend on ad design, radio spots, website edits, etc. Then multiply those numbers by 100 car dealerships. This approach is not perfect, but you're not trying to get exact numbers, you just need to get a sense of the size of the market you're going after. If the car dealership you interview only spends $500 annually on design services, that would be a total market potential of $50,000. And you could only earn that if you got 100% of the design work from every car dealer in your region!

DO YOU HAVE ANY ADVICE ON HOW TO BEST START A DESIGN FIRM?

Get clients first. Keep your expenses to an absolute minimum. Invest in your brand. Do killer work.
— NORTY COHEN, MOOSYLVANIA

Be smart and plan as much as you can. Then stop planning and just take the damn jump already. You'll never be completely prepared.
— JEN LOMBARDI, KIWI

Stay focused on bringing in revenue you'll have plenty of time to fine-tune your processes and work toward your end goals.
— JOSE VASQUÉZ, QUÉZ MEDIA MARKETING

Finding good outside voices to help you is critical at the beginning.
— TRACEY HALVORSEN, FASTSPOT

Do not allow your ego to stand in front of your bank account. I passed on many clients that would have written checks, because they were not cool enough for us. I wanted to build a very particular image for my company and I thought that had to somehow govern all aspects of the business, including where the revenue came from. Big mistake!
— DAVID GENSLER, THE KDU

Understand or hire or partner with someone who understands how to run a business. Starting out, firms will make a lot of mistakes but having a resource who has a good business development focus will make a world of difference.
— CHAD CHEEK, ELEPHANT IN THE ROOM

That sounds tough. Who wants to manage a client that is only ordering $500 worth of services each year? That's a pain in the butt!

When you take the time to pick a target market and do some research to make sure it's a viable market, you can then build your business plan and marketing around them.

Financial Projections. As part of your business plan you must do financial projections. These will help you understand what amount of sales you'll need to make and establish your burn rate: the speed at which your company is losing money. It can also be referred to as your negative cash flow. Burn Rate is a term often used when calculating how long your startup capital will last. If you know your company will be losing money at a rate of $5,000 a month for the first six months, then you better have $30,000 worth of startup capital in your bank account when you get started.

On the following page is a list of common expenses you can presume your freelance or small firm will likely encounter. I will include approximate amounts that Go Media paid in each category for years 2003 (two person firm) and 2007 (10 person firm):

	2003	2007
Advertising	$ 3,000	$ 14,000
Banking Charges	$ 300	$ 7,000
Computers/Equipment/Software	$ 1,250	$ 3,300
Medical Insurance	$ 1,500	$ 6,000
Entertainment, Meals & Transportation	$ 500	$ 11,500
Insurance (Renters)	$ 150	$ 250
Internet	$ 400	$ 8,000
Utilities	$ 1,000	$ 4,000
Phone	$ 2,000	$ 3,500
Office Supplies	$ 800	$ 7,500
Postage and Delivery	$ 250	$ 3,000
Printing	$ 15,000	$ 21,000
Professional Fees (Lawyers and Accountants)	$ 100	$ 10,000
Rent	$ 2,300	$ 29,000
Reference Material (Stock images and graphics)	$ 400	$ 5,250
Taxes (Payroll)	$ 7,000	$ 35,000
Payroll	$ 35,000	$ 171,000
APPROXIMATE EXPENSES TOTALS:	$ 70,000	$ 470,000

When you add up these monthly expenses, you'll begin to understand how much money you need to generate each month. Figure out how much money you have in the bank and how long can you survive if your business generates NO money. In the next chapter you'll see that I ask questions like: Do you really need a fancy office or can you work out of an apartment? You'll understand why I tell you to hold onto your day job as long as possible.

DID YOU WRITE A BUSINESS PLAN?

73% NO

27% YES

DID YOU DEFINE A TARGET MARKET?

27% YES

73% NO

KIDS CAN
COUGH *up* A STORM

Give little ones fast relief from cough and fever

100% NATURAL ★★★ SAFE FOR KIDS 2+

Similasan® Kids Cough & Fever Relief™ is **gentle** and **effective**. Instead of masking symptoms, the active ingredients kick start your child's natural ability to **relieve** cough and fever. Similasan helps kids **feel like kids again**.

Feel good about feeling better.

ACTIVATE YOUR BODY'S DEFENSES AT SIMILISANUSA.COM | f 🐦

NEW NAME!
SAME GREAT RELIEF!

ALSO FOR KIDS 2+ KIDS COLD & MUCUS RELIEF™ • KIDS EAR RELIEF • KIDS IRRITATED EYE RELIEF

If you want to grow a business, you have to be prepared to take financial risks.
— JOSE VASQUÉZ, QUÉZ MEDIA MARKETING

How do I raise money? When I was very young and taking karate, my instructor would always say: "If you're in a situation where someone is trying to pick a fight with you, what do you do first? Run!" From his perspective, knowing how to fight was no reason to fight. It should always be your very last resort. I feel similarly about borrowing money. Just because you can borrow money doesn't mean that you should. I believe you should always avoid borrowing money to start your business! Borrowing money does three things that are bad. First, it takes pressure off you to sell! If your rent payment is coming up and you have no money in the bank, guess what—you are going to feel a ton of pressure to go sell something. That's a very good thing! Second, borrowing money makes it easier to spend. As mentioned previously, frugality is key to survival in the early years of your business. You want to make it as difficult as possible to spend. Third, borrowing money puts you in a worse financial position and saddles you with interest payments as well as possible emotional debts. Owing money to your family can be a terrible burden to carry.

When you're getting started and you think: "Gosh it would be nice to own a Cintiq, but I only have $1,000 available and it costs $2,500." Your next thought should not be: "Well, let me get a loan from the bank."

Your next thoughts should be: "Do I really need it? Maybe I can find a used one on sale for $1,000." Or better yet: "If I can land a job that will pay me $2,500, then I can afford to buy it!"

"But Bill!" You say. "It does take some money to start a business. If I don't already have it, how do I get it?"

Don't Quit Your Day Job. I mentioned this in the previous chapter, but let me reiterate it here because of its importance. Don't quit your day job. If you already have a day job, then that's your business' first source of income. You're going to have to work that day job, save your money, and work on growing your own business in the evenings. I did say owning your own business was lots of hard work, didn't I? Well, this is how it starts.

> ## Don't quit your day job, until you need to sleep. In other words, work on building that client base first.

JULIA BRIGGS, BLUE STAR DESIGN

Too many people are eager to quit their day job when starting their business. The fact is, there is tons of work that needs to get done to get the ball rolling at the outset. Much of it can get done while you still have your day job. You should really hold onto your day job until your new business is putting so many demands on you that you simply must quit.

What kinds of work can you get done while you're still working a day job? You can set up your home office. You can write your business plan. You can build your company website. You can design your marketing

materials. You can work on writing copy to improve your SEO. You can choose a lawyer and set up your business structure. You can meet with accountants and get your books set up. You can find a payroll company. In my opinion it's best to get as much done as possible while still pulling a paycheck from an employer.

Family and Friends. OK, let's say you've saved every dollar you can, and stayed at your current job as long as humanly possible, and you are still in dire need of a cash infusion to start your business. In this case, the next best place to get money is from your family and friends. Typically there is less red tape; you can get a better interest rate, possibly at zero interest. Also, if you borrow from family or friends, you're more likely to pay it back because you're emotionally invested. Plus, there is flexibility. If you have a rough month and can't make a payment, your family and friends are more likely to give you a reprieve and not charge you a fine. Of course, you better be a person of your word and pay off that loan! This is your family and friends we're talking about. It's easy to destroy a relationship over lost money. Don't let that happen.

After Harry Truman's business went bankrupt in 1921, he did not declare bankruptcy despite being broke during the depression. Instead, he steadfastly paid off his debt over the next 13 years. If you're going to borrow money from anyone, particularly your family and friends, you better have a conviction as strong as Truman's about paying your debts. This is why I go back to my first point about borrowing money: avoid it at all costs.

Go to the Bank. If your family and friends will not give you a loan, the next best place to go is your bank. Unlike "angel investors" or venture capital firms, banks don't want to own part of your company. It's important to stay in control of your company if possible. When you have investors who own part of your company, your ability to make unbiased deci-

ELEPHANT IN THE ROOM

DRUMS//JOE BELLISSIMO
GUITAR, B3//HOWLIE MAXWELL
BASS//DAVILE PARRISH ALL MUSIC WRITTEN
GUITAR//BOB PARRISH PRODUCED
VOCALS//CHRIS REVEL
VOCALS//THE

PHOTOGRAPHY BY//
DESIGN BY//

ORANGEART

Star Energy
PARTNERS

Welcome. We are a premiere competitive retail supplier of electricity, natural gas, energy conservation, home protection and other products and services to residential and business consumers.

CHOOSE YOUR PATH...

Customer →
- Search for the best energy providers and prices by ZIP code
- Mobile/online energy management apps

Supplier Partner →
- Variety of energy & other prod/services with flexible fee structures
- Private online portal to monitor & track status of deals

Agent Partner →
- Use our unique data mining technology to market prod/services to qualified, targeted prospects
- Deliver targeted communications to your prospects

Not a member yet? Find cheaper energy, manage it simply and instantly access all the help in the world, right here. **SIGN UP, FREE!**

HOME APPLES TO APPLES ABOUT CHOICE ELECTRIC OFFERS NATURAL GAS OFFERS FAQs CONTACT

Compare *Apples to Apples* . . .
Anytime, Anywhere.

With the Public Utility Commission of Ohio's innovative tool, the differences between suppliers plans, terms and contract terms are always right in front of you.

Apples to Apples

WHAT IS ENERGY CHOICE?

Compare Electric Offers → Compare Natural Gas Offers →

KLN Logistics

Home About Services Industries Careers Tracking Contact

The KLN Advantage

SOCIETY
Lounge
CLEVELAND

ABOUT :: MENUS :: ENTERTAINMENT :: RESERVATIONS :: CAST OF CHARACTERS :: BLOG

A STEP BACK IN TIME...

Descending down the stairs to the Society Lounge opens a passage way back in time to an era where socializing transpires face to face, men shine their shoes, hats are never worn inside and a door is always opened for a lady. We return to the essence of this reminiscent era through the cherished art of handcrafted cocktails. Our passion is for concocting the highest quality cocktails and creating an atmosphere where our guests can partake in old fashion interactions. The Society Lounge will ravish your senses with the finest spirits, fresh squeezed juices and unique sophisticated syrups made from scratch. So come visit us with expectations for an exclusive experience and constant surprises that will always rely on our attention to detail (and your satisfaction).

SOCIETY LOUNGE
216 / 781 / 9050 :: Email Us :: Reservations :: Book a Private Room
2063 E. 4th St. :: Lower Level :: Cleveland :: Ohio :: 44115

- Web, Tech, & Software Design

sions is gone. Your investors will start sharing their opinions with you about how things should be. I believe strongly that too many opinions can steer a business in a bad direction. It's also known as "groupthink," when decisions are made not based on what makes the most all-inclusive sense, but instead are made on how to please a group. That usually makes for bad decisions.

Unfortunately, banks don't like to take risks. They're hard to get a loan from if they consider it risky and most new businesses are in a risky situation. You'll either not get much money, or you'll need to have leverage, like equity in your home. If you can get a loan from your bank, it's going to be the best interest rate while giving up the least control.

Credit Card or Angel Investor. If your bank won't give you a loan, then it's a toss-up between a credit card and an angel investor. Credit cards are relatively easy to get. That's their advantage. Everything else is a negative. They have terrible terms, offer horrible interest rates and if you fall behind the fees will pile up fast. If your business fails, they'll destroy your credit and with today's revised bankruptcy laws, it's not so easy to simply declare bankruptcy, clear your debt and start over.

An angel investor is an individual or small group that will invest in your company. They fill the gap between family and friends and venture capital firms that normally require much larger investments (typically at least $1–2 million).

Unlike the credit card company, an angel investor assumes the risk of the loan. If your business fails and you can't pay back the angel investor, it won't impact your credit. You don't have to declare bankruptcy. The investor has simply lost his money. The exact terms of a loan from an angel investor is also typically more flexible than what you'll find with a venture capital firm. But the downside is that an angel investor is going

to be an owner. You will be giving up a part of your business. In exchange for taking a risk, these angel investors will be looking for a steep profit on their investment: either a lifelong percentage of your profits, or a large payout.

My personal experience using loans. In my fifteen years building Go Media, I count on one hand the loans I took out. When I first left college, Go Media was a comic-book illustration studio. I was trying to get work drawing comic books. When I failed at that I decided to write my own comic books. When no publishers would print my books, I decided to publish them myself. I used a credit card and spent $5,000 printing the first edition of my comic book. At that time I made certain assumptions about how many comic books I could sell. First, I assumed that Diamond Distributors (the industry's only distribution company) would agree to distribute my book and include it in their catalog that goes out to all the comic book stores. It did not. Even after I finished the second and third editions of the book, Diamond Distributors did not accept my book. This left me with virtually no way to sell my comic book efficiently. I had a website, I mailed flyers to comic book shops and I spent six months driving from town to town attending comic book conventions trying to sell my books one at a time. The net result was that I was spending more money trying to sell my books than I was making. Plus, that $5,000 loan I took out was sitting on my credit card and needed to be paid back. I spent the next year and a half paying that debt off.

The second time I used my credit card was in my fourth year in business. Things just got very slow that year and I had bills to pay. There were two months where I used my credit card to pay for my rent and all my utilities. I was able to pay that back by the end of that year.

The third time Go Media took out a loan was in 2008 for a mortgage for our building. But I don't consider this a risky business loan. We were

buying a building for our offices. If the company failed, we wouldn't lose the value of the building. We could always sell it for at least as much as we had paid for it.

The fourth time we got loans was in 2009 when the economy collapsed. That year, Go Media was over staffed. We had more employees than our business could keep busy. Additionally, we were spending way too much time on future investments and nonpaying work. We were rebuilding our website. We were developing a WordPress image viewer we called "Go Gallery" and we were rebuilding Proof Lab, our customer and project management system. We were all working very hard, but there was almost no money coming in. When the economy collapsed, what business we did have suddenly dropped off. Basically, we just ran out of money. Things got desperate real fast. We had been operating with about a one-month financial safety net. That evaporated in a few weeks. We were suddenly faced with a situation where we couldn't make payroll. That month we laid off four employees. The partners also stopped taking payroll. We went to my father and uncle for loans. Fortunately, both my father and uncle had great faith in us and quickly gave us loans that helped stabilize the company. Those loans were paid back by the end of 2010.

After that experience, I learned it's important to set up a line of credit with your bank. You want to do that when you don't need the money. This is the catch-22 about getting loans from a bank. When you really need them, they won't give them to you. And when you don't need them, they will. It makes sense in a weird kind of way. When you really need them, you're obviously in some kind of financial strife; when you're in financial strife you don't look like a good risk to the banks. Conversely, when you're flush with cash, you look low risk. The secret is to set up your lines of credit when your business is in good shape. Then if things go sour, you have the line of credit already in place, and you can grab it.

So that's what we did. In 2010, while Go Media was doing better and paying off its debts, it also set up a large line of credit.

WERE THERE ANY PARTICULAR MOMENTS, LESSONS OR DECISIONS THAT HAD A PROFOUND IMPACT ON THE GROWTH OF YOUR BUSINESS?

The biggest lesson I have learned, by far, is that you cannot push people to become leaders; they either are or they aren't. I spent many years trying to groom various key employees into company leadership only to finally learn that often isn't at all effective or realistic.

I also learned that there is a reason that most creatives aren't business people and vice versa. When creatives are burdened with budgets, forecasting, etc. (aka the business stuff) they are far less effective as creatives. And it is difficult for a business person to constantly switch gears from number mode to design mode.

So, the best decision I have ever made was to ensure that each role is filled by the right person (hiring on new talent if necessary) rather then trying to morph someone from their natural form into something else that is not ideal for their skills and talents.

PHIL WILSON, FINE CITIZENS

The last time we took out a loan was in 2011. Go Media was two and a half years into building Proof Lab. We had a slowdown in business, and I needed capital to keep the Proof Lab development moving forward. In that scenario we had too much invested and too much momentum going with Proof Lab to let it slow down or stall. So we used the line of credit that we had set up in 2010 to cover payroll while we pushed Proof Lab forward. We were able to pay back that loan by the end of the year.

Overhead. One wonderful aspect of starting a design firm is that there is very little overhead. I started my business in my dad's house. I literally graduated from college, moved back to Cleveland Heights and into my dad's house. Fortunately for me my dad was very laid-back and supportive of what I was trying to do. He let me invade his life and set up my business in his house. This kept my overhead even lower. He didn't even charge me rent. It's easy to take for granted all the things our parents give us, and as I look back now, I'm very thankful for the financial and emotional support my parents gave me. Even if you're renting an apartment, the point is that being a freelance designer or starting a small design firm can be done relatively inexpensively.

Renting an office space. Here is a great example of the difference between WANTING something and NEEDING something. As I just mentioned, when I got started I ran my company out of a bedroom in my dad's house for two years. Then I moved into an apartment. After that I rented the first floor of a house (a duplex). After that I bought a house. None of these were a dedicated "office." They were all places where I lived and worked. For the first 11 years of my company I ran the business out of a residence. Certainly I WANTED a dedicated office. I would have felt more comfortable and confident. The duplex in particular was an ugly dirty old house. I was embarrassed to bring clients into it. But I didn't NEED an office, I just wanted one. So instead of paying an extra $500–$2,000 a month for an office, I made do with what I could afford. I would drive to my client's offices instead of inviting them to mine. Or I would suggest we meet at a coffee shop or restaurant. Also, I built a conference table by lacquering the surface with colorful flyers we had designed. The hope was that our clients would be so mesmerized by our crazy table, that they would ignore the rest of the "office." It worked. The first thing everyone said when we invited them into our "office" was: "Wow. This is an amazing table!"

Eventually Go Media did buy an office building and built out an amazing 5,000 square foot work environment. We absolutely love it. But we waited as long as we possibly could. Just before we bought the office, we had 12 employees working in 800 square feet of space. We were in my house at the time. My dining room, living room and flex space was filled with desks. We were elbow-to-elbow. One of our employees and I were sharing a single desk. It was crazy. The staff was getting frustrated because we were so close that there was no privacy. If someone was on the phone, they were right in your ear. If someone was in the kitchen cooking lunch, it was only a few feet from you. Again, the point is that we technically didn't need an office. We made do with a bedroom, then an apartment, then the first floor of a duplex and then a house.

It's a unique opportunity starting a design business—so take advantage of the opportunities it lends.

Furniture. I know there is crazy custom furniture out there. It's space-age looking, highly flexible modular stuff. It also costs a fortune. Almost all of Go Media is furnished with desks, chairs, tables and bookshelves from Ikea. It's an incredible value. Ikea's furniture looks nice and is durable. That's about all I have to say about that.

Equipment Overview. I've always been quick to make investments in technology and equipment. If some technology or equipment can make your company run more efficiently, I recommend making the investment. If you're uncertain about the ROI of some new technology or equipment, you can easily do a quick cost vs. benefit analysis. Generally, a design firm's wages are by far the largest expense. Anything you can do to maximize the efficiency of your staff is typically going to be a winner. I do like to hold off on buying equipment until I've landed a project that justifies the purchase.

Mac vs. PC. When I was in school at Ohio State I bought a Power Macintosh. I was a designer and designers use Macs. That was the unstated rule about design platforms. When I left school and went into business, I started with a Mac. But within the first year of being in business, I had many clients requesting PC-compatible design files. At that time (1998), PC-Apple cross-platform compatibility was not as foolproof as it is today. I decided to purchase a PC to go along with my Mac. Soon I found myself needing new software to run my businsess, including QuickBooks and Microsoft's Excel and Word. What I found was that this software was either not available for the Mac or significantly more expensive. Since I was a starving artist at the time, it was more economical to buy new software for the PC. When it came time to buy new computers, I kept buying PCs. I could get the same computing power for half the price, and I knew that all the software I needed would be available for that platform. Additionally, I wasn't experiencing much difference in performance between my Mac and my PC, running the same software for nearly the same experience. However, I was not doing processor-intensive work. I was not rendering 3D animations, editing video or processing high-end audio. I was doing basic print (branding, flyer design, brochures) and basic website design work.

As a result, with major cost savings, and minimal difference in performance, Go Media slowly built its entire company on PCs. We know it isn't sexy. But being in business and being the cool kid on the block are not always the same thing. You have to be pragmatic.

I don't want to bash Apple in any way. Their products are better. They are more stable, less likely to be attacked by a virus, and in some instances superior in performance. And let's face it, they are indeed cooler. They're designed more beautifully, their interface is better and their other devices are tightly integrated. But I was starting a business. Money was ultratight. We didn't have a few extra grand available to buy Macs. So, we did what we needed to do.

M3 Conference
Responsive website for the M3 Conference

Computers: most of our employees are using Dell OptiPlex machines. The OptiPlex line of computers aren't marketed as "workstations" for designers. The OptiPlex is marketed as a midrange business computer, nothing fancy. It's my opinion that computer manufacturing companies crank up the prices on machines they call "design stations." In my experience, the performance doesn't warrant the additional money. It's been my experience that the OptiPlex line of computers have been far more stable and reliable than the more expensive lines of "workstations." Strategically, I recommend looking for rock-solid midrange business computers, max out the RAM and upgrade the video card. The result is a machine that performs as well, if not better than a more expensive machine. I should qualify this statement with one thing: most of the work Go Media does is branding, print and web development. If you're doing 3D modeling, animation, video editing or something that requires much greater processing power, I don't have a ton of experience to know which machines run best under this type of workload.

Mac Pro: Go Media does own one uber-powerful Mac Pro. We'd begun producing video tutorials and felt the editing process would be much easier with Final Cut Pro using a Mac. It was fairly pricey, but it paid for itself quickly and I really enjoy editing with Final Cut. If you have a need, I recommend using the right tool for the job. But an office full of Pro Macs for day-to-day low-processor-intensive design work is a waste of money. (I know designers around the globe are hating me right now, but start your own firm, start paying your own bills and you might understand where I'm coming from.)

Monitors: almost our entire office is using dual 24" monitors. I've been told that the dual-monitor setup immediately increases work efficiency in an office. I only have anecdotal evidence to back that up, but I use my dual-monitor setup constantly. Almost all our monitors are Dells, but the quality disparity in monitors is shrinking rapidly. These days you

can pick up a beautiful 24" off-brand monitor for around $300 and they work great.

Equipment: Scanner, Cintiq, Monitors. There is probably a laundry list of peripheral equipment that you think you'll need to successfully run a design firm: such as an oversized flatbed scanner, an enterprise-level full-color printer and a Wacom Cintiq. Well, Go Media didn't have most of these items for the first ten years in business. I'm not saying that you shouldn't have them. But it is possible to build your business without them. My first recommendation is to hold out on buying any of these items until you land a project that not only justifies the need, but also finances the purchase. Remember, cash is king and equipment is hard to liquidate.

One piece of equipment I highly recommend is a simple black-and-white laser printer. I've had a great experience with the Brother line of laser printers. Almost every day we're printing documents on our Brother. It's a workhorse that doesn't break down and the ink is very reasonably priced. If you own an inkjet printer for day-to-day use, get rid of it, recycle it. Go out and buy a laser printer.

For our color printer we got a deal on a used Xerox color laser printer that can print up to 12x19 inches. It's been solid for us too, but an in-house color printer is not an acceptable machine to print color proofs. You should ONLY show your customer color proofs produced by the printing company that will be printing their job. The color printer is only to help us print impressive proposals. Ninety-nine percent of our proposals and proofs are delivered through the web. Which brings me back to my original point: you don't need a lot of expensive equipment to run your design company.

Go Media owns one oversized scanner that the staff shares. It's an Epson GT-20000. It works well and I would recommend one for your

office. We own a 24" Wacom Cintiq that we also share. It's an amazing tool that unfortunately gets underused. Most of the staff have smaller Wacom tablets at their desks. Perhaps they don't use the Cintiq because they're more comfortable sitting at their own desks. Given the use it gets, I can't recommend owning a Wacom Cintiq unless you can identify a recurring need and an employee who will use it.

Drafting table & Lightbox. It's sad that designers don't draw as much as they used to, but we still encourage it at Go Media. We have one large drafting table with a swing-arm light, lightbox and full array of pencils, pens, markers, pastels, brushes, inks, paints, paper types, etc. While it's not used as much I would like it to be, I want to make sure that my staff has all the tools they might ever want or need to draw. Having some staff that can bring a hand-drawn aesthetic to your firm's portfolio is a real differentiator.

Office Network: one item I cannot imagine running Go Media without is a rock-solid office network and shared server. Every company and client file is stored on an in-house server. This way, any designer can easily access every file. The only things our employees keep on their local hard drives are personal files. I don't have a lot of knowledge in the area of networks and servers. I have a good friend who is an IT expert. He set up our network and recommended equipment in exchange for some design work. Our server and storage is all Dell equipment. Currently we have about 8TB of space in a RAID 5 configuration. Once each quarter, we'll dump everything onto external hard drives and store them at a remote location just in case our building burns down.

I think a small firm can get away with simply networking their computers until they've reached about four employees. At that point they'll need to designate one central server where all the files should be shared in a single, well-structured hard drive. In order to set this up properly, I

recommend hiring a small IT firm or trusted IT freelancer. Explain to them what your needs are and projected growth over the next five years to ensure the right setup.

Organic vs. Inorganic Growth. Go Media was built organically. That is to say, we didn't take out loans or get investors to push our company forward with infusions of cash. Instead, we started with almost nothing, went to work, earned a dollar, then spent a dollar. A good analogy for organic growth is a tree. Your business is a tree. Let's pretend that you have a yard and you want a tree in it. You could invest almost nothing by buying a seed. You would plant the seed in the ground and wait. That's basically what I did with Go Media. I started with nothing, invested nothing but elbow grease and slowly grew the business. This type of growth is safe and predictable but takes longer than inorganic growth. Since you only make small investments, you're only taking small risks. And since you can only grow if you're profiting, it means that your investments will go into things that are working. Back to our tree analogy: when you planted that seed and waited a month and nothing came out of the ground, you would learn that either your seed was bad, the environment wasn't right or that there was something wrong with the soil. As that translates to business, it would be like starting a company and not getting any sales. Either your business model was wrong, the industry wasn't ready for your product or service, or your marketing was bad. But you would have invested little and lost little. Low risk, low reward.

If your seed did take root and start to grow, it would only be growing as fast as Mother Nature would allow. Does it rain enough in this environment? Are there proper nutrients in the ground? Is the winter too cold for the tree to survive? The point being that organic growth allows you to test your business as it grows since you're not building it artificially. It will likely continue to grow at the same rate of growth as in previous years, indicating how much it will continue to grow.

Inorganic growth is when you want a tree in your front yard, but instead of using your own money to buy a seed and plant it, you spend money (either your own or investors) and you go buy a tree that has already grown. You dig a hole in the ground and plant your tree. Voila! You now have a business that is much bigger than you would have if you had just planted a seed and waited. If you planted an apple tree, you might want it to produce pears. Well, you can pay to have a company graft branches from a pear tree onto your apple tree! Amazing. Your neighbor's organic business is little more than a twig in the ground producing no fruit, and you have a 20-foot-high apple tree that also grows pears! You're surely the superior businessperson, soon to be rich. Maybe.

Unfortunately, your house is in Arizona. You picked Arizona because you knew it was so sunny there. And trees love the sun! But you didn't consider that trees also need water. You overlooked this fact in your business analysis. Now your tree is dying. You borrow more money to pay a company to water your tree. But you didn't realize that the desert soil doesn't have enough nutrients to maintain your tree, so you hire a company to put fertilizer down to help your tree. Finally, it looks like your tree is stable; it's not dying. But it also isn't producing much fruit. In fact, you're spending more money keeping your tree alive than you are profiting from the fruit it's producing.

This is the risk you take with inorganic growth. You invested in a tree instead of a seed. You are gambling that you know exactly what your business needs to succeed, and instead of slowly growing one, you're going to artificially push it to a larger size. In this scenario your tree-in-the-desert failed. But who knew. It could have been a wise investment. If your tree would have thrived in the desert, then your investment would have had your company years ahead of your competition. But since you didn't grow your business organically, you didn't know if it would survive in the desert. If you had just put that seed in the ground and waited patiently,

you would have learned that apple trees don't grow naturally in Arizona. Unfortunately, you didn't go that route and now you have a business that is losing money and a mob of bankers and investors are hammering at your door, carrying torches and pitchforks. They want their money back.

Some businesses require inorganic growth; some require massive upfront investment even to open their doors for business. Fortunately, a design firm doesn't.

Organic vs. Inorganic: which to choose? I am not going to recommend one over the other. Personally, it is in my nature to go the conservative route. I like to plant a seed, go to work and build one leaf at a time. However, I have seen many of my peers get investors, spend lots of money and grow their companies rapidly. Sometimes I'm envious of their quick success. But I've also seen many peers borrow money, expand their business, then fail. It comes down to how confident you are in your business plan and what's in your nature.

> Finishing 2011, Quéz Media was realizing how dramatic our growth had become with the new customers and contracts coming our way. I knew we had too few resources to keep taking them on, so our choices were either to stay where we were, or break through to a new plateau. I chose the latter, moving to our new downtown location and hiring six new talented people to accommodate us. Ultimately, the decision worked in our favor, but I know the risks associated with it were high.

JOSE VASQUÉZ, QUÉZ MEDIA MARKETING

John D. Rockefeller started his oil refining business at the birth of the oil industry. From week to week, it wasn't known if oil was a plentiful natural resource or if it would run out. As one oil well dried up, oil prices

THE FILMS OF

WES ANDERSON

BOTTLE ROCKET (1996)

RUSHMORE (1998)

THE ROYAL TENENBAUMS (2001)

THE LIFE AQUATIC WITH STEVE ZISSOU (2004)

THE DARJEELING LIMITED (2007)

FANTASTIC MR. FOX (2009)

MOONRISE KINGDOM (2012)

skyrocketed, then a new source of oil would be found and prices would plummet. Rockefeller believed that his business was ordained by God and that his success was guaranteed. He took gambles that most sensible men wouldn't have taken. When prices dropped, he would buy massive quantities of oil. When it looked like the oil was running out and his competitors were liquidating their refining equipment, he would buy it all up. In this way he was able to build a company that made him the richest man on earth.

Did he know that there was a huge supply of oil for him to build a business around? Did he realize he was at the beginnings of a new market that would grow to become the largest industry in the world? No. He took a huge risk and got very lucky. Luck is a factor!

Organic growth until you have traction. Traction is a business term that explains early-stage success or "proof of concept" of a new service or product. While I tend to err on the side of organic growth, I understand the power and importance of inorganic growth too. You must be able to recognize when something is working and know when it's time to make an investment and artificially grow it.

Using our tree analogy, traction would be watching our seed grow. Perhaps we put that seed in the ground. We didn't water it or fertilize it. We just waited. And it did indeed sprout. Over two years it showed steady growth. That's proof that the environment and soil are right for this type of tree. It is proof of potential. That's traction. Now, you could buy fifty more seeds, plant them and wait. That would be a safe, organic way of scaling up your operation. But why would you do that? You've already tested the environment. You've got proof of concept. It's time to scale up inorganically. In this scenario I would feel comfortable taking a bunch of money and buying 50 saplings of the same type, plant them in the same field with confidence, knowing that they will not only survive, but that

they'll flourish. Utilize organic growth until you have traction, then use inorganic growth to scale rapidly.

Frequently, venture capital companies work using this model. They don't necessarily want to invest in a company that is a startup with no track record. Instead, they are looking for companies that are already showing signs of success, but could use a huge infusion of cash to grow quicker.

A real-world example of this business strategy took place for Go Media on our product "Mockup Everything." For those of you that are unfamiliar with Go Media, suffice to say that we have a line of digital design products that we sell to other graphic designers (arsenal.gomedia.us). One line of those products are Photoshop templates, layered files that allow designers to quickly mockup their designs onto everyday products. This line started as apparel: t-shirts primarily. As a marketing concept, we decided to build a Flash website that would show our templates in action. A user could upload a photo, see it on the shirt, make minor edits and download an image. It was a fun little web app called ShirtMockUp. com. After it had been live for awhile we decided to create a pro tier. The pro tier would include many more templates and the ability to download larger images without a watermark. We really didn't expect much from this little site, but it started to generate a steady but small stream of income. Over the course of the next year-and-a-half, we ignored the site, only making a few minor additions to the library of templates. We didn't market it. We didn't improve it. We didn't promote it on our blog. But a remarkable thing happened. Every month, for that entire 18 months, sales grew. It wasn't a record-breaking pace, but it grew and grew, completely unaided by us. If ever there was a proof of concept, this was it. Our little sapling was growing steadily.

Proof of concept warrants inorganic growth. Having slowly come to the realization that ShirtMockUp.com was no fad, but served a real

need in the market, made us wonder. How big is its potential? Shirt-MockUp only had t-shirt templates. What if the site had templates for everything? I was confident about the concept. It was time for inorganic growth. I gave my product developer a budget and said "Build me Mockup Everything .com" Since that site has been live, we've been pushing it hard with investment. We're growing it inorganically. We're investing in new templates and marketing it heavily. While we're experiencing a loss in net revenue because we're investing in it, we're seeing the user base steadily grow and we can pull back on investments and turn a nice profit whenever we choose. For now we'll continue to push it forward.

First: organic growth. Second: traction. Last: inorganic growth.

> I was forced to not only be an efficient and hard working artist, but become a business man in order to keep the company moving forward.

DAN KUHLKEN, DKNG STUDIOS

Final Thoughts. I once heard a successful businessman say that he didn't like to get into any business that he couldn't afford to lose money on for five consecutive years. When I heard that it resonated with me instantly. I thought: "Yes, this guy gets it. No wonder he's so successful at business." If business was easy and money grew on trees we'd all be millionaires. In fact, running a business is a daily battle. You are going to be facing many challenges, both known and unknown. The most important thing is having enough capital to keep your business alive while you learn how to be successful.

DID YOU RAISE MONEY?

60%
NO 40%
YES

WHERE DID YOUR MONEY COME FROM TO START YOUR FIRM?

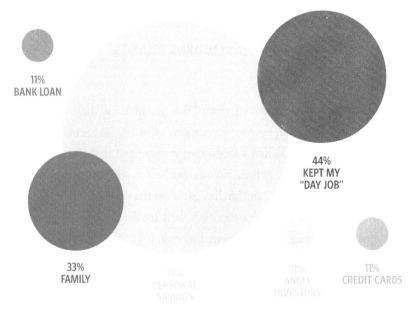

11%
BANK LOAN

44%
KEPT MY
"DAY JOB"

33%
FAMILY

78%
PERSONAL
SAVINGS

11%
ANGEL
INVESTORS

11%
CREDIT CARDS

WHAT KIND OF OFFICE WHEN STARTED?

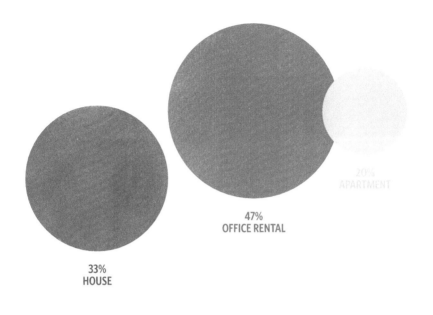

47%
OFFICE RENTAL

20%
APARTMENT

33%
HOUSE

TYPE OF COMPUTERS

87% MAC

CURRENT OFFICE TYPE

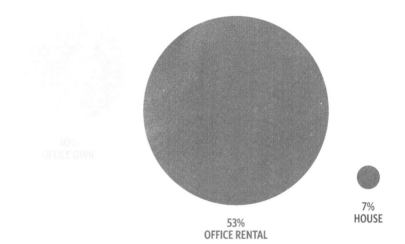

40%
OFFICE OWN

53%
OFFICE RENTAL

7%
HOUSE

Honest, frequent communication is critical.

— BEN CALLAHAN, SPARKBOX

One of the most common questions I get from young designers who are either freelancing or starting a firm is "What should I charge for my design services?" To answer this, let me tell you the story of how my pricing evolved into what it is today.

Flat Rate Billing. Flat rate billing is when you set a specific price for a particular service or product. Typically, you do this in advance of meeting with a customer. It's the McDonald's model. You have a set list of products (a menu) and their associated prices which is published for your customers to see. So long as the scope of the service requested does not change, the price does not change.

When I first started my business I used my experiences of shopping at other companies to shape my perspective on how my company should charge its customers. I was a big fan of having a straightforward menu of easily understood services and pricing for each item. It's like walking into a McDonalds: I look at a board, see exactly what I want and its cost. Straightforward and honest. This is how I liked to shop. I had had some past negative experiences at auto repair centers where they quoted me one price upfront, only to change it once I arrived to pick up my car. They would explain: "Oh, well, we found a bad seal on your front rotator

gasket," or some other mechanical lingo I surely wouldn't understand. Then I was stuck. The work was already done. Even if they were telling the truth, I FELT like I was being ripped off.

For my business, I wanted a menu with upfront pricing. This way my customers would know that they're getting a square deal from me, so that's what I did. My company website had a services section where I laid out in menu-style all the different types of services I offered and their associated prices. Here is that actual list with the prices I charged in 2001:

DESIGN COSTS:

Rave flyer (full-color, two-sided, with original illustration)
Quarter and Half page (from 4.25x5.5 up to 5.5x8.5)...............300.00
Full page (8.5x11)...400.00
Double page (11x17)..600.00

Black-and-White Single-Sided flyer (with original illustration)
Full page (from 4x6 up to 11x17).....................150.00

Black-and-White Two-Sided Flyer (with one original illustration)
Full Page (from 4x6 up to 11x17).................250.00

Full-Color Single-Sided flyer (with one original illustration)
Full page (from 4x6 up to 8.5x11).....................300.00
Double page (11x17)..400.00

Full-Color Two-Sided Flyer (with one original illustration)
Quarter and Half page (from 4.25x5.5 up to 5.5x8.5)...............300.00
Full page (8.5x11)...400.00
Double page (11x17)...600.00

CD Cover Design (with one original illustration) (includes design of backing board)

4 panel..400.00

6 panel..500.00

8 panel..600.00

Logo Design ...300.00

Business Package

Includes design of letterhead, business cards, and envelopes.........100.00

Website Design

Go Media would be happy to give you a quote on a website design after a discussion concerning how extensive your site is going to be.

You'll notice that many of these projects say: "With one original illustration." These illustrations were major undertakings. I would frequently spend up to three days working on a single illustration; to charge $300 for three plus days of work was horribly under-charging for my services. But at that time, what I really wanted to do was to make cool art. The money was secondary. Not only that, I based my prices on what I thought I could get. I based it on my emotional perception of what I was worth. I didn't do any market research. I didn't try to charge different amounts to see what I could get. I based my prices on my emotions. When you're young, $300 feels like a lot of money.

> **We asked our clients and vendors what competitors were charging to learn typical market rates.**
>
> **JULIA BRIGGS, BLUE STAR DESIGN**

These were flat rate prices. They included unlimited concepts and revisions which put all the pressure on myself and none on the client. The client could be as picky as they wanted. So long as they paid my rate I had to work till they were satisfied. At these rates, and with the incredible effort I put into all my designs I soon found myself very busy with work. In those early years of the business I worked insane hours. A typical week looked something like this: Monday through Friday, 10:30 a.m. till 1:30 a.m.; Saturday, 11:30 a.m. to 7:00 p.m.; Sunday, Noon until 5:00 p.m. I was putting in over 85 hours a week. Can you guess how much money all that hard work was earning me? Not much. I was constantly broke and trying to figure out how to pay my bills. But I was earning something that was far more valuable than money. I was gaining experience. I was learning how to work with clients. I was learning how to sell, bill, keep my books, market, do payroll and deliver a final product. I was learning how to run a business. I guess you could say my "pay" for all that hard work was knowledge. If I had over-priced myself, I may have never been able to work on so many projects with so many different clients.

I've heard that some of the very best doctors and medical procedures come from the military during war times. The reason is that the doctors in those situations are forced to conduct hundreds or thousands of procedures in a very short time period. They are forced to practice their profession a LOT. And there is NOTHING like practice to make you better at your profession. The same is true in design, illustration and business. Early in your career, experience is more important than money. You need to learn. I'll often tell young designers: "Work. Do whatever you have to do to get work and keep yourself busy—even if that means giving your services away for free." That's right. I said it: WORK FOR FREE. I mean, get money if you can, but if your schedule isn't full with projects, get out there and find something to work on. Good things come out of keeping yourself busy, even when it doesn't pay. You're getting experience, improving your skills, producing more art for your

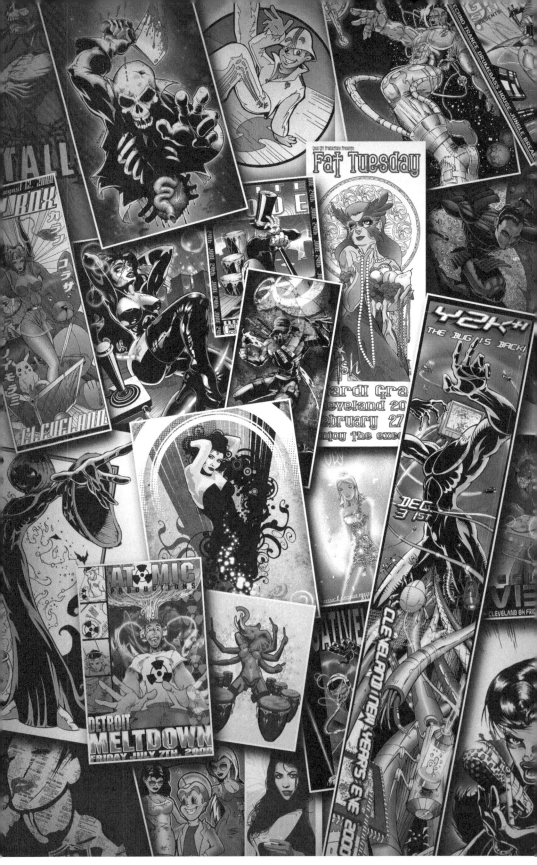

portfolio and making connections with clients who might refer you to other businesses.

Get slammed. Then raise your rates. The easiest way to know when to raise your rates is when you're slammed. If your design schedule is booked solid for three months and you have more requests coming in, then it's probably time to raise your rates. This is a great way to discover your market value. Start with your rates low. Work hard until you're slammed, raise your rates, repeat. This is what I did over the first few years of my business. My logo design pricing for instance, went from $300 to $500 to $900. But I was holding steadfastly to my flat rate, upfront pricing system. Admittedly it was becoming more difficult. A customer would ask for a logo design, I would quote $900 and they would say: "$900?!? But I already did a sketch. I just need you to refine this letter 'C' I made. It should be very simple. Really? $900? That doesn't seem fair." In this scenario it would have only taken me a couple of hours to do what the client was asking for; that wasn't fair. A flat rate system just didn't seem to account for the variables in design projects. One price didn't fit all cases.

More and more my flat rate menu system was showing its faults. Here are some of the major problems I was having with my flat rate menu of services:

The time it takes to complete a design project varies dramatically, even when the "product" is set. An example is a t-shirt design. How long does it take to design a t-shirt? I've spent an hour on a t-shirt design and I've spent an entire week on another. The answer is that it depends on the project variables. Unfortunately, a flat rate doesn't account for the specifics of each project.

If you don't set a specific limit on concepts and revisions, a client can easily take advantage of you. There is no pressure on the client to work ef-

ficiently, or be decisive. Since they know their price will not go up, many client seem to relish the design process and drag it out for sheer pleasure.

A client will assume you can't do anything that is not on your menu (in your portfolio). For instance, if my menu doesn't include "Banner Design," they assume I can't do it. Of course I could do a banner. It's no more difficult than laying out a business card or a billboard. But since I've created a specific list of services, that's the only things that people assumed I could do. After several years in business I ordered a banner for Go Media. Before I had the banner up in my office, I hadn't ever sold a single banner design project. The week that I hung my banner up in my office I had a client walk in and say: "Oh! You can design banners?" As if this medium required some special skill or software they assumed I didn't have. That first week I sold two banner designs. It seemed absurd to me that a client wouldn't understand that I could design almost ANY print piece. But this has been reinforced frequently throughout my career. Clients typically want to see examples of exactly what they want drawn or designed before they'll hire you.

> It can be very beneficial for both the client and the firm if a lower rate for design work can be agreed to up front, with the complicit understanding that eventually rates will have to increase as the client's business grows and as the firm takes on more responsibility.

CHAD CHEEK, ELEPHANT IN THE ROOM

Another more ambiguous problem with my menu system that I wasn't conscious of was that it cheapened me. My pricing, along with the way I explained my services, shouted "commodity." I was selling my services as if there was nothing special or unique about them. I was modeling my

menu after those you would see in a fast-food restaurant. That's how I came across to my potential clients: fast-food design.

There were, of course a few pros with my flat rate menu. Client knew immediately what I did and how much it cost; I seemed approachable. Clients knew exactly what they would be charged upfront. I didn't have to write proposals or estimates.

Hourly Billing. After years of selling my design services using a flat rate menu and discovering that it wasn't perfect after all, I decided to try something else. I already knew, but did a little research to confirm the fact, that most service industry businesses bill their customers by the hour. This included professions like lawyers, accountants, auto mechanics and contractors. For each hour I work, you pay me X dollars.

At first this seemed like a great system. I would get paid exactly what I should, based on how long I worked. If a client was picky, that meant more money for me. This system took all the pressure off me and put it squarely on the shoulders of the client. It seemed great. But then reality set in.

First, when you're billing hourly, you can't just tell a person what your hourly rate is. Saying: "I bill $100/hour and it will cost as long as it takes me. I don't know how much it will be." That doesn't work. The customer still wants an estimate of the total cost. Once again you're forced to give your client a flat rate number: "Here's what I think the total will be when I'm done." Although this is like having a flat rate menu, there are two important differences. First, you're thinking in terms of hours worked. This is an important psychological perspective. If you're think-ing in those terms, you're more likely to be tracking your hours. And if you're tracking your hours, you're going to be collecting information that will help you make decisions about how to change your business. With

a flat rate business, I never tracked my time. Since I didn't track my time I didn't REALLY know how long it was taking me to get things done. Was I being efficient and profitable designing logos for $300? I didn't know. Secondly, since my estimates were unique for each new project, it allowed me to adjust the pricing based on information I gathered from the client. I've learned that pricing needs to be based on more than just the product that you're designing. Here are a few things I think about before I quote a project:

Quoting. When you're quoting hours on a project, it's easy to do what I would call "emotional quoting." You have a general feeling about what something should cost, so you price it accordingly. This is what I did for a very long time and it's a really bad approach. If you're empathetic like myself, it's too easy to worry about the client's budget and artificially lower your numbers to what you think they can afford. Of course, you don't always know what they can afford, so you're negotiating against yourself before they've even seen your cost estimate. Or, if you're greedy, you'll artificially raise the number to what you want to make. While going too high may be less of a problem than going too low, I think both of these approaches are wrong. Even if you want to overcharge your customer, you still need to learn how to quote accurately. Otherwise you won't know how much "over" you've charged them; what you think as an overcharge might be an undercharge.

How do you accurately estimate the time it takes to do a design project? I have two main thoughts on this. First, you need to break each project down into as many small pieces as possible. Then you need to quote each of those individual pieces as accurately as possible. Once you've done that, add them all up. This is particularly critical as the projects get bigger. Let's think of a website design. You could quote a website design as one single line-item. Basic business website: $10,000. That feels right. This would be emotional quoting. Or you could break it down some-

thing like: Project Management, Design, Development and Deployment. Breaking it down into these chunks might help you consider how long each item would take to complete. If you quote the site by considering each item, then adding them together, I promise you'll get a different (more accurate) number than your emotional single line-item quote. Go Media breaks the quoting down even further. When we're putting numbers together for a website build-out it looks more like: Project Management, Site Map, UI/UX, Wireframes, Design Homepage, Design Services, Design About, Design Projects, Design Projects Details, Design Contact, Front End Development, Back End Development, Deploy, Train, Hosting. This is a far more accurate way of estimating hours.

The other important piece of accurate quoting is historical data. If you track the time you spent on a project accurately, you'll be able to learn from your history. Obviously, the first step in being able to review historical data is recording the data in the first place. To do that, you'll have to identify project types such as "logo design" or "website development." You'll also need to break the project down into individual tasks or phases, depending on how granular you want to get with it. Ideally, your data collection structure should reflect your quoting structure. For instance, when Go Media designs a website for a client, the first round of visual concepts is a homepage design and one interior page. This is an efficient first step in the visual design process because the homepage and one interior page are just enough to establish the aesthetic foundation for the rest of the pages in the site without doing too much work. As this is a major task in the overall project, we track the time it takes to get these particular pages designed. It's also treated as an individual item when we go through the cost estimating process. Once you've recorded your hours on a number of similar projects, you'll see trends that will allow you adjust your estimates.

ADDITIONAL THINGS TO CONSIDER BEFORE QUOTING PROJECTS BASED ON HOURS:

What's the product and specification? Logo, Business Card, Brochure? How many pages? Does it require an illustration? This is all the obvious stuff you would normally ask. The rest of the list is less obvious.

What's the turnaround time for this project? Turnaround time is a great tool for negotiations. If a client can't afford my full rates, I'll ask them if they can give me more time to get the work done. This allows me to fill in the gaps (slow times) with their work. Conversely, if a client is on a very tight deadline, I will charge them an additional rush fee of between 10% to 20%.

How much the client will be providing to the project. For instance, how well thought out is their concept? Have they planned the whole thing? Do they understand all aspects of their business model, brand, and how Go Media will fit into that? Do they have examples of design styles they like? Do they know what color range they want? Every project requires a fair amount of thought. The more thought a client has put into a project, the less work for me.

Is the client high maintenance? Here is a perfect example of a potential nightmare client that I just had call me. The conversation went something like this:

Me: "Thank you for calling Go Media, this is Bill, how may I help you?"

Potential Client: "Um, yeah uh, your company does, like, media in the computers and stuff right?"

Me: "Yes, we're a graphic design firm. We can handle any print design, web or branding needs that you have."

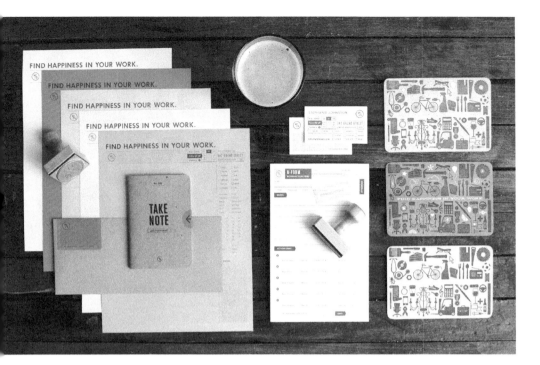

Potential Client: "I have this idea for a business. It's like Tap-Out, except my market is traditional boxing—real old-school style. And I don't want to sell t-shirts."

Me: "OK, so what's your business model? What are you selling? How do you make money?"

Potential Client: " I haven't decided exactly—we could sell clothes, but not t-shirts, my brand is higher-end than that. Perhaps it's about the advertising, we could get sponsors. What do you think?"

At this point my brain is quickly sizing up this potential customer. They don't sound particularly knowledgeable about their industry; it doesn't seem like they even know what they want to do. Any hope that they have a brief, or business plan, or anything concrete for me to sink my teeth into is remote. A client like this can quickly suck up your time and energy as they are working through exactly what it is that they want to do. You either need to cut this client loose immediately, or you need to start charging them immediately for consulting time.

If a client is well-organized, and appears well-financed, I'm willing to spend weeks on a proposal for them. If a client is disorganized and seems a little shaky on finance, then I'll charge them for the production of a proposal. In those instances, me writing a proposal is writing their business plan for them. I will probably require multiple client meetings to extract what they are trying to accomplish. I'll probably be doing a lot of business and brand consulting. And then I'll be tying it all up for them. That's work, and with such a low probability of payout, it's just not worth my time.

Another way to quickly filter clients that might be a poor investment of your time is to have a frank discussion of your billing rates, ballpark figures on costs, and your billing policy upfront. I've often found myself

saying something to a client along the lines of: "That's quite a robust website you've just described. I would estimate building something of that magnitude might cost between $35 to $75K. Are you comfortable with that?" Of course, you need to make sure you're being kind and supportive of a potential client's dreams when you're laying out big numbers. Don't be a jerk. Kill 'em with kindness, though sometimes a client needs a little dose of reality so you don't waste hours or days on them.

The money conversation is going to come out eventually, so don't be afraid to talk costs early—and often. Early in a conversation with a client any numbers you give are going to be ballpark figures, so I like to qualify my statements before I give them a number. I'll say things like: "There are many ways to build a website, with dramatically different costs. Normally, we like to write up a functionality list before we give any price estimates. ...BUT...based on what I think I hear you describing, but don't hold me to this, I'd estimate costing somewhere in the $XX,XXX dollar range."

Does the client seem decisive or indecisive? Some clients know exactly what they want. They tell you straight. This can be frustrating from the perspective that your personal design tastes will largely be ignored. We call this design-by-client. This frequently means less work for you because you're not having to come up with much. You're just giving the client what they want. On the other hand, a client who cannot decide can be a nightmare. If they say: "I'll know it when I see it," you're in trouble. This consideration plays a major role when quoting return customers. Once I've worked with someone, then I'll know just how decisive they are, how picky they are, etc. The high-maintenance clients get their estimates bumped up by 25% to 50%. This isn't personal. I like many of my high-maintenance clients. It's not about their personality. It's not a penalty fee for being jerks. They're going to make you work more hours because they're indecisive, so you need to charge them more. It's just good business.

> **Charge more to clients who are difficult to work with. And be don't afraid to tell them the reason.**
>
> **CHAD CHEEK, ELEPHANT IN THE ROOM**

Are they providing the content and if so, how well-organized is it? Here is a classic example: a client is ordering business cards for their staff. In scenario "A" they provide a single Excel document with all their staff's info. It's all been perfectly organized and it all follows the same format; name, title, phone number and e-mail. In scenario "B" I get three different e-mails with partial information of their staff. Then I get several e-mails directly from staff members. I am not sure if I've gotten all the information. What I did get doesn't match. Some people want fax numbers, some want a second e-mail address. They're just business cards; it doesn't seem like gathering content should take that much time, but it adds up quickly. Let me tell you what happens. In scenario "B" I need to gather all this information. This means checking in until I think I've gotten the complete information. Then I need to copy it and verify it with my client. Invariably, something is missing and further e-mails need to be exchanged. Since the staff requested different information on their cards, I have to make multiple card templates. Since the content they provided was disorganized, the proofing of the cards will be equally disorganized. Instead of one list of feedback, I will get multiple e-mails with differing feedback over several weeks. This means I have to open, edit, proof, and close the project many more times. Since the client didn't look closely at their content, when they see the proofs, they realize people are putting different information on their cards. He or She doesn't like that, so I need to redesign them so they all have the same information fields. Then I have to start the proofing process all over again. These scenarios may

sound exaggerated, but I promise you they are not. You can easily see how something like having organized content can have a major impact on how long a project takes to get finished.

What's their personality like? I like to think that I can get along with most people. But let's face it—some people are just harder to get along with than others. If you're sensing a personality conflict, you might seriously consider passing the client off to another design firm. If you are desperate for their work, then don't underprice yourself: you'll begin to resent them. Your bad feeling will mix with the personality conflict and soon you'll be refunding their money and asking them to leave. Don't waste your time!

> Seeking clients outside of the immediate geography is also a good way to grow the rate structure. Local companies tend to try and get work for cheap or free.
>
> **CHAD CHEEK, ELEPHANT IN THE ROOM**

Problems with hourly billing. Hourly billing has its advantages. Hourly billing gave me the ability to modify each estimate based on the each projects's particular circumstances, but there were problems, too. Even though I told my client: "This is only an estimate, you will be billed actual hours worked." That's not what they heard. What they heard was: "This is what your project will cost." When a project went over budget, they were not happy. When you give a client an estimate, they think of it as a flat rate. They are very upset when you go over budget. This cannot be understated.

Another problem with hourly billing is that you cannot capture the true value of your services. Here is an example: our developers have spent many long hours writing code that can be reused on multiple web development projects. We charged clients for this code when it was first being written, but now it's done. We can reuse it and save many long hours on a web development project. Is it fair that the first client got charged for it and the second client didn't? Should we be giving away this code simply because it's done? No. It's our custom code. It has value and we need to be able to capture that value. Hourly billing does not account for these types of scenarios.

The Go Media Hybrid Billing System. So, flat rate has problems. Hourly has problems. What do you do? We did what we've always done at Go Media: we developed our own system. At its core, it's hourly billing. I call it "hourly billing with caveats." If a client asks us: "How do you derive your estimates?" we will tell them: "It's based on hourly billing rates." But we no longer give the client a line-by-line breakdown of how we're adding up those hours. We also stopped showing them the hours we've actually worked, which we used to do.

Sometimes we eat hours. Clients don't like it when you go over budget. If a client stays "on scope" and we just go over budget because we misquoted, or the client was a little pickier than we expected, we will eat a number of hours to try and close out the project on budget. I think we would be willing to eat up to 20% of the project's hours to try and come in on budget. This puts a little pressure back on us to work efficiently and to quote accurately. However, we make sure to let our client know the value they're getting. We'll trumpet the fact that they just got X hours of free design services so we could stay on budget. However, if the client is going WAY over budget, then we start billing them again. The keys to making this work smoothly are:

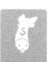

Make sure they understand your policy before the project begins. Even though most clients tend to ignore it, make sure you put in writing and tell them in person: "Our quote is an estimate based on an hourly rate. If your project goes over budget we will be billing you at $XX dollars an hour. We are going to work very hard to stay on budget. Our quoting is typically very accurate, but you need to be aware of this policy."

> There will ALWAYS be somebody [priced] lower than you. There will also ALWAYS be somebody [priced] higher than you. Compete on something other than price...expertise, personality, technical skills, etc.

JEN LOMBARDI, KIWI CREATIVE

Start giving early warnings when you start to see a project going over budget.

Discuss what you're going to need to do to get back on budget. Give the client options: "We can reduce the number of pages in your brochure or we can replace the infographic with a photograph."

Give 'em something for free and make sure they know it. Nothing smooths over an over-budget project like the awareness that they got a deal. You can either give your client some free hours on the current project or get them to order another project by giving them some free hours on a future project. "Sorry, we did go over budget by five hours on your project, but we're going to only charge you an extra 2.5 hours on

this project, and we'll give you a 2.5 hour discount on your next project, so you'll recoup that money!"

We also don't tell them we'll discount their project if we come in under budget. Since we're eating hours when we go over budget (within reason) we also will capture the profits when we come in under budget (within reason). Now, this is not a cut-and-dry scenario. If we discover a project is extremely under budget, then we likely will give the client a discount. It's a judgment call. Obviously, you have to give the customer good value. If it's clear you hardly worked on something and charged them a lot, they're going to get pissed. You need to use a little common sense as to when you can capture some extra profit and when you need to give some money back.

Value pricing. The last caveat to this hourly billing system is capturing extra profit for items that we feel are more valuable than the hours we'll spend on them. Earlier I spoke about boilerplate code that our developer have written that we feel is very valuable. If we have items like this that we're reselling and feel have an intrinsic value, we're going to charge a flat amount for those items. Even though our developers can copy that code in a few seconds, we might charge the client for the many hours he spent writing it originally. This is a strategy that lawyers use a lot. They'll write one contract, then resell it to different clients. All they have to do is make a few modifications and they're able to capture the value of what they've delivered to the client instead of the time it took to produce it.

The Responsive Pricing System. When I started Go Media, it was just me. I had a set list of prices I wanted to charge, but I was frequently desper-ate for money—any money. So, when it was slow and the money was running out, I made deals. I adjusted my prices. If it was slow, I felt sad. If I felt sad, I lowered my rates so I had something to do. If I was busy, I felt confident. When I felt confident, I demanded full rates—maybe

even padding my hours a bit. In effect, I had a responsive pricing system. When I was slow, my rates went down. When I was busy, they went up. They changed to fit the situation. It wasn't something I planned out. It was just an emotional reaction to the moment.

> ## DO YOU HAVE ANY OTHER THOUGHTS, ADVICE OR STORIES ON THE SUBJECT OF PRICING/BILLING?
>
> We use an extremely detailed project estimate spreadsheet to determine our fees. Having everything broken down in a granular format helps us better to communicate the basis for our project fees, establish trust with the client and justify the overall costs.

PHIL WILSON, FINE CITIZENS

As Go Media grew and I had other members in the company selling with me, I naturally shared the pricing of our services with them. I didn't tell them that I adjust the pricing based on how busy we were. How could I? I didn't even realize it was an important aspect of how I sold Go Media services. Now that I was part of a team of salespeople, I felt that I had to define a very clear pricing model. Not only did I give the team a pricing model, but I tried to stick with it. Our pricing became very rigid. Under any circumstances, we charge exactly XX dollars an hour.

Here's why being extremely rigid on your pricing can be a problem:

If your pricing is too low, you'll soon find yourself swamped. Despite being swamped, your pricing remains low, which means the work piles up. When the work is piled up, you start falling behind. You're not capturing the maximum amount of profit for the time you're working. The quality of your work suffers and clients start to leave.

KIWI CREATIVE

WELCOME

to the Class of 2017

Look inside for a special message from
your enrollmenent manager, Allison Garmon!

E ABOU

& Your Futur

a Blue
means
ere. In
ted to

op
t

✢ JohnCarroll
U N I V E R S I T Y

...ges of
...to you and your development
...ects – mind, body, and spirit. You'll learn and
contribute in small classes, with individual attention
from professors who are experts in their fields.

Similarly, I am committed to you and to helping your
family through this process.

If your pricing is too high, then it's too slow. While you're capturing good money for the hours your staff is working on paying projects, they're also sitting idle some portion of each day. That's also leaving money on the table.

> We use our hourly rate as a way to control the flow of work. If we're very busy, our rate increases. The net effect of this is that we win fewer jobs, but ones that are higher paying.
>
> **BEN CALLAHAN, SPARKBOX**

Go Media had several experiences where our pricing got too high and we weren't being flexible. We didn't cut deals when we got slow, we "stuck to our guns." The result was horrific: all our work dried up and we had almost no money coming in. Only when we realized that we were quickly going broke and would soon miss payroll, did we cave in and start adjusting our rates down to capture some work.

Additionally, some clients feel the need to negotiate you down. It doesn't even matter what the price is! They just won't accept any deal unless they feel that you've sacrificed something. Being too rigid will scare off these potentially profitable clients.

What you're shooting for is to keep your staff as busy as possible while collecting as much money as possible. That's a simple concept, right? So how do you do that? You go back to what I was doing when I was responding to my emotional swings. Your pricing needs to be RESPON-

SIVE to the situation. Except this time we formalized the concept into a well-defined business system. It works like this:

If our staff is booked solid for 12 weeks or more, we offer no discounts and will only sell projects that are worth $5,000 or more. If we're booked solid for between 8–12 weeks then we're willing to discount our rates by 20% and we'll take any project worth $2,500 or more. If we're booked solid for between 4–8 weeks, we're willing to discount our rates up to 40% and will take any project worth $1,000 or more. And if we're booked for less than four weeks, we're willing to discount our rates up to 50% and take any project worth $500 or more.

This formalized responsive pricing system allows us to always stay busy and ensures that we're capturing as much money as possible. So, how does this system look in practical application? First, you don't share this information with your potential clients. This is for your eyes only. You certainly don't walk into a meeting and say: "Today is your lucky day! We're slow, so all our rates are 50% off!" That would be silly. You will always start a discussion of cost using your full retail rates. Hopefully they can afford to pay your normal rates. It's only AFTER the potential client has told you that they cannot afford your normal rates that you start to negotiate down. The tricky part is getting the client to engage in that negotiation. Many clients see a high price and don't even ask if you're flexible on price. However, you also don't want to present your cost estimate and then tell them: "But if this price is too high, just let us know and we'll lower it!" That's the same as saying that you're not worth what you're asking. What you need to do is delicately encourage your potential customer to negotiate with you. Here are a few tactics on how to get your potential client to engage in a negotiation on price:

Ask for their budget upfront. If you know what they can afford, you'll tailor your solution to their price. Then it becomes more of a negotia-

tion of how much service you'll provide for that dollar amount. The system still applies. When the service you'll provide exceeds in value the discounted rate you're willing to offer, then you'll know you don't have a deal. In other words, if the client has a $5,000 budget, and you're willing to discount up to 50% off because you're slow, the client essentially has a $10,000 budget. If you calculate the retail rates of your service to be $15,000, then you know you can't make that deal.

Follow up. The simple act of following up with clients after you've sent them a proposal can frequently spark a conversation that will lead to a negotiation. You can call with just about any excuse. "I was just calling to ask if you had any questions about our proposal. What's that? You would love to work with us, but we're too expensive? Well, that's a shame. We would really love to work with you too. Are we even close on the price?"

Make sure they know how much you want the project. Sometimes, if a customer knows you really want their project badly, they'll assume that you'll be willing to come down on price. So, if I'm giving a potential client a price that I think is too high, I'll stress how excited I am to work on their project and how great it will look in our portfolio.

There are couple additional details to this responsive pricing system that are important. First, your retail rates need to be high enough that they will allow you enough profit margin to quickly grow your company. If your full retail rates are too low, then you have no margin with which to negotiate. You'll just be landing everything at too low of a rate. If you're only landing 30% or less of the proposals you're sending out, then your retail rates are probably high enough. Also, you'll need a system for knowing how far out your team is booked. This is one of the fundamental metrics that drives this system. Currently, Go Media uses an Excel spreadsheet to forecast our resource allocations. Experiment with a few and find one that works for you. Your system could be as simple as blocking out days on a calendar or taking a weekly poll of your design

team. Lastly, the minimum order portion of this system does not apply to existing customers. Obviously, a current client who calls with a need, even a very small need, should be taken care of immediately.

Billing Policies. While knowing what to charge is obviously very important, knowing how to collect it is equally critical.

Recognizing Busters—The Millennium Story. In my fourth year in business I was still essentially broke and living project-to-project, just barely paying my bills. I had recovered from my first two years of utter failure and had just paid off those debts. I had struck out on my own again after working a corporate design job for nine months when a young music promoter called me with what I thought was an awesome opportunity. He was throwing a giant outdoor music festival in southern Ohio. He seemed to have amazing momentum behind his project. He had about a hundred acts lined up—everyone from rock bands, to DJs to country music. Nobody was super famous, but it was still an impressive lineup. He hired me to design his flyer and to handle the printing. At the time I was brokering printing to make extra money. I would pay for the printing upfront then mark up the price a little bit on my customer.

Everything was happening very fast and was very exciting. Each time we talked this promoter would pump me up with exciting news about what new acts had signed on, the buzz in the community and press coverage he was receiving. He always had some new item for me to work on or print. Mind you, he hadn't paid me a dime yet. At this time, I was billing all my clients on 30 day terms. Which basically meant I did the work first, then gave the client 30 days to pay. In his case, those 30 days came and went and still I had no payment. On one hand I was starting to get worried, but I was also caught up in the excitement. He owed me lots of money, so I didn't want to act like a jerk. When I finally did press him about money, he assured me he would be making a FORTUNE at the event, and that he would pay me a bonus for being patient with him. He offered

to DOUBLE what he owed me. Well, naturally I was appeased by this offer, still worried a little, but excited to make so much money. This was going to be my biggest payday in a long time. Of course, he kept coming back to me constantly for more work and more printing leading up to the show. By the time of the event, he owed me about $3,500, $1,600 of which I had paid out-of-pocket on all the printing I did.

The day of the event arrived and I drove out to collect my money. Can you guess what happened? I bet you can. The turnout was terrible. He explained that things were dire, that he owed tens of thousands of dollars and there was no money. Of course, there was a heated exchange, threats of physical violence were made, but alas, I drove home with empty pockets. I harassed him for several weeks with e-mails and phone calls. Eventually I did get something from him—a letter from the government explaining that he had declared bankruptcy and that I needed to cease and desist all harassment immediately. I never got a dime.

I felt completely dejected. My business had failed the first time. Now, for a second time I found myself destitute. I was already broke when this project began. I had poured my efforts into it for over a month. I had paid over $1,600 out-of-pocket for his printing—which I still owed. I decided that very day I was getting out of business. It wasn't worth it. I felt as though I was losing more money than I was earning. I called my mom to recount the story and explain that I was getting out of business. I think she knew how much I loved it. Apparently she didn't want me to quit, because this is essentially what she told me: "In the grand scheme of things, this is actually a cheap lesson. In the future you will have many much larger deals than this. So, you've learned a lesson that will save you a fortune in the future."

She was absolutely right. By the time that conversation had ended, I decided to stay in business. I had indeed learned a lesson that I wasn't

going let slip by. I needed to make some changes to my billing policies. The truth is, that my 30 day payment policy was killing me. I worried constantly about getting paid. Many of my clients would miss their 30 day payment deadline. This meant I had to remind them—repeatedly. It was an emotionally draining task. Then there were those who simply decided not to pay. It's not like my clients were Coca-Cola. If I had large clients, then I wouldn't have had to worry. Lawyers would be lined up around the block willing to work on consignment to sue Coke. But my clients weren't that big at the time. No lawyer is going to waste his time chasing after some no-money-having punk kid for me.

DO YOU HAVE ANY OTHER THOUGHTS, ADVICE, OR STORIES ON THE SUBJECT OF PRICING/BILLING?

If you're one person, start simply, probably by project. Get half upfront. As you grow, necessity will compel you to become more sophisticated, but early on, you need to just get it done.

ALEX WIER, WIER / STEWART

I went to small claims court once to try and collect from a deadbeat client. The very first thing out of the judge's mouth was: "Small claims court is not a collection agency." Translation: "Even if you win, we take no action to help you collect what you're owed." And that's exactly what happened. My client never showed up to the court hearing. I won my case and I got no money.

All this pain and suffering I was going through over collecting money had to stop. In the same way my flat rate billing had put all the pressure on me to perform and no pressure on the client to decide, so too had my pay-me-later 30 day billing terms. That policy put all the power into the hands of the client and left me flapping in the breeze. I needed to

change the rules. Either my business was going to work with a different billing policy, or I was going to get out of business, because all the worrying and rip-offs were not worth it.

Require a Deposit. The real game-changing policy for Go Media was when I decided that we needed to start requiring a deposit. I wanted money upfront. Typically, I asked for a 50% deposit. At first I had a few clients balk at my new policy. By that point I didn't care. I was fed up. My clients were either going to play by my rules, or they could hit the road. Some did. But in my estimation, that was a price well worth paying to achieve peace of mind. As soon as I started requiring a deposit, another interesting and wonderful thing happened: I practically eliminated 100% of my "buster" clients.

> At Quez Media, we use two main methods of billing: project-based contracts, and retainer-based contracts. In project-based contracts, we outline a set scope initially with a given price, and execute that scope within a set timeframe. In retainer-based contracts, we outline a set amount of hours per month or a set amount of deliverables each month, with a recurring monthly fee. We find using a 50/50 split of project-based and retainer-based billable projects allows us to see the best of both worlds, and protects us from any dramatic shifts in the market.

JOSE VASQUÉZ, QUÉZ MEDIA MARKETING

"Buster" is a term I adopted and have used throughout the years to describe any client who knowingly or unknowingly rips you off. I want to stress the "unknowingly" part of that description. Not all busters intend to rip you off. Sometimes it's just a combination of their attitude, ignorance and arrogance that allows them to start a project with good intentions, but fails miserably and leaves you holding the bag.

DO YOU HAVE ANY BILLING POLICIES THAT YOU FEEL ARE CRITICAL TO YOUR COMPANY?

A major shift for us was to go from deliverables-based billing to regular monthly installment billing. For example, our invoice schedules are based upon an up-front payment followed by equal payments for each 30 day period until the project is complete and the total fee is paid.

PHIL WILSON, FINE CITIZENS

Here is what I learned: most busters (particularly those who ARE planning on ripping you off) do not like to pay deposits. They don't plan on paying you at all. So why would they give you a deposit? By requiring a deposit, I accomplished two things. First, I got cash upfront, and second, it acted as a filter for people who were going to rip me off anyway. Deposits are like kryptonite to Super-Busters. It takes away all their power and renders them harmless to my business. This deposit policy was like a ray of golden sunshine shining through my pain and misery. My business was transformed overnight by this single change in my billing policies.

Exceptions to the deposit rule. Every rule has its exception. First, there were my lifelong clients. There are some relationships that mature to the point where you can simply trust them. If your client has been with you for a year or more, they bring you consistent work, and they always pay—you can probably trust them. In these cases, I will eventually relax my deposit policy. It is more efficient to only bill them one time after a project is done vs. billing them before, during, and after a project. Second, eventually I did start to land some truly large clients—Coca Cola, American Greetings and Progressive Insurance. In these cases, the companies are big enough that it isn't worth it for them to rip off a design firm. The negative press

they would suffer if they knowingly stiffed their vendors would be more damaging to them than the cost of paying. I trust the bigger companies and have yet to be ripped off by one. And quite frankly, the bigger companies are big enough to demand the rules by which you play. Most larger companies simply tell me their payment policy and I can either "take it or leave it." On the upside, they pay well, so of course I "take it."

> If you are busy doing work, you should be busy sending out invoices, as well. It can be very easy to get too focussed on doing work and not asking your clients to pay you. This will cause cash flow problems that can be tough to solve when things get far behind.

CHAD CHEEK, ELEPHANT IN THE ROOM

Monthly billing on bigger projects. Typically, the way we're billing for our smaller projects (say, anything below $3K) is a 50% deposit upfront, then a final 50% payment at the end of the project. For larger projects we may split it up into 33%–33%–34% payments, with the middle payment being made once we've determined we're about halfway through the project. For our larger projects (anything over $10K) we like to bill in the following manner: 25% deposit upfront. Then we bill monthly, based on the actual hours worked that month. The client has 15 days to make a monthly payment. If they don't make it, we stop working. In the last month of this payment system we add up all the hours worked, subtract what's been paid so far, including the deposit, and bill them for the difference. This monthly billing is an important safety measure when working on very large projects. Let's say for instance you were using the 50% deposit upfront and a 50% payment at the end of a project for a truly large project, let's say $100K. I know that for most of us (Go Media included) this is not your typical billing range, but I want to make a point. Let's say

MONTHLY BILLING COMPARISON

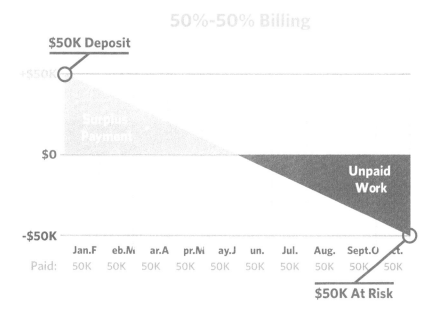

50%-50% Billing

$50K Deposit

+$50K

Surplus Payment

$0

Unpaid Work

-$50K

	Jan.F	eb.M	ar.A	pr.M	ay.J	un.	Jul.	Aug.	Sept.O	ct.
Paid:	50K	50K	50K	50K	50K	50K	50K	50K	50K	50K

$50K At Risk

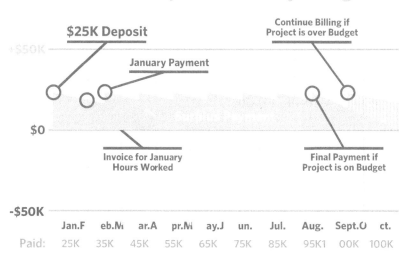

25% Deposit + Monthly Billing

$25K Deposit

Continue Billing if Project is over Budget

+$50K

January Payment

$0

Invoice for January Hours Worked

Final Payment if Project is on Budget

-$50K

	Jan.F	eb.M	ar.A	pr.M	ay.J	un.	Jul.	Aug.	Sept.O	ct.
Paid:	25K	35K	45K	55K	65K	75K	85K	95K1	00K	100K

this project is going to take you and your staff ten months to complete. That would mean that you'd get a $50,000 deposit. Sounds great, right? But what happens if you're stiffed on the final payment? That means you would have been working for free for five months! And the fact that you had a deposit upfront of $50K can make it too easy to overspend early on in the project, and wind up with a shortfall at the end.

> You may feel like a phony writing up contracts and collecting deposits since you're not a lawyer or an accountant. These documents don't have to be perfect or full of "legalese;" the odds that you'll go to court are low. They're just to show clients that you're a legitimate business serious about getting paid.

JEN LOMBARDI, KIWI CREATIVE

Let's take a month-by-month look at how these two billing styles would play out.

50%-50%:

M1–50K; M2–0K; M3–0K; M4–0K; M5–0K; M6–0K; M7–0K; M8–0K; M9–0K; M10–0K; FP–50k.

Totals: M1–50k; M2–50K; M3–50K; M4–50K; M5–50K; M6–50K; M7–50K; M8–50K; M9–50K; M10–50K; Final Payment: 100K.

Deposit + Monthly Billing:

M1–25K; M2–10K; M3–10K; M4–10K; M5–10K; M6–10K; M7–10K; M8–10K; M9–10K; M10–10K; FP–50K.

Totals: M1–25K; M2–35K; M3–45K; M4-–5K; M5–65K; M6–75K; M7–85K; M8–95K; M9–105K; M10–115K; Final Payment: 15K.

By billing monthly you're able to smooth out those payments so it keeps you on an even keel. Also, it gives you the opportunity to get ahead of your estimate just in case the project is going over budget. Most importantly, it allows you to stop working if your customer stops paying. At worst, you'd lose 1.5 months of work minus their 25% deposit (which would be close to a wash financially). In the 50%–50% scenario you could have possibly lost five months of work!

The great thing is that clients actually like the second option better because they see that they only have to make a 25% deposit. It's amazing how much more a client is likely to spend if they know they don't have to pay as much upfront, or if they know they have a payment plan to extend their payments.

Hold your client's files until their final payment has been made. Another policy Go Media lives by is that our clients do not get their files until we have received our final payment. This includes high-resolution print-ready art and source files. In the case of website designs, we build our client's

websites on our own servers first. Once the final payment has been made we will migrate the website over to their servers. While our deposit first policy eliminates most bad customers, this policy of holding a client's files until their balance is paid is a nice safety net.

You're going to get ripped off. Get used to the idea. If you're going to be in business you are going to get ripped off. It's a fact of life. You don't have to like it, but it's best if you accept that fact now. Otherwise you may overreact when it happens and decide you don't like business and want to quit. At least, that's how I felt the first time I got ripped off.

Accepting that you will get ripped off is not the same as letting yourself get ripped off. While it's important to be emotionally prepared for the fallout of getting swindled, there is no reason to not make every effort to avoid it. Over time, you will learn how to spot a buster.

> The most difficult lessons have been around knowing when and how to end a bad client relationship. Trying to maintain client relationships when it is clear they will not be profitable for the business or there is not a strong opportunity to do great work will be the biggest drain on the business and will suck energy away from growing stronger client relationships or finding new business. Every time I have walked away from bad business, it has created a very positive impact on the opportunities to grow the business in other areas.
>
> **CHAD CHEEK, ELEPHANT IN THE ROOM**

The billing policies I just covered will filter out most of the buster clients, but I don't want to gloss over this section. It's important that you know how to recognize clients that are not going to be worth your time.

Here is a list of the different types of busters I've come across over the last 15 years in business. Hopefully my bad experiences will spare you the same headache. Look out for these guys!

TYPES OF BUSTERS:

The Promoter. The promoter is probably my favorite type of buster simply because they're so entertaining (and easy to spot). A promoter is full of energy, and everything with them is bigger than life! I think of a carnival barker: "Step right up! Step right up to the greatest design project on earth! Wealth and fame beyond your wildest imagination are just behind this curtain!" They feed off your emotions, pump up your ego and make outlandish promises: "This business is going to make millions of dollars, and I'll share it all with you!" They also operate with a constant sense of urgency. Everything must be done quickly! They'll promise you part of their "can't-lose" business, but there are never any contracts or lawyers, just empty promises. If you ask about payment they'll say something like: "Yes, of course! I can pay you a ton…but we just need to get this one little item designed before…[fill in the excuse here]. It's going to be amazing! You're my man! You're the best designer I've ever met, that's why I want you as a partner. Now, quickly, get this website designed by the weekend!" The promoter's energy and enthusiasm never seem to end as well as their excuses. There is always one more problem, one more project, one more step. The magical fame and gold at the end of their rainbow of dreams is always just out of reach—tantalizingly close, but just beyond your grasp. Fortunately, the deposit first policy works very well with promoters. They will never give a deposit, or pay a dime. But one funny thing is that they're so damn persistent. Even after you tell them your policy…it's likely they'll say something such as: "Great! No problem. I'm happy to pay a deposit. I just need this one little project done before I'll have access to cash to pay that deposit!" Don't get sucked in! Stick with your policy!

The Delegating Entrepreneur. The Delegating Entrepreneur is also deflected easily by a deposit policy. They are a little like The Promoter except the main crux of their pitch is that you will be a part owner of the company. They will also play on your emotions and hype the dream of "your" business. They may even go so far as to write up contracts for your partnership. But here are the problems with these types of busters. First, "The Company" is mostly just them giving you work. They don't do much themselves other than daydream about how amazing the company is going to be, then pile up more work on you. They're master delegators. They're like Tom Sawyer convincing everyone else to paint the fence for him. Second, they're not necessarily good businesspersons, they just happen to be arrogant and overconfident, so it's easy to believe in them. Ask yourself this: Do you really want to risk your future on someone else's business dreams and skills, or your own? Third, if "your" company ever does start to make some money, this buster will surely keep it himself or sink it into other people to build the business more—after all, he already has you working for free. Why start paying you anything now? Getting money out of this guy is like getting blood from a stone.

This is not to say that there aren't good, honorable entrepreneurs out there who need a business partner. Obviously, there are some who bring a solid work ethic and good business skills to the table. But taking on a business partner is a serious undertaking. In my experience, nine out of ten people who will quickly offer you a portion of their business in exchange for free work are busters. I'll speak more about finding partners later in this book.

Mr. Add-On. Mr. Add-On is the first type of buster who slips past the deposit policy. He or she will pay you for the services that they have you quote. Here's their trick. They won't tell you everything that they need done. Then at some point during the design process, they'll start asking for a little more. They try to play-down the amount of work something

will take and try to make it seem like it's part of the current project. You might hear something like: "Now that you've finished my business card, can you just slap that information onto a letterhead? That should only take a second, right?" If the designer in your company is not the salesman, Mr. Add-On will exploit the situation by telling the salesman as little as possible, then trying to trick the designer into doing extra work for free. It's important that your staff knows exactly what's been paid for when dealing with this slippery buster.

> ### HOW DO YOU HANDLE PROJECTS THAT GO OVER BUDGET?
>
> Full-on prayer meetings, holding hands and singing "Kumbaya." We try to keep a contingency budget of 10% and learn from mistakes.
>
> **NORTY COHEN, MOOSYLVANIA**

The Slave Driver. The slave driver is similar to Mr. Add-On with one critical difference. Mr. Add-On is at least pleasant in his approach. The Slave Driver is merciless and hard to please. He may not add-on to a project, but he's going to squeeze every ounce of effort from you that he can. The Slave Driver is incredibly picky. He'll make you feel like you've made a mistake, done a poor job or misled him in some way. He'll lay heavy guilt trips on you. Working for a Slave Driver is never fun. The only upside to working for a Slave Driver is that you'll often do your best work for them, because they'll make you do it three, four, or five times before he's satisfied. You might get better with each design iteration and produce good work. The difference between a high-maintenance client and a slave-driver is that when you're done with the project for the slave-driver you never want to work for them again.

The Long-Con-Artist. The last type of buster I've dealt with I call the Long-Con-Artist. This type of buster has a longterm plan. He's trying to get design services for free, or for a greatly reduced rate. Here's his plan: pay for services, get most of my work done, then act like something is wrong, set the designer up for failure, then demand their money back. This type of buster starts out all sweet and loving, but the closer you get to completing his or her project the more difficult and demanding they'll become. At some point they'll start shifting deadlines or making demands that are virtually impossible to accomplish. Near the end, this con-artist will start acting inappropriately upset, start claiming that you've somehow hurt his business. He or she will invariably ask for a refund, refuse to pay his balance or even threaten to sue you. All of this is done as a way for him or her to steal your design services for as little as possible.

I'm sure there are many other types of busters out there, but these are the most common ones I've come across over the years. It takes time and experience to know how to identify and deal with these sleazebuckets. Here are a few red flags I look out for:

- They are in a big rush. Everything must be done fast.

- They're overly anxious, checking in with you frequently.

- They're coming to you because they had a falling out with a previous designer.

- They're overly enthusiastic and play on your emotions. This frequently comes in the form of flattery.

- They make future promises, like extra pay, more work or exposure.

- The industry they're working in is stereotypically sketchy—bars, nightclubs, movies, porn, etc.

- They generally talk too much about money.

- They sound high or drunk. (This really happens.)

Fortunately, if you follow the billing policies I've outlined above—and I mean REALLY STICK TO THEM, you will save yourself a lot of pain and suffering in the long run.

FLAT RATE OR HOURLY?

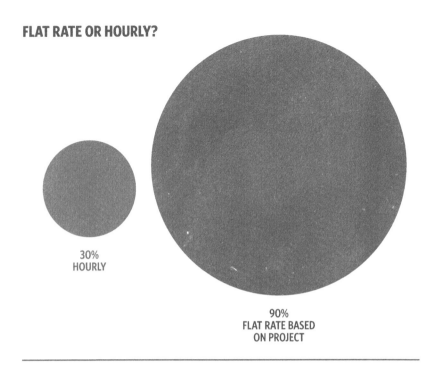

30%
HOURLY

90%
FLAT RATE BASED
ON PROJECT

DO YOU REQUIRE A DEPOSIT?

One of the most important factors to long-term success is having a trustworthy, reliable, and passionate team—do NOT simply hire people to fill seats.

— JOSE VASQUÉZ, QUÉZ MEDIA MARKETING

Keys to hiring: If you've read Jim Collins's book *Good to Great*, then you'll know how important your staff is. (If you haven't read his book, I highly encourage you to do so.) Simply put, your staff IS your company. And your relative success or failure is frequently a result of the quality of your people. If you think you can hire mediocre people and train them to be great, well, think again. Particularly when you're small and getting started, the impact of your staff is amplified. A very small business is really more about its people and less about its systems. You need to make sure you're finding and hiring the very best employees.

The Myth: more employees equals more profits. I had this idea stuck in my head for most of my life; the more employees I have, the more money I make. Even before I was seeing any real return on the hours I was working in my business, I was anxiously trying to hire on employees. The thought was that an employee was like a little engine, churning out profits. The more little engines you have running, the more profit is pouring out onto your company floor. Well, this is a fun idea, but what if your engines produce $1 per hour in profits and what if your engines require

$2 worth of gas each hour to run? Now your little money engines aren't churning out profits, they're burning money at a rate of $1/hour.

It's important to blow up the myth in your head that staff will somehow magically make you money. Having an employee is not inherently good or bad for your company's profits. They may make you lots of money, or they may cost you lots of money. The only real guarantee is that you have to pay them either way. So, before you run out and start expanding your staff...

> ## Only hire when you absolutely need to. You would be surprised how much one person can do.
>
> **DAN KUHLKEN, DKNG STUDIOS**

Do the Math: hire what you can afford. Don't be tempted by that high-priced gun. When Go Media first got started, we wanted to hire the very best employees, so we did. We paid them what they asked for. Unfortunately, we couldn't afford the quality of employees that we hired. We never did the math. We assumed that because they were good designers, somehow their value added to what our firm would produce: the extra income necessary to pay their salary. We had a problem. We weren't charging our customers enough hourly to cover the employee's hourly wage. The employee may very well have been worth their salary—but not as a part of our company. They were doing A+ work, we were paying them a B+ salary and we were charging our customers D rates. It was a guaranteed losing situation. So, when we hired our A+ superstar employee, our bank accounts were relatively full. After six months, we were broke and forced to lay off our newfangled employee.

When do you hire? A good rule of thumb for hiring is when you have enough money coming in that you can afford to pay that new employee EVEN IF THAT NEW EMPLOYEE DOES NOT CONTRIBUTE ONE PENNY TO YOUR INCOME. If you have any doubt whatsoever about your ability to afford a new employee, you probably shouldn't be hiring them.

> ## HOW DO YOU KNOW WHEN YOU NEED TO HIRE A NEW EMPLOYEE?
>
> Everyone is stressed out, yet work still isn't getting done on time, for more than a few weeks.

TRACEY HALVORSEN, FASTSPOT

This is the way I look at building a business: like a system. Adding employees is scaling up your system. When you get all the components of your business right, generating good leads, charging the right amounts, etc., then your system is working. It's effective. And if it's working, it should be generating enough money that adding employees is a no-brainer. You're scaling up a winning system.

But too often (in my case, for example) people scale their businesses before the system is working. It might be kind of working. It may be generating SOME profits. But it's probably not a slam-dunk. They haven't figured out how to generate a serious inflow of cash. They decide to scale too early. Since their system is only mediocre at best, they're only scaling mediocrity.

Before you start to scale up your business you need to ask: "Is this system humming? Am I dialed in? Are we churning out rock-solid profits every

month?" Or, are you hoping to fix your system by bringing in more people? Are you bringing on people hoping THEY will be the ones who start bringing in the money? If this is your perspective, then you shouldn't be hiring. You need to figure out how to make your company work when you're small. You need to insure you have overwhelming evidence that you can afford an employee. You need to have the need.

Another question you can ask yourself when considering whether or not to hire someone is: "Is there historical precedence for their job?" In other words, are you getting regular requests for the job they're going to do? For instance, a client may want to hire us to build them a complicated Flash website that will require extensive action scripting. Do we hire an action scripter? We certainly need him for THIS project, but how often do we need action scripters? If there isn't a proven track record of demand, then I would look to an alternate option to hiring a new employee. Even in the case that you plan to build a particular area of your business and are forecasting the need of a particular skill set, I would still recommend selling it first and hiring second. Build the demand first, line up the work, and THEN hire a new employee. If you have a part of your business that you're regularly outsourcing to some other company, this is an ideal opportunity to save some money by hiring an employee and bringing that work in-house.

Hiring friends. Early on in the business I hired a friend who was a big fan of my business and really wanted to be a graphic designer instead of a construction guy—the job he was working at the time. Hiring a friend with limited design experience was an obvious mistake. He wasn't a good designer and what he did design (poorly) he took a very long time to complete. Not only that, but his skill sets were a subset of my own skills. He couldn't do anything that I couldn't. In fact, the stuff he wanted to do was my area of expertise.

When I hired my first employee, we weren't doing twice as much client work. I didn't have that work lined up in advance of hiring him. Instead, we were simply splitting what work I had between the two of us. Not only that, I also did my best to pay him a prevailing wage for a first-year designer. Although that wasn't much, it was more than I was paying myself and it was more than I could afford. I hadn't done any projections on my new employee. I just hired him and assumed the money would come. What happened is that the money didn't come, it went. Over six months I slowly watched my bank balance fall. Eventually it was clear that I wasn't earning enough to afford an employee and was forced to lay him off.

> We use Myers-Briggs personality-type assessments. This helps us see whether a candidate fits our needs (e.g., detail-oriented) or if there might be gaps. We also use these assessments to help our staff understand each other and our natural tendencies. It helps us appreciate one another for their strengths and be more understanding when they don't work the same way as you. The differences are more appreciated and celebrated and the strengths are leveraged so that the individual and company benefit.

RACHEL DOWNEY, STUDIO GRAPHIQUE, INC.

So, what went wrong? Looking back now I can see that the first problem was I was simply not charging my clients enough money. I hired and fired a whole series of employees early in my business. I can tell you that the primary reason I had to fire those employees was because I was not charging my clients enough money and thus couldn't afford the employees. Even when I hired more talented designers who had skills that complemented mine, it didn't make a difference. The money coming in did not match the money going out.

DO YOU HAVE ANY WORDS OF ADVICE ON HIRING EMPLOYEES?

Hire for cultural fit before skill.
— BEN CALLAHAN, SPARKBOX

Finding someone to fit our culture is the number one thing we look for in a new hire because personality is something you cannot teach.
— JULIA BRIGGS, BLUE STAR DESIGN

Never assign anyone to a contract longer than 3 months, at any level. Test people like you test ideas. If the chemistry is right and they produce, then invest hard to secure them longterm.
— DAVID GENSLER, THE KDU

Look for the diamond in the rough. I love an underdog. The hardest working, most successful employees don't all look like supermodels with degrees from the Royal Academy of Art in London. In my experience, the best employees weren't born with a silver spoon in their mouth and a silver brush in their hand. They don't necessarily fit the stereotypical designer model. Maybe it's a mother who has been out of the business for ten years while she was raising her kids. Maybe it's the self-taught kid who couldn't afford to go to college. These are employees who appreciate an opportunity and have something to prove. They may have a chip on their shoulder and lack the sense of entitlement that many young designers have when coming out of school. The underdog is going to be more open to learn. They'll work harder and be more loyal. They also typically have a better attitude. Obviously, if a potential employee's portfolio isn't good enough, you can't hire them. Even if they have the best personality in the

CELEBRATE OAKTOBERFEST

BACARDÍ

world, you cannot hire someone without a good portfolio. If their work is good, but they don't have the pedigree of "champion," you just may be looking at a diamond in the rough. I encourage you to hire them.

> We like to hire on a trial basis. We'll give someone six months where they're getting paid hourly with the opportunity to go full-time after. It's important to make sure their personality works within the office. If it doesn't, we don't hire them.

ALEX WIER, WIER / STEWART

Try before you buy. In my opinion, one of the most important steps in the hiring process is the tryout. You need to get to know your potential employee and test them with work before you decide to hire them full-time. There are many simple ways that you can accomplish this. First, a designer's portfolio can be very deceptive. Far too often I've hired people with amazing portfolios only to find that their design skills were far worse. How did they build such beautiful portfolios? Maybe they copied someone else's work. Maybe their designs were created by a team that they were a member of, or maybe they were stolen. Who knows? The point is, you need to give potential employees real-world projects with real-world deadlines and see how they perform. Does the quality of their work match what you saw in their portfolio? The other critical aspect to the tryout phase is that it reveals their personality. In an interview, everyone is on their very best behavior. If you ask them if they'd mind working late because of a rush deadline, of course they're going to say: "Absolutely! I LOVE working late!" But what happens in the real world when they have tickets to a concert? Will they step up and get the job done, or will they refuse? Here are a few different ways you can try-before-you-buy.

Have Interns. Interns are college kids or recent graduates that you hire for a short period of time, usually about three months. They work for either college credit or extremely low wages. The benefits they reap are experience and education. In return, you get cheap labor. Having interns is a fantastic pool of potential employees. You'll get a real-world taste of their design skills and personality.

> Many of our employees began as interns. It was a great way to get them accustomed to how things work around our studio and a great way for us to get to know them.

MIKE DAVIS, BURLESQUE OF NORTH AMERICA

Give potential employees freelance work. If a designer is a potential employee, I like to outsource some work to them first. Even if I've already interviewed them for a position, I'll tell them we're not ready to hire but we have some work I can send them. Note how they respond. Are they positive and enthusiastic? Do they stay in touch? Do they quickly work through their projects? Is the quality what you expect? If the potential employee does a very good job on two to three different projects, then I'll consider them for hire. If there are any warning signs—poor quality, missing deadlines or a bad attitude, you must resist the urge to hire them, even if you feel desperate for employees. Hire slowly, fire quickly. Having bad staff is a dead weight on your business.

Six-month junior level design position. As Go Media has had good success with our interns, I wanted to figure out how to extend those relation-

ships. We recently introduced what we call our six-month junior level design position. It's similar to an internship except it's six months instead of three. It also pays a wage versus no wage for an internship position. If a junior level designer does very well during their six months with us, we can either offer to extend the position by another six months or offer them a full-time job. If they do a poor job, then we can let them go without a major emotional investment. Of course, we don't tell them that this six-month position might lead to a full-time job. That would be misleading them, as most of the time it won't. I don't want them to get their hopes up.

Find employees through referrals, not cattle-calls. It's always better to meet potential employees through trusted referrals instead of posting "Help Wanted" ads that will attract the unknown. Attitude is so important in your employees, and a referral is good because it's typically given by someone who has known the potential employee for an extended period of time. If there were any major red flags in their personality, it's likely the referrer would have detected them.

> Most of our hires have also been proactive, calling several times to ask if we are hiring or to simply meet with them. Showing that kind of interest often proves that they will be dedicated.

JULIA BRIGGS, BLUE STAR DESIGN

Look for self-starters. Is the potential employee already doing the things you want them to do? Self-motivation is key for an employee. If you have to prod your employee to get them to work, they're not good employees. I look for signs that my potential employees are self-starters.

If, for instance, a recent college grad who hasn't landed a job is going around the neighborhood looking for freelance work, it's a good sign he's self-motivated. Designers having a number of personal "passion projects" in their portfolio is another good sign. It shows that they love what they do enough to do it in their spare time. If they need a teacher or a boss over their shoulder and a deadline looming to get something done, then, again, they might not be the best employee.

Make them jump through hoops. When designers ask about a position, we'll give them some work. We tell them to e-mail us a cover letter, resume, five low-res .jpeg examples of their best work and a link to their online portfolio. How do they respond to that? Do they follow directions or do they take it upon themselves to interpret your instructions and send you something else? If they can't follow directions when applying for a job, you can be sure that they probably won't be good at following instructions once they're hired.

Hiring individuals without college degrees. In my experience designers (and employees in general) with degrees are more consistent and dependable than those without. I suppose the process of making it through school filters out some individuals who have a hard time sticking with something for an extended period. As a business owner, that's what you're really after. It takes a long time to get a new employee up to speed. Finding and hiring employees takes a lot of time and energy. Staff turnover is expensive for your business. I'm looking for employees who are going to STAY. And a college degree is an indicator of that. If I have two potential employees with similar portfolios and personalities, and only one has a college degree—that's the one who will get the job.

Having said all that, I will also say that I have hired a number of employees without degrees. Some turned out to be amazing employees. They would fall into the "diamond in the rough" category I wrote about

earlier. You should look for those individuals and not discriminate blindly against anyone without a degree. I would only suggest that a degree says something about a potential employee.

Recruiting talent and selling your vision. If your business has an amazing reputation like Nike or Google, you probably won't have to work very hard to recruit good talent for your organization. Even Go Media at this point has developed a strong reputation and have designers applying to work for us on a daily basis. If you're making huge profits, you can probably afford to pay premium wages and will also be able to easily attract top talent to your company. But for most startups this is not the case. Your situation is probably a bit precarious and your cash is probably tight. So, the question becomes: how do you convince good talent to take a gamble and work for you at below-market wages? The answer is simple—sell your vision.

> Recruiting is one of the hardest things I face. We only want to hire a half a percent of the people who might be looking for a job. Great talent creates great work which will attract great clients. Never settle for talent that is just good enough. Because, in reality, they will not be good at all.

CHAD CHEEK, ELEPHANT IN THE ROOM

When Go Media first started I was full of self-confidence, but my confidence in being able to provide well for an employee was simply not there. My word is my bond, so how could I make promises that I wasn't confident about? I have always been someone who follows through with what I tell people. I want to give people the most realistic description of what they will be facing by joining my company. There is great scientific evidence that supports the fact that employees are happier if

you give them a realistic job description. It makes perfect sense. If you tell someone they're going to be a world-famous designer doing work for Nike and making millions, and in truth they're working for a manure farm and getting paid peanuts— they're not going to be happy. They'll probably quit. I recommend that you give your potential new hires the straight facts about where things stand today, but giving them harsh realities is only half the story.

It's important that you also share your vision with the person you're recruiting. Why are you in business? Do you believe that you're just going to grind away for the next thirty years scraping out a meager wage? Hell no. You are going to be a world-renowned firm. You're going to own a skyscraper in the middle of your town. Eventually you want to break into 3D animation and produce feature films. You want a chef cooking everyone lunches twice a week. You're going to install a twenty-story water slide connecting your offices to your pool! Your designs are going to feed the hungry and cure cancer!

In Steve Jobs's biography, there was a story included from a former Apple employee who told about why he decided to work for less money at Apple than he could have made at another company. He said: "Steve Jobs asked me: 'Do you want to build computers, or do you want to change the world?' How could I refuse that?"

People crave leadership. They want to know that their lives are worth more than just a paycheck at the end of the day. They want purpose in their lives. They will make major sacrifices to be part of an organization that they can take ownership in. If they believe their efforts are going into a place that they want to be, they're willing to wait for a bigger payoff. As a small startup, you have some very serious advantages to offer your potential employees. Designers at a small firm get far more responsibilities. They're not just cogs in a big machine spitting out the

same thing day after day. They get to work very closely with the owners, learning valuable things about project management, sales and marketing. If the company grows rapidly, they'll be senior members of the management team. Being part of a startup is exciting. It's a great atmosphere to be part of, something they can tell their grandkids about. At Go Media our employees get to produce podcasts, throw events, design art for the heck of it, use our building as space for building their own companies and generally have major influence over what direction we take the company. Would this be possible at a larger firm? Unlikely.

It's important to tell the truth and be realistic. But your dreams are also part of your reality. You need to share those as much as you can to prepare them for the day-to-day challenges.

Freelance work and noncompete contracts. I've heard that some businesses require their employees to sign noncompete contracts. I've also frequently been asked by my employees what our policy is on freelance work. Are they allowed to do it? My answer is that that we do not have any noncompete contracts and our designers are allowed to do all the freelance work they want, so long as it's not done during the hours they are working for us and so long as they're not stealing our clients. If I found out that an employee was reaching out to our clients and offering them the same services at a discounted rate, I would fire them immediately. I am OK with our employees freelancing for our clients under certain circumstances. Occasionally a client will have a project that's simply too small for us. In a case like that we might send an e-mail to the staff asking if anyone wants to do the project on a freelance basis. Obviously, the client wouldn't have any guarantees from us, wouldn't get the full Go Media treatment, project management, etc.

I believe that owners' fears of their staff stealing their clients is unfounded. At least, in Go Media's atmosphere, our staff wouldn't dream of such

a thing. Most designers get enough time designing at work and really don't have the desire to do a ton of work after they go home at night. They also typically don't want to deal with sales, negotiations, management, billing, etc. In fact, we encourage our staff to bring work into the firm. Particularly if the project is large, a partnership between the firm and the employee working in their spare time can be a win-win situation. An employee, for instance, may be able to design the front-end of a website but require our development team to get the project done.

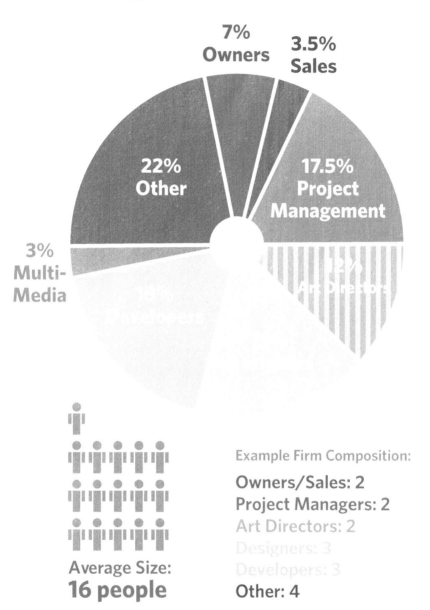

7%
Owners

3.5%
Sales

22%
Other

17.5%
Project
Management

3%
Multi-
Media

Art Directors

Average Size:
16 people

Example Firm Composition:

Owners/Sales: 2
Project Managers: 2
Art Directors: 2
Designers: 3
Developers: 3
Other: 4

HOURLY OR SALARIED?

7% HOURLY

93% SALARIED

PERCENTAGE OF OUTSOURCED WORK?

0-10%

31-40%
7% OF SUBJECTS

11-20%
29% OF SUBJECTS

51-60%
7% OF SUBJECTS

BENEFITS PROVIDED

Retirement Account	**33%**
Medical Insurance	**67%**
Vision Insurance	**53%**
Dental Insurance	**53%**
Paid Vacation	**87%**
Paid Holidays	**87%**
Paid Sick Days	**87%**
Life Insurance	**20%**
Education Assistance	**33%**
Wellness Program	**20%**
Stock/Ownership Options	**7%**
Cash Bonuses	**60%**
Auto Allowance	**0%**
Laptop	**40%**

Going to design school doesn't exactly prepare you for running a business. While I have smart people consulting for me now, I wish I would have identified this network sooner. They have been invaluable.

— RACHEL DOWNEY, STUDIO GRAPHIQUE, INC.

GENERAL STRATEGIES ON HOW TO APPROACH PROFESSIONAL SERVICE VENDORS (ACCOUNTANTS, LAWYERS, INSURANCE BROKERS, ETC.)

I believe that having a smart, strong team of professional vendors for your company is critical to your success: make a considerable investment in these people. Smart accountants and lawyers are more than just vendors, they're business advisors. But similar to building up your business systems, your professional vendors need to grow with your business. Good lawyers and accountants are expensive. I wouldn't suggest that a one-person design firm go out and hire the biggest firm in the city. When you first get started, you should probably find a lawyer that is about the same size as your company or a little further along. A one-to-three-person law firm and accounting firm would be a good size to start with. Similar to the hiring process, I think getting a referral is a better approach than looking someone up on the internet. Reach out to your family, friends and peers who own businesses and ask them if they have a good lawyer or accountant. Also, just like employees, it's critical that your accountant and lawyer have good personalities. You need to like

them, feel comfortable with them, be absolutely confident in their skills and communicate well with them. If you hire a professional vendor and you're having doubts about them or feeling uncomfortable during your interactions, don't hesitate—get rid of them and find someone else.

> There are a lot of annoying factors in the reality of business that go beyond what you may expect—from personnel to taxes to financial management. All of those can suck if you don't have a good set of consultants to help you along.

NORTY COHEN, MOOSYLVANIA

Good lawyers and accountants = good business consultants. In my experience, my lawyers and accountants are among my most trusted business consultants. When faced with big decisions or perplexing problems, your lawyer and accountant probably have a vast amount of experience to pull from. After all, they are probably working with hundreds of different businesses and in my case my lawyer and accountant were older than I was, so generally, they have more experience. Although lawyers and accountants can be expensive, in my opinion they're worth the investment. This assumes they're not jerks out to rip you off. Which is why I strongly recommend that you get a referral, and make sure you're very comfortable with your lawyer.

For the rest of this chapter, in lieu of me trying to give you legal and accounting advice, (of which I'm not an expert), I decided to interview my lawyer and accountant. Based on community suggestions, I put the following questions together. One thing you'll notice is that some of the questions I ask the accountant sound like legal questions and vice versa. This is because your legal decisions can affect your accounting and some accounting questions can affect your legal issues.

ACCOUNTING QUESTIONS

Note: My accountant asked to remain anonymous as he is not currently taking on new clients.

Bill: What are your qualifications?

Accountant: I went to Ohio State and earned a bachelor of science in business administration with a concentration in accounting in 1985. I am a CPA and have been since 1989. I've been practicing in public accounting for about 25 years and have for a little over 20 of those years specialized in small businesses and entrepreneurial enterprises. I've also handled some rather large companies as well. Those in excess of 50 million dollars in annual revenue.

Bill: Should I incorporate my business and when?

Accountant: There are a number of ways to do business now in the United States. There is the corporation, and within the corporation there is the S Corporation and C Corporation. A C Corporation is a tax-paying entity that is not used by most small businesses because it results in double taxation. The S Corporation is quite common for small businesses and allows all of the income from the entity to pass through to the owners and only be taxed once to the individual owner or owners at their tax rate or tax bracket. The partnership is another form of doing business which is an unincorporated group of more than one individual and it is also a passthrough entity like an S Corp. But it has some substantially different tax rules in terms of how things can be allocated, how certain things are taxed, etc. And then there is the sole proprietorship. So those are the three main forms of businesses. You've got the corporation, the partnership, and the sole proprietorship. A lot of people ask about a limited liability company. A limited liability company doesn't really exist in tax law, it exists in state statute.

Bill: This book is mostly going to be written for freelancers or small design firms that are trying to start and build a design firm that ends up with about 15–25 employees. Similar to my path. How would you suggest someone go about that—from beginning to end?

Accountant: The best answer to that is, a partnership or sole proprietorship could offer the opportunity to write off early year losses of an entity if funds had been borrowed from the outside. So I'll walk you through an example. If as a sole proprietor, you borrow money, and you have a loss in your first year, you're going to effectively get to write off that loss. A partnership would be the same thing because the partners are deemed personally responsible for borrowed funds. And you'd get to write off those early year losses. If you were a C Corporation, those losses could only be carried forward in the future against income. And if you were an S Corporation, the only way you'd be able to deduct the losses is if you had provided the funds.

> Find a reliable person to help you with accounting software and practices. This is the lifeblood of your business, so take it seriously.
>
> **JULIA BRIGGS, BLUE STAR DESIGN**

If you borrowed the money from a bank in an S Corporation, you signed personally to guarantee the note that, still according to tax law, doesn't give basis and the loss couldn't be deducted, it would be suspended in the future. So I might say to somebody, look, given our situation, we're not going to be profitable for two years, I'm married and my wife makes a ton of money as a partner at a law firm. I'm gonna find a way to get those

losses deductible in the early years and we might go with a partnership or sole proprietorship, depending on the number of owners. So we can write off those losses against her substantial income and provide benefit to the family. But if the individual has no other sources of income from anywhere, the losses don't help me now anyway. I'm gonna want to be an S Corp and I'll carry the losses into the future against when we're making money. If I wasn't worried about any of that, and I was just picking the best methodology my preferred choice, absent any other information that would change my opinion, would be an S Corporation.

And I believe that's how we have Go Media taxed.

Bill: Absolutely. Go Media is an S Corporation. And then there's cash basis and accrual basis of accounting. Can you talk a little about those and what you would recommend for a small designer?

Accountant: OK, so let's talk about what cash is and what accrual is and then how and why we use it. The cash basis recognizes income when received and expenses when paid. The accrual basis recognizes income when earned regardless of when it's received and recognizes expenses when incurred rather than paid. So in accrual basis you will have accounts receivable for earned but unpaid income. And you will have accounts payable for incurred but unpaid expenses.

Bill: So incurred being when someone sends me a bill but I haven't paid them yet. And earned means I've sent out an invoice but I haven't received a check yet.

Accountant: Exactly. Now tax law requires certain taxpayers to use the accrual basis of accounting. And mainly that rule is if you have inventory. Because inventory is something that you pay for and you're not going to be allowed a deduction for it until you actually turn around and sell the item, i.e., cost of goods sold. Otherwise people would effectively be

deducting their inventory before they ever sold it. And we wouldn't have proper matching of income and expenses. So again the accrual basis of accounting is required when inventory exists. If you have no inventory and you're picking between the cash or accrual basis of accounting, the next thing we would look at is, does the individual generally have receivables that exceed the payables. If the receivables would exceed the payables, the use of accrual accounting would basically require us to recognize income before we got paid for it, which we wouldn't do. Whereas if our payables generally exceeded our receivables it would mean we were getting to deduct expenses before we actually pay them. So generally what we find for service-based businesses is that the cash basis of accounting provides a better result to owners in that they are not paying taxes on unreceived income.

Bill: OK. What is the best way to get paid? PayPal, checks, credit cards? How do I accept payment?

Accountant: Any way you can. You get paid any way you can. We would never turn down a form of payment. I might be weary of somebody asking me for my bank routing number and account number for purposes of wiring into it, but it does happen in rare instances. Giving your banking information to others is always a risky proposition. Getting paid via credit card, check, cash, is all acceptable. Professional service firms generally find checks to be the most common form of payment, followed by credit cards. In small business you don't see a lot of wire transferring or electronic funds transfer.

Bill: Now with check vs. a credit card, credit cards have got a processing fee, so technically you're actually going to get a little more money if you're receiving a check.

Accountant: Yes. However, we view credit card processing fees as part of

the cost of doing business. We don't ourselves process a lot of money in credit cards. If we felt it was becoming more expensive, we would adjust our hourly rates to account for some increased overhead. If in a given year, a business had a 1% of gross revenue spent on credit card processing fees, they might want to modify their pricing structure for business. But unto itself it is not going to be the difference between whether you're profitable or not profitable.

> **Have a good accountant or CFO. Remember — it's a service industry — so your hours are your inventory.**
>
> ### TRACEY HALVORSEN, FASTSPOT

Bill: How should I invoice a client? What's the proper way? How do I send an invoice?

Accountant: Generally now you are seeing invoices come out of some form of software. Many of our clients use QuickBooks or some other form of small business software, including but not limited to Account Edge and Peachtree. All of these programs have the ability to generate invoices which can either be mailed or emailed to clients and customers, which is a form of asking to be paid for goods and services rendered. It is essential that any business that wants to be successful has a good process for billing and collecting. It is very difficult to make money if you don't pay attention to billing and the collection of receivables. And when we use the term "receivables," even cash-based businesses have receivables. They might not recognize them for tax purposes but they exist. Our firm is a cash basis entity but we have a billing package that produces

our invoices and keeps track of what's owed and we review that aging on a regular basis and have a practice of calling clients that are behind in their invoices and aren't servicing them in an appropriate fashion. For example, we might send an invoice to somebody and it's substantial but they might want to pay it over three months. Certainly that's not an issue. But if we issued somebody an invoice and it was not in any way paid or acknowledged during the first three months, we're going to pick up the phone and call and discuss arrangements. Because again we have expenses to pay as every other business does. You need to be bringing in the revenue for the work that you produced. So that you can cover your expenses, payroll and so forth.

Bill: So a followup question is: designers are frequently marketed a product called FreshBooks. Have you heard of that one?

Accountant: I have not.

Bill: That one is all over the designer websites. Do you have recommendations or preferences or opinions about these different pieces of accounting software? I know that QuickBooks can be kind of intimidating when you open it for the first time if you're not familiar with it. It seems robust.

Accountant: It is. A good accounting package is essential for a business. Obviously I can only comment on the ones that I know. We're big fans of QuickBooks in part because a lot of our clients have used it happily and successfully. The objective quite often is not only to do the things that a business needs to do like invoicing, paying bills and all those financial tasks. The objective is also to provide their accountants at the year end with a package of information that allows us to be efficient at getting year end financials and tax returns done. In the old days, people used to bring a bunch of papers to an accountant and the accountant

worked on all that stuff and the bills could be quite substantial. The use of a good software program can save a client an awful lot of money in time spent by the accountant at the end of the year. Our firm has a number of people who specialize in QuickBooks so we're able to install it and help clients manage it if they have questions or problems. Where the one you mentioned, Fresh Books, if you got it and tried to use it in your system and said, "Hey, I don't understand how to do an invoice." The time that I'm going to spend looking at that for you could dig deep into any savings you could have otherwise generated by using something else. For example, QuickBooks might run about $300 in the store right now, which is in our firm around two hours of professional time. That's a pretty good investment because you're going to save us a lot more than two hours by giving us a good clean package. When you do that you're able to save professional fees. Quite honestly, every business should strive to save professional fees when they can. So again Account Edge, PeachTree and QuickBooks are some of the lower-cost small business accounting packages. And that's what your design firms will typically look for. I certainly think QuickBooks is a perfect program for any design firm, can be set up and a client can be trained on it, and purchased, all for under $1,000. And that's not a bad investment for something that can last you a great number of years with the only additional cost being an update every three or so years.

And in your case, if we go back to looking at when Kim (Go Media's bookkeeper) started with the firm, and the fact that she had little or no experience with the program, and not a whole lot of accounting experience, if any. Now she's providing us with a comprehensive set of work at the end of the year that allows us to rip through what is a pretty big operation. So she's a perfect example of somebody with no experience with the software, no experience in accounting, running a good size design firm's QuickBooks with very little need of help from our firm over the year. I'm gonna say her number of questions during the year is five or

less. In the beginning when she started, she was doing some things that we figured out were misunderstandings on her part and we were able to convey to her why they were errors and how not to repeat them. And she obviously picked that up rather quickly. So I think that system works. I recommend QuickBooks for any design firm.

[This is a great example of why having the right accountant is so important. Our accountant was willing to work with us. He was willing to answer our questions and teach Kim how to keep the books a little better each year so that today we don't have to spend nearly as much money for his services.]

Bill: What if I'm a young freelance designer. I'm just one guy working out of my house. Do I really need an accountant?

Accountant: Yes—and that's not self-serving. If somebody said to me, can I prepare my own 1040 using TurboTax? I have mortgage interest, real estate taxes, I've got some brokerage statements for interest dividends and stock transactions, I made some charitable contributions, that is a no brainer for TurboTax. You're gonna spend a couple of hours and $50 or $60 and you're gonna get a solid tax return. Now you throw in having the business. I'm gonna tell you that you'd need to be reasonably savvy to complete Schedule C correctly which is the schedule on Form 1040 for those who are self-employed. And if you've incorporated or set up a partnership, you're gonna need to be extremely savvy to correctly prepare any corporate or partnership income tax return and you would be foolish to not have some type of professional preparing those items for you.

Bill: What if a client doesn't pay me? Can I take them to court? Send to collections?

Accountant: Yes and yes. Nonpaying of receivables is certainly something that every business needs to address. You try to work these situations

out amicably but there are gonna be times where being amicable doesn't work, in which case we suggest some legal course of action. Which can involve using your attorney or a collection entity; every situation needs to be evaluated. Clearly you want to establish a practice for getting your troubled accounts collected.

Bill: What type of things can I write off on my taxes and what does that even mean?

Accountant: Well the writing off means deducting as expenses, items against income for purposes of lowering the taxable income. The broad definition of what can be written off is ordinary and necessary business expenses. It includes anything that is proper in connection with the production of income. Obviously wages paid, payroll taxes, rent, insurance, interest on business debt, office supplies, technology equipment, including but not limited to, computers and printers, software. Basically if it's for the business it can and should be deducted. Many times businesses or the owners of businesses desire to write off things that have some element of personal use to it. It should be done in accordance with tax law. For example, an automobile, only the business portion of the automobile should be written off. There are a number of ways to do automobile and it depends on your form of organization. A corporation can reimburse anybody driving on behalf of the business who submits a mileage report and can reimburse at whatever the statutory mileage rate is. Currently I believe it's 55 and a half cents per mile. Businesses oftentimes lease cars for those who are using the automobile to drive on behalf of the business. If the person is allowed to use the vehicle personally, there should be a personal amount calculated and included in the W-2 of the employee. Additionally there are other tax compliance issues that relate to owned or leased vehicles run through a business. Meals and entertainment: if you're running those types of expenses through a business and they are certainly appropriate, you should be able to answer

the questions of where, when, how, why, and what as it pertains to business. What was discussed, why was it discussed, how was it discussed, when and where was it discussed. Those would be the types of things that would defend, under exam, the writing off of an expense that one might question whether it was personal or not. You and I are gonna go out to lunch today and I'm going to write off that lunch as a business expense because you're a client of mine. If you and I were going out to dinner on Saturday night as two buddies, it would be inappropriate for me to try and write that off, although people do try to write those things off all the time. Again you need to be prepared to answer those questions as to what makes it deductible and you go back to the ordinary and necessary test.

Bill: If I work from home, does that entitle me to any sort of tax benefit?

Accountant: If your home is your primary place of doing business, and we're talking about the home office deduction. There is a deduction available, though it's never one that's excited me a whole lot because it really only benefits somebody who's self-employed. It effectively allows you to depreciate the portion of the home that is used exclusively and entirely for business. You would have a depreciation deduction along with the ability to shift a portion of mortgage interest, real estate taxes, insurance and utilities, onto the Schedule C to lower the income but more importantly to also lower the self-employment income where FICA taxes come into play. Over the 25 years that I've been practicing, the home office deduction is still one of the rarest items that we see.

Bill: If I do a little design outside of my 9–5 job, do I have to report that as income to the IRS?

Accountant: You are supposed to. The tax law says that if you have income, you gotta report it. If you barter, for example, if I was to agree to do your 1040 in exchange for you doing my website, we both should be

reporting the income for the value of the transaction. If we had determined that the value of your 1040 and the value of the website you were going to design for me was $500, each of our businesses should recognize $500 of income from the barter. But you could also recognize $500 worth of deduction for the expense in accordance with what you had done for us. The real bartering issue comes when people engage in a personal transaction and a business transaction. The example that I just gave you kind of doesn't matter if we make that a trade one because we're both going to be tax neutral to a $500 income and deduction item. But now let's take an example where my landscaper says: "Hey will you do my 1040?" and I say "Sure." He has an otherwise deductible expense for preparing his tax return assuming it's in connection with his landscaping business. Whereas I have no basis for deducting landscaping and I need to recognize $500 of income from preparing that 1040 if I'm avoiding a landscaping bill that's personal in nature.

Bill: I've heard that if I start a business I say goodbye to my tax refund. That sucks, or does it?

Accountant: Again it's a fact and circumstances thing. If you start a business and again if you're self-employed, you are going to be generating income with no taxes being withheld against it. After the first year, you're going to set up estimates and those estimates will be sufficient based on the prior year's income so if your income for the subsequent year was higher, you're going to be deficient in taxes. But if your income for the subsequent year was lower, you're going to be overpaid.

Bill: Do I need a vendor's license?

Accountant: Generally no, unless you are providing materials subject to sales tax. The services provided by a design firm are exempt from sales tax and only tangible property such as a computer or similar device, sold in connection with those services, would be subject to sales tax.

Bill: Now this is specific to Ohio?

Accountant: That is correct. Every state has a different set of rules for sales tax and someone should check with their tax professional to review rules outside the state of Ohio.

Bill: Do I need a tax ID?

Accountant: Any corporation or partnership has to have a tax ID number, along with an LLC. And if you are a sole proprietorship that has payroll, you have to have a tax ID number. A sole proprietorship that has no payroll can just report under the social security number of the owner, otherwise have a tax ID number. It is still advisable to get a tax ID number for banking and other reasons. And so we still advise getting one for purposes of opening up a bank account in the name of a business even if it's just a sole proprietorship or DBA. It allows them to keep things separate for both banking and tax purposes.

Bill: OK, so that kind of addresses this question. When setting up a bank account for a sole proprietorship, should you use your name or should you use a DBA name and register for an EIN? You're saying use a DBA name and register for an EIN?

Accountant: Yes, I would say that's the preferable way to go.

Bill: How do I run payroll?

Accountant: Generally, most advisable is to engage a payroll service. There are a number of reputable ones out there including but not limited to Paycor, Paychex, ADP. Those are the three national brands that come to mind. Every city has some local providers that can also provide excellent services depending on where you are.

Bill: Are there advantages to weekly, bimonthly, or monthly payroll?

Accountant: The advantage to an employer of less frequent payroll is lower charges from the payroll service. They charge based on the number of times they process, so weekly payroll is going to be more expensive than monthly payroll.

Bill: When should I transition from a sole proprietor to a corporation?

Accountant: When there are tax advantages whose value can be measured that exceed the cost of the extra work that will be done from both lawyers and accountants to have a corporation. A small business or a low revenue business doesn't necessarily need to be incorporated to have great tax advantages but as things get bigger, there can be tax advantages that make those other costs worthwhile, including paying an attorney to draft and get you incorporated and an accountant to complete the annual corporate tax return that needs to be done.

Bill: Not to pin you down, because obviously all of these scenarios are very specific, but let's say that for each employee, as the company grows their revenue, at least what they're selling every year is something akin to $70,000. So you've got one guy working by himself making $70,000, you got two make $140,000, you got three making $200,000, ya know.

Given that scenario…

Accountant: Is this a one-owner business?

Bill: Yeah, let's say that.

Accountant: OK, because if it's a multi-owner business, you're already on an entity tax return anyway. I would tell you that I would probably be switching to a corporation, if I had to be pinned down to an answer, once I had an employee.

Bill: So just the two of you?

Accountant: Yes, right. That would be enough for me to have a reason to move to the next level. One of the reasons is that as a sole proprietor, let's say something happens to your employee, and there's a lawsuit. All of your personal assets could be attached. But if you're incorporated and you have an employee, then the personal assets could not be a part of any lawsuit, and again, not to get legal because that's not where my training is. Only the business assets could be attached unless the issue came as a function of the owner of the business doing something to the person where it was personal in nature, what they call a tort, and where the owner of the business is still held responsible regardless of corporate status. That question is often reviewed on an as-needed basis with the lawyer and/or accountant during the initial stages of the business, but on a somewhat regular basis annually when you're looking at things you ask yourself is it time? I've had sole proprietorships that have existed for 20–30 years and there's never been a need to change.

Bill: Should you open a tax savings account, and about what percentage of your profits should be set aside for taxes since you will be paying self-employment tax in addition to local, state and federal?

Accountant: The answer is yes, it's always a good idea to have tax savings either to pay the taxes when due or to pay the estimates that are scheduled after your initial filing. As a good rule of thumb, given the self-employment tax, income tax, state and local taxes, a conservative number is 40%. And that would be made up of 13.3% currently for self-employment tax, but could rise to 15.3% when the current tax relief expires at the end of 2012. You've got generally 15% or more for federal income taxes, 4–5% for state, and 1 ½ to 2% for municipal, depending on where you live.

Bill: Do you need to charge sales tax for your freelance services or is that just on projects where you produce a physical item such as printing? And how would you register your business for that in Ohio? What if you order the item from a third party that already charged sales tax and you are not producing the item yourself?

Accountant: Let me break that into multiple parts. First of all, sales tax should only be charged once on any item and most correctly it's done to the end user. However, if you as a designer have paid sales tax on something and you turn around and provide it to somebody else, you do not have to re-tax it. It's assumed that in the price they are paying you, that they are already paying the sales tax that you paid.

Design services aren't subject to sales tax in the state of Ohio.

Bill: How do you register a business to pay sales tax in Ohio?

Accountant: You complete a vendor's license application. It is assigned on an address basis. So a particular vendor's license is generally assigned by the county. In Cuyahoga County for example, a vendor's license would start with the number 18, since alphabetically Cuyahoga is the 18th county, 18th in the list of counties for the state of Ohio. And you apply with the county, I think the fee is $25 to get it. And you will be required to file a sales tax return online either monthly or semiannually depending on your volume of sales tax collected.

Bill: How much does your freelance business need to be profiting per year in order to pay quarterly estimated taxes?

Accountant: Kind of not a fair question but the answer is you need to pay estimated taxes whenever you have a projected tax obligation that's not being met by other sources of tax payment, like withholdings on a W-2 or so forth. The threshold for avoiding penalty on a federal return is

under $1,000. If you owe under $1,000 you're not going to be subject to a penalty if memory serves. Anything over that, you're expected to be making estimated tax payments on a quarterly basis to meet your obligation.

Bill: What is the best method to keep track of business expenses as well as expenses for client projects such as purchasing and shipping printed products on behalf of the client since those expenses will be deducted from your profit as well. Would spreadsheets be enough for a freelancer with just a few clients?

Accountant: The answer is you could do it with spreadsheets, although I would still advise anybody to get a software package like AccountEdge or QuickBooks as they're relatively inexpensive and they allow for all the accounting work to be done what needs to be done such as reconciling the bank account and keeping a summarization of income and expenses.

Bill: How do I know how much to pay for federal, state and local taxes. How about Social Security and Medicare?

Accountant: That depends on whether somebody is incorporated, a partnership, or a sole proprietorship. A sole proprietor should conservatively set aside 40% of their share of income for taxes. That should be ample, but it depends on the level of income which drives tax bracket and ups the tax. But 40% is a good savings number to cover those. Same thing for a partner and a partnership. In an S Corporation, the owners are going to be required to take salaries from those companies and are going to have the FICA taxes, state and city taxes paid out of their W-2, and might not need to have any estimated taxes paid. Generally, when we have S Corp clients as you realize from your situation, we're not going to have you make estimated payments when we can address your tax needs by doing withholdings from your payroll. There are of course always situations where you need to do extra for an abundance of income passing through to the owner of an S Corp. It's not on their W-2, but again, it's on a case-by-case basis.

Bill: Lots of tax stuff seems to be dependent on the state and county where I live. Where do I go to find out specifics for my state/county?

Accountant: To your accountant. For people trying to do their own taxes or to get a handle on those issues, you could always start with the internet. You can find out anything you need to by Google searching. Even if you are able to capture the information correctly, sometimes the issues of compliance and properly filing things escape people and it's always best to have a professional's assistance.

Bill: What documents do I need to keep on hand in case I get audited?

Accountant: Bank statements, invoices for expenses paid, receipts if credit cards are used, as a credit card statement is not considered sufficient proof of expense; you should save the receipt. I will tell you that in real life, people don't do that, and that includes me. You and I just had lunch, I got a receipt, I even stuck it in my wallet and I'm guessing I'd have it shredded in 48 hours. If the IRS questions whether I legitimately had a business lunch with Bill Beachy, the president of Go Media, on May 3rd, I'd refer him to you to confirm we had, in fact, had lunch and discussed business.

Bill: And we have it recorded.

Accountant: And we have it recorded. But the law says you've gotta save the receipts. So I would tell people to save the receipts. Quite honestly, I would shove them all in a folder or in a big envelope for only the purpose of needing to give them to the IRS if they ask. And quite honestly I would hand them the package and say, "I never wanted to keep these, I kept them in case you guys ever came. Here they are now yours, but they are all there and we have the statements to support them and so forth."

Bill: Yeah, we do that at Go Media. We've got a manilla envelope that sits on Kim's desk and every receipt that comes in the door we just throw

in there. At the end of the year, we cram them into a big envelope and stick them in our filing cabinet and forget about them.

Accountant: That's the way it's supposed to be. I'm never going to ask to see a receipt. But you want to keep invoices for your expenses, things that you've purchased, equipment and the like. Bank statements are a must. The IRS will ask to see all bank statements for the year under audit in question, along with the last statement from the year prior and at least the first statement from the year after the audit to review to see if anything was being moved around between years for purposes of tax avoidance.

Bill: Do I need a special type of bank account for my business?

Accountant: No.

Bill: What does it mean to incorporate?

Accountant: Without getting into all the legalese, an incorporated entity or a corporation is a separate legal entity apart from its owners. It owns all of its assets, it owns all of its liabilities, they are not the assets of the owners, nor the liabilities of the owners. It must keep its own sets of books and records and really is its own being.

Bill: Let's say I only do a small amount of freelance work. How much do I have to make before I have to actually report it?

Accountant: $1. All income should be reported. Anybody paying you that income that is a business is required to report payments to anybody that are $600 or more in a calendar year. Those forms, 1099s, are sent to the government. And if you fail to report income that was otherwise reported to you on a 1099, you'll generally get a letter from the IRS indicating that you didn't report the income and they will be seeking the additional tax.

Bill: Should I get a loan to buy all my equipment?

Accountant: If you have no other sources for financing, the answer is yes. Preferably it should be a term loan over a period of years that allows you to pay it back in monthly equal installments. Obtaining a line of credit and using it to buy equipment can hamstring a business's cash situation if there's ever a need to borrow money when receivables are not coming in as fast as they might. Lines of credit are best for dealing with cash flow issues whereas term loans are best for dealing with equipment and other financing issues.

> Having someone to give you legal and accounting advice is priceless. This is not something to just guess at. Just pay them and let them worry about stuff you shouldn't have to deal with.

MIKE DAVIS, BURLESQUE OF NORTH AMERICA

Bill: How would you treat a situation if you partner up with a friend to do a client project (say a developer to code a site that you design for a client)? What would you need to do to pay them for a contract assignment, and not as an employee? Would you need to issue them a 1099 for the company if you pay them more than $600? If it's less than $600, do you just write it off as an expense?

Accountant: The answer to that question is yes that's exactly the way it is.

Bill: Any last advice that you would give to some young designer or freelancer who's about to embark on trying to build his company?

Accountant: Not to sound self-serving, but it is great advice to have an outstanding lawyer and an outstanding accountant. And to add to that, an outstanding doctor. You want to have good, confident professionals

FEATURED PROFILES

JASMINE

HAILEY

KATHERINE

MARQUIS

CHRIS

NICOLE

JASMINE KHUBCHANDANI
Biology, '12

Jasmine completed **three research projects** with Stonehill faculty that gave her the confidence — and the curriculum vitae — to be chosen for an internship at the famed **Institut Pasteur** in Paris. One of only four interns from the United States, Jasmine spent her time conducting research in the Chemistry of Biomolecules Unit.

COMMUNITY AND GLOBAL ENGAGEMENT BLOG

Coping with Post-Abroad Depression

COMMUNITY & GLOBAL ENGAGEMENT

Before I left to study abroad in Florence, Italy, I remember assuring myself: "It's only 113 days, I'm sure it will go by fast." I said this HOPING it would go by fast and that I would be back home with my family, friends and beloved Perfecto's...

READ POST

in various disciplines in the important areas of your life, and your health and your finances are two of those things.

INTERVIEW WITH SHARON TOREK

Bill: Why don't you give us a quick background introduction of who you are, your educational background and areas of expertise as it relates to this book.

Sharon: I'm Sharon Toerek and my firm is Licata and Toerek and I focus my law practice on intellectual property, marketing and advertising law for folks in the creative services and communications industry. I'm a lifelong Clevelander, went to school here and my family is from Cleveland. But my practice is national; I work with agencies and design firms all over the country helping them protect and monetize their creative essence.

It's a great client market to work with, it is fun, it really is; the issues that you get presented with really keep you on your toes and you think to yourself: I can't believe that happens and I get to work on it.

I get inspired all the time by the way creatives attack a business problem, the solutions that they develop and the way they make things look. It is just amazing to me as someone who is not very artistic or creative in that way, so it's fun to be around creative people.

Bill: If someone is getting started or they want to start their own firm, do you have recommendations in terms of what form of legal entity they should be?

Sharon: Forming an entity is an advisable thing to do if you're starting a business. It is what creates that legal barrier between your personal assets and the rest of the world. If something ever goes wrong, you have a liability, you have a debt, or dispute with a third party, and you want to protect

yourself personally, having an entity is the best way to do that. Deciding what kind, whether it is an LLC or an S Corporation is a decision that should be a team decision between you, your accountant, and your lawyer.

If you are a single owner company, we almost always recommend an LLC because they are simple to administer; a little bit more paperwork is required upfront, but it is easier to manage over time. Most states laws aren't restrictive in terms of what needs to be in your charter documents, so it is usually an appropriate entity. But it's a combined legal and a tax decision and one that you should always make in consultations with both of those professionals. You should have an accountant and a lawyer that you are comfortable working with on your team from the start.

Bill: I thoroughly agree, I read Rich Dad Poor Dad by Robert Kiyosaki and one of the first things he talks about in his book is that the best money you will ever spend is on a quality lawyer and accountant. He advises to use them as your business advisors.

Sharon: Right, I agree. I'm very proactive in my approach in dealing with clients' issues and I would much rather they use their resources this way so that they can focus on other aspects of running and creating their businesses, rather than being reactive, which is always going to cost more.

Using these resources after a problem occurs costs a business more time, more business interruptions and more money. So I'm very proactive in my approach and I recommended when you start your business up, get a team you are comfortable with and that's preventive and proactive in nature.

Bill: Go Media is an S Corp; does that make sense for a firm of our size (14 people)?

Sharon: Most of the clients we work with are either an LLC, or if they are a corporation, they are an S Corporation. And there are sometimes

smart tax reasons for being a particular type of corporation, so it depends. These are as much accounting issues as they are legal ones. Your liability shield and your liability protection is the same, whether you are an LLC or a some kind of corporation. And there isn't any difference legally between an S and a C Corporation; the difference is in the tax treatment of those two entities. So I would say to answer the question, I'm not surprised you're an S Corporation. It's a pretty common entity choice for a small business with multiple stakeholders.

Bill: Are there any other legal structure issues for new business owners to consider?

Sharon: Well, I can tell you that most small business owners don't take their legal structure far enough. They may charter their entity with their state government offices and don't do anything else. They'll send their piece of paper to the Secretary of the State office, pay their fees and they think they are done. They don't put any bylaws in place. If there is more than one owner of the company, they don't have a shareholder's agreement, which would tell them what will happen if one of the owners wants to exit the business or if the owners have a dispute. They skip that. They don't have a basic set of contract documents with their clients and their customers. If an agreement is presented to them, they don't invest the resources in having it reviewed. Skipping steps like that is "penny wise and pound foolish." I would also say that most small businesses tend to undervalue their intellectual property assets. By that I mean their customer list, their prospect list, their original processes. If you are a design firm, you are creating new product and capital all the time. You might be coming up with concepts that clients don't execute which you still own. They have got this inventory of stuff and they tend to undervalue it and their business name; they don't protect the trademarks and the products and the services they create and sell.

So that is really a good round description of most of the basic things that business in their infant stages tend to gloss over. It's understandable. Folks who do design work for a living didn't go into business to deal with legalities, accounting and finance.

Bill: Sure, most of them are designers.

Sharon: Legal issues are not their passion and they don't want to spend a lot of time on it, which is another reason why you need a team there to handle those day-to-day details or at least to help you put the structures and foundations in place. Finally, the step that a lot of small businesses skip as they are growing is they don't put employment policies and procedures in place. In the design world in particular, they work with a lot of freelancers and contract workers and they don't put any contracts in writing with those people. A major reason why that is a problem is because of the way the copyright laws in our country work. If you are working with freelancers and you don't have a written agreement with them that states that you own the rights for the work they create for your company, you don't own the rights to the work—even if you have paid for it.

Bill: I always thought that the moment I pay someone cash to produce something, it is owned by me.

Sharon: If they are a salaried or waged employee, (you are paying them via payroll) then yes, you own the intellectual property and all the work they create for your company. If they are a contract worker and you're not withholding taxes and you don't have them on your payroll, no, you don't own the rights for the work they create for you even when you have paid them. That's why you need something in writing that clearly states who owns the rights to the work being done.

That is a huge step that a lot of design firms skip. Most of the time it never becomes an issue, but it's a huge issue if your client is asking you

to transfer all the rights to the work you have done over to them and you don't own the rights; it's a domino effect.

Bill: So if a client doesn't specify with me whether or not he owns the rights to the work, then I own it? Does an email qualify as a written agreement?

> [Your accountant and lawyer] should always be offering you valuable advice for improvement. If not, they don't care and you should find someone who does.

JULIA BRIGGS, BLUE STAR DESIGN

Sharon: It depends on the language used and if it clearly points to the fact that it is an agreement between two parties, executed by both parties. The safest way to do it is a contract signed by everyone. There are plenty of tools out there that let you E-sign contracts. United States copyright law requires a written agreement. This is really important in the design industry. Unfortunately, almost everybody skips this stuff. It's important in your contract relationships with clients that you transfer the rights to the work you do for them only once they have paid you. You want to make sure you are not triggering the rights transfer until you have been paid because it's great leverage for you if you don't get paid, adding a copyright ownership claim in addition to your contract claims.

Similarly, if you are using freelancers, you have to make sure you have an agreement that the work they are creating for you is a work-for-hire and they are signing the rights over to you. Your client is expecting you to warrant to them that you own the rights to everything you are giving them, and you can't convey something that you don't own.

Your clients are going to want to own all the rights on the work you do for them. They will be really ticked off to learn that because of a lack of contracts you can't do that. They have paid you a ton of money for that work. Sooner or later you want to make sure you have taken care of that—obviously upfront is better than after the fact. Any third party you work with, whether it is a photographer, a videographer, a developer, a software coder or a freelance designer—should have a work-for-hire contract. As a backup, if you haven't done this before the work was done, you should have the freelancer sign a rights transfer agreement.

Bill: The amount of work that would go into having nicely prepared documents signed by everyone I interact with on a regular basis would be overwhelming. It feels like I barely have time to get my work done.

Sharon: I hear you. My best response to that is first of all, I totally understand. Secondly, I think you can eliminate a lot of the stress and hassle that surrounds this process by taking good steps early on to put best practice documents in place. Then you need to get into the habit of not deviating from them unless you have good business reasons for doing so.

Your standard agency services agreement or design services agreement with clients should have this intellectual property transfer language in it.

You should never be engaging with a third party freelancer to help you serve your clients without having a signed agreement with them. Each agreement doesn't have to be different; you can have a single best practices agreement form that you use with all your freelancers. You should have one that you use with any third party vendor you use, and one with your clients. And centralize the process so that any time you engage somebody new, whether it is a client or a vendor, it's: "Where is the blue form, where is the pink form?" And make sure that you make somebody responsible for keeping track of your contracts. Most design firms are going to be too small to have a business affairs persons, but they need

the equivalent of a business affairs person. Whether it is a part-time admin or somebody who you are virtually contracted with to do your admin or business affairs work or whether it is a secretary, a law firm, or whatever. Put someone on point in making sure all that stuff is always done, and then it's not so overwhelming.

Bill: What would you list as the essential documents every small design firm should have?

Sharon:

> **1. Client Services Agreement:** the absolute bottom line everybody needs is a client services agreement. This is what you give to your customer. It's your terms and conditions. It has rules and rights to what and when they transfer.

Bill: Go Media treats its proposals like a contract. We have the terms and conditions in the proposal. We also have language that says something along the lines of: "When you place your deposit on this project, you are accepting this proposal as a contract." Is that legal?

Sharon: There is nothing wrong with doing it that way; you just need to make sure the terms and conditions have the intellectual property provisions and accurately describe the engagement.

> **2. Independent Contractor Agreement:** If you are a firm that uses freelancers to help you deliver services to clients, you need an independent contractor agreement

> **3. Vendor Agreement.** If you are going to be pulling a lot of outside resources in terms of vendors or strategic alliance firms (companies like software developers, photographers, videographers) to help you serve a client need, you should have an agreement to use with these resources, and it will be similar to

the freelancer agreement in terms of transfer and ownership of intellectual property rights and the like.

4. Nondisclosure Agreement. A nondisclosure agreement is something you should have in your tool kit. Many clients are going to present you with theirs and you want to make sure that it is mutual. Ensure that whatever ideas you are giving them about how to sell their stuff or how to make more money are confidential until you have entered an engagement. So, having a nondisclosure agreement protects the agency as well as the client.

Those are the four basics.

As you get larger, an employee policy and procedure handbook can be very important in shielding you from employment litigation. Year after year, it always get more complicated and more costly for employers, so as you get employees, you need to think about layering that on.

Bill: I have a lot of opinions about company culture. However, I don't necessarily know what needs to be in an employee guide book so that I can protect myself legally. Is that the sort of thing a firm like yours would have already written where most of those bases are covered and would then be customized for Go Media?

Sharon: We would cover your bases legally after talking to you. We would present you with our best practices. If there were provisions in those best practices that didn't feel comfortable to you, we would discuss the risks of making those changes and adjust the document accordingly. Once you're comfortable with the employee guidebook, we like our clients to personalize their introductions to set the tone. It's definitely a team approach because if a client feels uncomfortable handing a document to their employees, then they shouldn't be using it.

Bill: It's got to reflect the culture of the company.

Sharon: It does, and that said, even though it's not a comfortable exercise, as you get busier and you make more money and there is more at stake, you're protecting your own assets and protecting the jobs and everybody you are employing. So it is a necessary proactive tool.

Bill: Alright. Any other sort of core important documents that should be prepared?

Sharon: Well, it isn't a document, but one core part of the process of protecting yourself legally is taking steps as early as possible to clear your brand and to protect it legally with trademark registration. I'm a brand girl. Your brand is important. Almost everybody is engaged in interstate commerce these days because of the web, so almost all of us have a basis for a federal trademark registration.

You want to make sure that you are not going to butt up against anybody else who is using a similar business name. That would cause confusion, so trademark clearance and registration is important. And everything after that is situational.

Bill: OK, let me recap the six most important legal steps you've recommended so far:

 1. Create a client services document

 2. Create an independent contractor agreement

 3. Create a vendor agreement

 4. Create a nondisclosure agreement

 5. Create an employee guidebook

 6. Trademark my company brand

In my experience, dealing with courts and lawyers is very frustrating. Even when I've taken a client to court and won—nothing happened. I didn't get paid. Meanwhile, I've wasted a lot of time and money. So, instead of spending a lot of time and money on contracts, lawyers and court cases, Go Media has focused on strictly enforcing a pay-as-you-go billing policy. Does this make sense?

Sharon: Your experiences are the perfect illustration of why a proactive approach is so important. You are saving yourself a lot of time, money and aggravation by putting in those billing policies. Whether they feel like business processes or legal practices, they are both. It doesn't matter what you call them. You are doing exactly what I would advise a client to do, which is to put more aggressive terms in their contracts that cover milestones, receipt of payments, etc.

Bill: What happens if I do find myself in a situation where a client owes me a lot of money and they're refusing to pay? In my experience, a court case didn't help me at all.

Sharon: It is true that a small business owner can attain their judgment in court, but that doesn't necessarily mean they are going to get their money. There is a whole science and art to collecting receivables and it is probably beyond the scope of our discussion here, but I will say that doing exactly what you have done, which is being more proactive on the front end with your contract terms, milestones and retainer payments in advance is the best preventive medicine. If you find yourself in a collection situation, it is a team approach between your corporate counsel and a lawyer who focuses on collection matters.

Many times a lawyer who focuses on collections has alliances with collection agencies. There are some things that you can do when you get your judgment that are quick and relatively inexpensive and can give you

more leverage over a debtor. Placing a lien on their assets is an option. If they go bankrupt, it won't do much good in the short term, but it will affect them if they ever need to borrow money or get a contract in the future. So, it's some leverage. I have had clients who put liens on assets of folks who owed them money. And eventually they did get contacted about payment because those people needed to have those liens lifted.

Those are some things that a really skilled collection counsel can help you with. The best prevention, though, is to keep yourself from being in that position. This is where young design firms cut corners, because they don't want to slow themselves down long enough to put these processes in place. It's boring. It costs money. They're trying to make money, not spend money. I've heard it all. It's a common mindset of a startup business. I get it. Unfortunately, that mindset can flip against you.

The main reason for having effective intellectual property (IP) transfer language in your documents is critical is because if you don't, then it's just a collection or a contract case. If you do, then it's an IP infringement claim in addition to a contract and a collection case and that gives you way more leverage.

Bill: Let's talk about IP for a little bit. My approach to intellectual property at Go Media has been very generous. I have always had a blue collar mentality. When my client pays me for my time, they own the work. I am certainly aware that many successful artists and designers make a barter out of IP. They negotiate what rights the client is purchasing. For instance, they will design someone a t-shirt but only allow them to print 500 copies of it. If the client wants to print more than 500, they have to pay more.

Sharon: The most common scenario in which these issues arise for a design business are at a new business pitch. You want to pitch a new piece

of business for a potential client and they want concepts. They want to own the rights to those concepts. And they are going to pay you nothing—or almost nothing—for them. Recently, the industry has turned away from spec work, so we are not having that problem as often as we once did. Five to ten years ago, when the economy was starting to get really crappy, clients were clubbing agencies over the head with spec work. That was extremely unfair to the agencies but it was the cost of being able to get yourself in front of them. The pendulum has swung a little bit away from that now. These days, you are seeing agencies take the position that they're not going to create a bunch of IP for client, only to have the client take it somewhere else to get it executed.

So there are a couple of different ways that you can address this situation. You can agree to a set fee for your pitch work. It's usually not enough to cover the entire time spent but it solves the problem of who owns what upfront. It's an agreed-upon consideration for your concept work for them.

Bill: And in that scenario, they would pay you for ownership of it, but at least you get some money for your efforts.

Sharon: Correct. It is just for the cost of pitching, because pitching some of these big clients can cost a lot of money and take resources away from the pursuit of other business opportunities.

Related to IP and how you charge your client is the concept of value pricing. Many small agencies are migrating away from 'you pay me for my time to you pay me for the value.' We think the end result of our work is worth X, so that's what we charge.

As a lawyer, I'm in the professional services industry. I understand this because with lawyers, accountants, etc.; our clients think in terms of 'how long did that take you to do the work?' Well, I'm not going to charge

you on how long it takes me to do it. I'm going to charge you based on what the fair value of the end product is to you. The fact that I've done it for five or 10 other clients like you, and therefore I might be more efficient, doesn't make that product any less valuable to you.

So I think that for agencies, design firms, any professional services firm, the model of hourly pay is becoming more inefficient.

Bill: Do you see other small firms out there that are doing a better job capturing extra money for IP and can you give me a typical case scenario of how they are doing that and what it looks like?

Sharon: A good example of how to extract the most value out of intellectual capital might be a franchise cooperative marketing situation. You are creating variations of the same creative concepts for local markets, customizing them for various promotions and periods of time. The fundamentals of design don't change that much: I have seen models where you are being paid based upon the number of markets or the size of the markets or the number of deliverables.

Another model I'm starting to see more of is agencies basing a portion of their compensation upon the results of their work for the client. If a marketing campaign does well for a client, then the agency that created it will receive some form of additional pay.

Bill: How do you introduce the concept or usage rights or alternative pricing models to a customer?

Sharon: I'm for transparency. I don't think surprises in that situation would suit anybody well. You don't want to look underhanded. Even if you are not thinking that it is underhanded, you don't want that uncomfortable conversation with the client down the line. You want long-term, honest relationships. I absolutely think you should be transparent and

upfront. Fortunately, more and more, clients understand alternative models, especially when it appears that the interest of the client and the designer are aligned.

So it's up to everybody to determine their value. That is a marketing decision, not really a legal one. Whatever your decision, it can be reflected in the terms and conditions of that agreement. Every relationship with a client or a prospective client is a legal relationship to the extent that it is reflected in legal documents.

Bill: I've always had a question about the nondisclosure agreement. Let's pretend that I had an idea for a specific widget. I hadn't executed it yet, but I had the idea. Then, after signing a nondisclosure agreement with a client, they pitch me the same idea. Now I'm in a quandary. If I execute the idea, the client can sue me in court because I signed a nondisclosure agreement. But the fact is that I had the idea before I signed the agreement. How does one avoid this?

Sharon: There is almost no good legal answer to that. What you're describing is a really bad coincidence. What I like to remind people of is that ideas are free once they are expressed. Unless you can outright prove copyright infringement, it's not misappropriation. Which means that the idea has to be expressed in some tangible form in order to protect it.

The problem in your hypothetical situation is: how are you going to prove that you had the idea already? In that situation, you would be stuck with whatever proof you had on hand of having the idea before the client conversation. The only potential way out of that would be if you had some documentation to support the fact that you have been working on a similar idea before meeting with them.

The best way to protect your ideas (intellectual property) is to document

Columbus Zoo Animal Guide
Responsive website for the Columbus Zoo and Aquarium

as much of it as you can. Storyboard your ideas as frequently as you can. Put copyright language on your proposal, concepts and on any deliverables. Leave as little to the oral and verbal expression as you possibly can because you can't protect an idea once it's out there. What you can protect is written, tangible expressions of ideas, concepts, recommendations, etc. The more you document, especially in the new business process, the better your position will be regarding intellectual property rights.

Bill: I recently had a client who wanted me to carry errors and omissions insurance. Is that something you've heard much about and would you recommend that most firms get errors and omissions insurance?

Sharon: I would. I think every agency should have it. In your early stages of building your business, the premiums are going to be fairly low. You can get errors and omissions insurance through organizations like AIGA or the American Association of Advertising Agencies.

Bill: Is there a certain amount of coverage I should have?

Sharon: A million dollars in coverage is pretty standard. I have seen up to five million.

Bill: Is using LegalZoom.com or other similar online legal services an acceptable way to set up a corporation and/or prepare legal documents?

Sharon: In my experience, clients are extremely dissatisfied with the trademark work being done by companies like that. They are exercising no legal judgment. They are only filling out forms for you. A trademark registration is so much more than that. I would feel a little better about them filing your corporate registration. I think they are less likely to screw that up. But the problem with online companies is that they are not going to be available to answer specific questions. They won't be able to tell you how the decisions you make are going to affect you.

To be candid, I am not a fan. Of course, my opinion is going to sound biased given that I'm in the legal industry, but they are not set up to understand IP and how to protect it, beyond the mechanics of looking at a government database or completing some paperwork.

Bill: What type of licenses do I need to run a design firm?

Sharon: I don't know of any specific license needed to run a design firm other than if you are occupying commercial office space and your local municipality or state requires some sort of occupancy permit for you to be in there. It's not like running a food business, a liquor business or a hair salon, where there are public safety and health concerns. If you have employees, you are going to need to have workers' compensation coverage. Same for your unemployment, but those are not really licenses, but are evidence that you are insured and you are complying with those laws. Other than that, there is nothing specific for this industry, in Ohio at least. I don't know if any other state has design industry specific licenses or permits. I don't think so.

Bill: Should I trademark my company name?

Sharon: Yes.

Bill: What does it cost to trademark a name?

Sharon: We always start the process with trademark searching and screening. It's important to have an adequate assessment of whether or not your mark is even going to be registered or protectable over time. There is the preparing and filling of the applications and there are filing fees to the trademark office. A ballpark price for all of that work is around $1,500 to $1,800. Trademarking your company name becomes part of your intellectual property portfolio. It adds value to your company. In this global marketplace, it's an additional layer of protection against someone using the likeness of your name and your mark.

Bill: A young business owner probably can't afford to do all of this legal work at once. What do you recommend they do first?

Sharon: I recommend that at least on an annual basis they do a mini legal audit with their lawyer to prioritize. There is always going to be a project list out there. You should triage them in terms of urgency then start from the top of the list and work your way down.

Bill: Are there state trademarks versus national trademarks versus international trademarks?

Sharon: There are state trademarks for a business that operates strictly within the bounds of that state. A state trademark doesn't have a basis for a federal filing. We used them a lot more when businesses were local or regional and it didn't go outside the state. That almost never happens anymore and I rarely bother with them. What you want is a US federal trademark registration if you have the basis for one. As for international trademarks, each country has its own trademark laws so you need to register in whatever locality in which you are doing business. In the European Union zone there is a common application, but generally, you need to register in each country. There is no such thing as one international trademark registration for the entire planet.

Bill: If I own an URL, does that mean I will be able to get a trademark on that name?

Sharon: No. Finding a name available as a URL is not trademark clearance. Just because you can buy the domain, it doesn't meant mean that your mark is cleared necessarily. I want to make sure that your readers understand that that is just one component of doing trademark clearance due diligence. You might be able to buy the domain you want and you might still be infringing someone else's trademarks by using it. On the other hand, you might own a trademark and someone else might have

the identical URL registered and using it for their business and not infringing on your trademark if they are in a completely different industry. The relationship between domain registrations and trademark ownership is complicated. It's going to be getting even more complicated as more top level domains are released in months and years ahead. Domain name expansion is definitely a mess for trademark owners.

Bill: I happen to know that there are at least three other Go Media design companies in the US.

Sharon: You need to determine if they have federal trademark registrations. If you find yourself in conflict and you are not the first user, then it's in your best interest to stay under the radar. It doesn't mean that you

shouldn't register your other products. These are things we would determine during the search process.

Bill: Does the trademark cover the visual mark, the type treatment of the name, as well as the name of the company?

Sharon: It depends on how you register it. We typically advise the "belt and suspenders approach" which is that you register the name and the logo together, and you also register the name version of the mark and the logo version of the mark separately. So that is three registrations. It's costly. You have to make a choice about how well you want to protect yourself. My preference is always to start with the name alone, and then the logo or the name and the logo together, because the literal name is usually the most important part of your brand.

Bill: There seem to be a lot of different ways to protect your creative work: copyright, intellectual property, patents, trademarks and trade secrets to name a few off the top of my head. Keeping all of these straight can be confusing.

Sharon: Intellectual property is the umbrella. It goes over all these things, which are different types of intellectual property. Trademark is a type of intellectual property. It's the only type of intellectual property that can last forever as long as you continue to use it in commerce to identify whatever you are selling. Copyrights are a type of intellectual property. A copyright is a term that refers to a group of rights that you can have in an original creative product that includes the right to change it, sell it, display it, or allow other people to use it. Then you have patents, which are your rights in a particular original innovation or invention. Copyrights and patents will eventually expire. They all have different lifecycles based on federal law. A trade secret is confidential information that provides your business with a competitive advantage or one that

could do you economic harm if it was in the hands of your competitors. The information has to be kept confidential using whatever practical measures the law considers reasonable. Every state has its own definition of what it deems reasonable. You do have to take measures to keep the information secret in order to be able to enforce it as a trade secret. It's commonly an issue when a key employee, supplier or vendor leaves a company and has access to your trade secrets.

Trademarks, copyright, patents and trade secrets all fall under the umbrella of intellectual property which is a broad term that describes various types of property rights you have in intellectual capital.

Bill: I was under the impression that copyright applies to anything that you put into tangible form and doesn't require any filings. Is that correct?

Sharon: Yes, you do have copyright protection as soon as whatever you're producing is finished, the paint is dry, or the code is written, etc. It doesn't require any filings. Common law copyright is enforceable and legitimate. However, if you ever find yourself in an infringement situation, federal law requires that you have a federal copyright registration on a work before you can file a lawsuit for infringement. Secondly, the reason why it's important to register your copyrights is that having a registration entitles you to collect statutory damages in an infringement situation, which are frequently higher than just actual damages.

Copyright registrations are economical to obtain. This is an area of intellectual property law where self-help is reasonably exercisable. Once you get a hang of how to fill out a copyright application it's an easy process to replicate.

Bill: So if I register a copyright, is that where the ® symbol comes from?

Sharon: No, the ® symbol is for a federally registered trademark, the © symbol is for copyright.

Sandra Turley
ON BROADWAY

1 | SPARK OF C...
4 | FOR GOOD 5 | TH...
8 | THE SOUND OF M...

Sandra Turley
ON BROADWAY

7 | THINK OF ME

8 | THE SOUND OF MUSIC

9 | POPULAR

10 | LES MISERABLES MEDLEY

Bonus Track:
11 | CHRISTMAS LULLABY

RA TURLEY

Bill: So if I trademarked my company logo, do I want to put a TM symbol on there or do I put an ® symbol on there?

Sharon: If you have a federal trademark registration, you can use the ® symbol. If you only have a local trademark then you must use the TM symbol. The TM doesn't have any legal significance, but it is commonly used to identify that a mark is proprietary to you. You use the TM symbol if you are identifying a product and an SM (servicemark) if you are identifying a service.

Bill: Many people sell digital scrapbook pages through eBay and Etsy. They frequently use a character in them. In some cases it's a licensed character like Strawberry Shortcake. Under the listing they post a statement like this: "Copyright notice, you are paying for a creative service and my time spent designing and personalizing your item which is permitted for a onetime personal use, this item is not a licensed product, all character images used are free and not being sold. I do not sell or claim ownership over the character, clip art or graphics. They belong to their respective copyright holders. Items purchased are not to be resold for any reason." Does putting a disclaimer like this on your work really make it legal?

Sharon: Nope. If a company wants to pursue those artists who are selling stuff on Etsy using their licensed characters, a disclaimer is not going to save the person using them.

Bill: What about using copyrighted images for non-commercial use? Let's say I create a design tutorial on how to draw Hello Kitty. I put it on the blog for free. I'm just showing people how to draw Hello Kitty. Is that legal use of the Hello Kitty image?

Sharon: Fair use is a defense to a claim of copyright infringement. People usually oversell the concept of fair use and try to extend it to anything

you find on the internet. That is not what fair use means. One of the exceptions to copyright infringement under fair use is education. If you are replicating or copying or making use of some original copyrighted work to instruct or to teach, then fair use might apply. I would recommend that you stay away from that. I would use a different example of a less famous character in your tutorial.

Bill: Do you have any advice on how to find a lawyer?

Sharon: For design firms a good place to start is the local professional associations in your community that serve your industry. Many times they might have a lawyer in their membership who focuses on their needs. AIGA in particular is an organization with many chapters and that is one of their sources. Many communities have volunteer lawyers for the arts, although they really focus less on commercial enterprises, but they might be a resource for a referral to someone who practices in your area. Obviously, you can use the internet to find lawyers that specialize in your industry in the area.

The best thing to keep in mind when you are looking to find your professional team is finding someone with whom you have good chemistry. You want someone who you feel is going to give you the right amount of attention, the right amount of counsel, not too much or too little, and who understands your industry.

Bill: Any other topics, thoughts, or advice that we haven't covered that you feel is important to pass on?

Sharon: I would simply stress the value of the proactive approach and protecting your IP. Those are both passions of mine and I provide both value and money savings over the long-term.

WHAT TYPE OF LEGAL ENTITY ARE YOU?

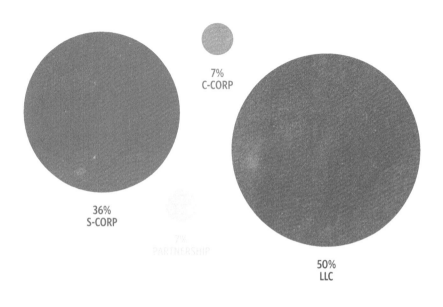

7%
C-CORP

36%
S-CORP

7%
PARTNERSHIP

50%
LLC

SOFTWARE FOR BOOKKEEPING

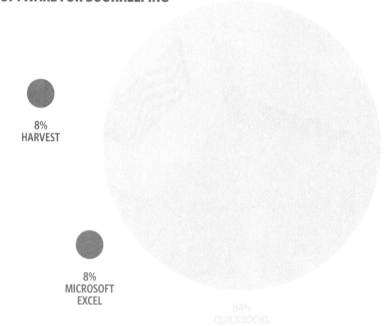

8%
HARVEST

8%
MICROSOFT
EXCEL

84%
QUICKBOOKS

I've often heard that having a business partner is like being married. I think this is a great analogy. You have to be on the same page at all times, be able to nearly read each other's minds, and be willing to negotiate about absolutely anything and everything.

— JULIA BRIGGS, BLUE STAR DESIGN

A Partnership is a marriage. During my first four years in business I didn't have any partners and only occasionally had employees. It was just me— one man, one computer and an apartment. Since the entire company was me, that meant I had to handle all aspects of the company—marketing, selling, bookkeeping, designing, etc. And while I struggled with my company for various reasons, I watched a few key peers closely as they built their companies faster than I did. One thing that I noticed in almost all of them was that there were several partners in the company instead of just one owner. I was certainly familiar with the concept of efficiency through division of labor, but don't know that I necessarily had that in mind when I decided I needed a partner. I think it was a bit more basic than that. Perhaps I was thinking: "Those guys have partners and they're succeeding, so I'm going to copy them." Whatever the reasoning, I decided I did need a partner, so I got one. It was only after I had a partner that I realized the many benefits of having one. Here are a few immediate benefits I noticed by having a partner.

THE BENEFITS OF PARTNERSHIP

Efficiency through division of labor. This is number one. By splitting up the responsibilities of running the business, we were each able to focus on fewer tasks. And since we both had fewer tasks, we were able to master those items and become significantly faster.

Company. This may sound silly, but working all by yourself for months on end can get very lonely. Just having someone else by your side to bounce ideas off of, inspire you or point out when you're about to make a mistake is a huge asset; even if that benefit is mostly providing you with happiness. Happy people are productive people.

Added skill sets. Not only can a partner take some of the work responsibilities off your shoulders, they can bring new skill sets into your firm. In our case, Wilson (my first partner) loved the technology side of the business. He took to website development like a fish to water. It was an area that I was weak in and really had no passion for. By having him as a partner, my firm was immediately more capable. A good analogy would be a rock band. Having a mix of different skill sets is important. Typically you'll have one singer, one guitar player, one bass player and one drummer. In most cases this mix of skill sets is going to produce better music than having a band made up of four drummers.

WHY DID YOU DECIDE TO GET PARTNERS?

Because no one person can possibly know everything to effectively start a new company. And, the shear volume of work to launch and maintain a company is a lot for a single person to bear.

PHIL WILSON, FINE CITIZENS

Go Media has three partners and we all complement each other very well. Here is a general breakdown of Go Media's partners and their skill sets:

William A Beachy: Business Management & Strategy, Accounting, Sales

Wilson Revehl: Technology (IT, Hosting, Front and Back End Development)

Jeff Finley: Social Media, Internet Marketing and Community Building

We all started as designers, so these were the extra skill sets we each brought to our partnership.

DO YOU HAVE ANY WORDS OF WISDOM ON SELECTING PARTNERS?

No friends or family. Mutual respect is probably going to be the most important factor. That and a similar work ethic.
— ALEX WIER, WIER / STEWART

Selecting a partner is a business decision - not a personal one. So, while it certainly is important to select a partner you can get along with, I think it's much more important to select a partner who will bring real, long-term value to the business.

It's also important to select partners who share a very similar vision and set of values as you. I have heard many horror stories about partnerships that went bad because people couldn't agree on the direction of the company or just couldn't get along as people. Staying in business is hard enough on its own; much less having to constantly deal with a challenging relationship with another partner.
— PHIL WILSON, FINE CITIZENS

Picking a partner. What if I told you that you had to marry your business partner? Would that change the way you picked them? Consider this: you and your business partner will most likely spend more waking hours of your life together than you will with your spouse! And managing employees often feels very much like raising children. You will share financial responsibilities, much like running a household. And you will divvy up work responsibilities, much like dividing up household chores. The point is that picking a business partner is a major decision. It should not be taken lightly. Here are my recommendations for selecting a partner:

Really get to know them first. Knowing someone socially and getting to know how they work professionally are very different things. The way someone operates before they become your partner is a good indicator of how they'll work once they are your partner. Before Wilson and I became partners, we knew each other for years. We first met when he hired me to do an illustration for a flyer he was designing. The fact that he was running a business and could afford to hire me was a good first sign. The second good sign was the fact that I kept running into him at the printer and on the streets. He was always working. I didn't see anyone else busting their butt the way he was. When we would meet at the print shop I always made sure to chat with him about what he was doing, ask how things were going and plant the idea that maybe one day we would be partners.

Try Before you Buy. If it's possible, you should even try a partner out before you invest in a bunch of legal documents. This can be a little tricky, but it's worth doing. You could, for instance, move both of your businesses into a single office and just work side-by-side for a year or two. You could also collaborate on a few design projects. In our case, Wilson and I jumped into it by combining our company names and acting like one company. However, we didn't get our company incorporated for about a year. Technically if either of us had doubts, we could have easily dissolved the partnership without any legal fees. When we brought Jeff on board we had been following him and working on-and-off with him for about two years before we offered him a partnership. Even after we did that, he was working in the office with us for a year before we finalized the legal paperwork. We fully intended to make him a partner during that entire year. We weren't tricking him into the office to try him out. However, taking a little time to get the legal work done did give us an opportunity to make sure there weren't any major red flags. Who knew—Jeff could have turned out to be a lazy alcoholic who would embezzle money from the company. If this had happened, we would have been glad that we didn't have those legal documents signed on day one.

> Your partners should have a value to the company beyond just a financial investment. We've been fortunate to receive financial contributions from partners who have given us valuable advice, collaboration, and material resources that have helped the company succeed.

JOSE VASQUÉZ, QUÉZ MEDIA MARKETING

Check their financials. The financial stability and history of your partner can have a major impact on your business. If your partner recently declared bankruptcy then you're putting your business into a bad position financially. Banks don't like to give loans to businesses that have a partner with a bankruptcy on their record. One partner may need to accept 100% of the responsibility for the loan. This is a very unfair situation for the partner saddled with the liability of a loan. It also helps if your soon-to-be partner has little debt and a nest-egg of cash reserves to help keep the company stable in the event of a slowdown. Conversely, it's important to know if your potential partner is living paycheck-to-paycheck. If he or she has six kids, a stay-at-home spouse and a $3,000 a month mortgage, well, it's very important that you know these things. That type of situation puts tremendous pressure on your business. Your company is going to have to start making money fast. Before you get too far along in a partnership conversation, you need to have a serious conversation about each partner's financial state. It can be a tough conversation to have, but full disclosure is critical. This conversation will be a good indicator of how well you and your partner will be able to tackle financial issues. If the conversation is difficult or you feel that your potential partner is not being forthright, you should be very concerned.

Deciding how to split the ownership percentage. Of all the aspects of taking on a partner, this one can be one of the most contentious subjects. Who

> ## Understand that good friends can often make the worst partners.

DAVID GENSLER, THE KDU

owns what percentage of the company goes straight to one's ego. I own 60% and you own 40%, therefore, I am superior to you. At least, that's what it seems to communicate.

From a purely mathematical perspective you could determine your percentage ownership based on exactly what each partner brings to the company in terms of financial contribution. You could add up the value of each partner's clients, add any equipment and furniture they're bringing to the company and add any cash investment they want to bring to the company. Tally all that up and split the business based on the total. Partner A is bringing in clients valued at $75K, Partner B is bringing in no clients but is going to make a $25K investment into the company, so you split the company 75/25%. This seems straightforward and equitable, but is it really the right way to go about it?

In my opinion, this is not a complete picture. It's critically important that both partners feel very fairly treated in terms of ownership percentage. You're about to get married. You're about to spend the foreseeable future of your life locked arm-and-arm with this person, battling for your livelihood. If there are ANY second thoughts or doubts about how the company is split, it's going to be a splinter that slowly grows into a giant wedge between you and your partner.

Think of it like this. Your potential partner offers you 35% of the business because he has more clients than you. You're not very happy about

JEFF FINLEY, GO MEDIA

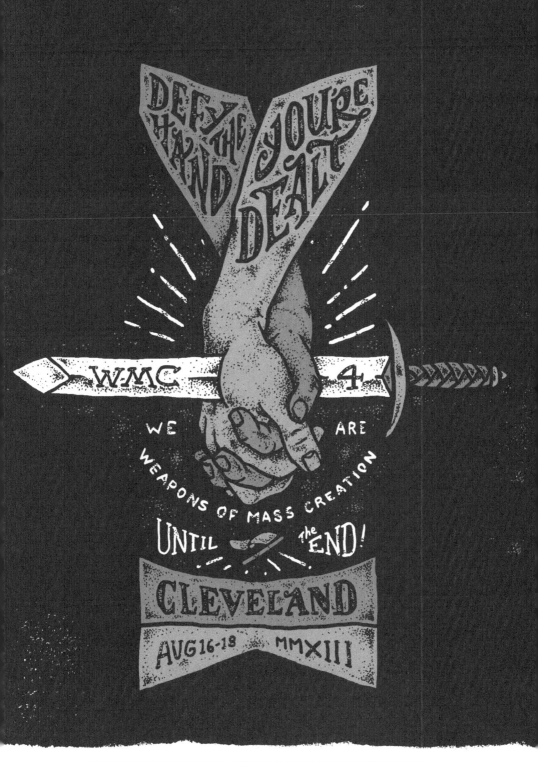

WEAPONS OF MASS CREATION FEST 4 • AUGUST 16-18, 2013 AT CLEVELAND PUBLIC THEATRE
POSTER DESIGNED BY JEFF FINLEY AT GO MEDIA & PRINTED WITH LOVE BY VG KIDS

it, but you really want this partnership so you begrudgingly agree. After six months the honeymoon phase has worn off and you're both working extremely hard, but you're having disagreements. Every time you feel frustrated at your partner your brain wanders back to the fact that you only own 35% of the company—and your dissatisfaction about it is growing. You have thoughts like: "Well, maybe I shouldn't work as hard as my partner since he owns more of the company than me." This kind of negative thinking will slowly sink your partnership.

That's why, if possible, I highly recommend forming an equally balanced partnership. If you have two partners, seriously consider an even 50/50 split. Even if one partner is contributing significantly more than the other. Remember—this is the very beginning of a long journey. You're both about to risk your financial lives together, work long hours and hopefully build an empire. Whatever amount of financial value you bring to the company at the start might be a pittance compared to the value you're going to build. What you're both bringing to the company is years of hard work. If you're very concerned about the inequality of what you and your potential partner bring to the beginning of a partnership you can always put a clause in your buy-sell agreement that states that you'll get a payout of $XX dollars prior to splitting up of the profit of your company in the event that you eventually sell.

What about future investors or additional partners? "But Bill," you ask, "what if I plan on getting investors in the future and need a percentage of the company to give to them?" Even in this case, I still suggest that you split your company as evenly as possible. You and your business partners need to agree about how to build your company. Decisions of giving back to help grow the business are made every day, not just when bringing in a new investor or partner. Every time a dollar comes into your company the partners must agree on where that money goes. Do we put it in our pockets? Do we invest it in new equipment? Do we put a swimming

pool into our office? There better be agreement on how you plan to build your business. And certainly, when it comes to giving up a percentage of your business to investors or bringing on a new partner, all the current partners need to be willing to put up their fair share of ownership to get those investment dollars.

"But Bill," you say, "that means I'm not in control of my business and my partners could refuse to give up their shares. We might miss an opportunity for investment." Well, this is what a marriage partnership is all about. If you don't want to give up control of your company, then don't have partners. In my experience, having resentment about how the value of a company is split is terribly destructive to a partnership. And the positives that come from being generous and having faith in your partners over the long-term pays huge dividends worth much more than what you've given up.

Sidebar: Treat your partners and employees with the utmost respect and the expectation that they will achieve amazing things. Treating them in this way will result in them working hard to live up to your expectations. Treat them like children and they will act like children.

In Wilson's and my case, things were quite uneven when we brought our companies together. At the time I was generating significantly more income than he. But the truth was, it was a pathetic amount of money. Looking back I can see that we were both two broke kids struggling to stay in business. At the time I knew there was a disparity, but I recognized that it was irrelevant when I considered the years of work that lay ahead of us. So, when Wilson and I joined forces we agreed to split the company 50/50. I wanted Wilson 100% invested, willing to work crazy long hours and to have no doubts or regrets about becoming my partner. I've never had a single regret about making that decision. The dedication and hard work that Wilson has put into Go Media has been amazing.

I'm sure some part of that came from the fact that he knew he had equal ownership of the company.

Balancing an unbalanced partnership. Not all partnerships are going to be balanced. In particular, if you're adding partners to a firm that you've been building for some time, you'll likely not bring them in as an equal partner. It would be unfair that a new partner of a five-year-old firm should get equal ownership as if they had been building the company from the start. Not all partnerships are going to be perfectly split. It's important that partners are appreciating each other in different ways.

One way to do this is with compensation. Percentage of ownership is not a benchmark for compensation. Partners can pay themselves whatever they want regardless of ownership percentage. In very large firms, a new partner may only receive 1% ownership of the firm. The founder may own 20%. Does this mean that the founder receives 20 times the salary of the 1% partner? Of course not.

In our case, when we added Jeff as a partner of Go Media, he did not receive an equal percentage of ownership of our firm. But we did start paying him the same amount that Wilson and I were paying ourselves. In many ways, the amount of compensation you receive while you're working at your firm is more important than how much of it you own. Let's face it—your ownership of a company is only worth something if you sell the company or do some form of ownership percentage-based bonus. And when are you going to sell your company? If you're going to sell it, what can you get for it? These are all amorphous things set way off in the future.

I'm not saying that percentage ownership isn't important. It is. Who knows, maybe someday in the distant future your business will sell for millions. But it also may not. It's one part in the equation that makes a

partnership fair and equitable to all the people involved. Some firms will use the percentage of ownership to determine an annual bonus based on profit. In this way you can make a connection between ownership percentage and compensation. But it's really up to you and your partners.

If you and your partners cannot come to an agreement on your percentage ownership and compensation amounts, then I would suggest that you probably shouldn't be in business together. Unfortunately, if you do not share a common perspective on value allocation, then it's probably going to be a recurring problem for the life of your partnership. Going back to my marriage analogy, if you and your potential spouse are fighting on the very first date, you'll probably be fighting for the life of your relationship.

> I would highly recommend that any design firm is formed out of a partnership between a lead creative and a businessperson. I don't think an agency can be successful unless there is a good balance of strong business practice and creative vision.

PHIL WILSON, FINE CITIZENS

Partnership Agreement. As part of forming a partnership, I highly recommend writing a short and simple partnership agreement that covers basic responsibilities and expectations of the partners. Here are a few things to consider:

What will each partner will bring to the company in terms of clients, projects, cash and skills.

What roles will each partner handle. For instance, who is in charge of hiring new employees when the time comes?

CELLAR DOOR RENDEZVOUS

2013

The MODERN ELECTRIC, HERZOG, BETHESDA, OHIO SKY, Attack Cat, Ragers, HUMBLE HOME, SUNSPOTS, FilmStrip, NIGHTS, GOOD MORNING VALENTINE, The Universe Doesn't Stand A Chance Against Joshua Jesty, The COMMONWEALTH, SO LONG, ALBATROSS

BEACHLAND BACK-ROOM AND TAVERN

MARCH 8-9

CLEVELAND OHIO HELL YEA!

CELLAR DOOR VOLUME IV RELEASE
CELLARDOORCLE.COM

jakprints

ROCK AND ROLL

go media

Poster by Jeff Finley · go media.us

Who's doing the bookkeeping? Who's doing the selling?

Who's responsible for managing?

What is the process you use to make decisions and how do you resolve conflicts when they arise?

How many hours a week do we have to work? What happens if someone works more hours than the other partners?

How many vacations, sick days and holidays will we take?

What's the dress code?

How long can you take for lunch?

What are we going to pay ourselves?

How do we allocate annual profits or losses?

How do we decide to bring on new partners? Where will their ownership percentage come from?

If we decide to sell, dissolve or split the company, how do we handle that?

What happens in the event of a partner's death or disability?

It's likely that you and your partner(s) will not agree 100% on these things. You'll need to come up with a compromise that you can all live with. In our case, Go Media had an inequality issue that we had to deal with when we brought Jeff onboard as our third partner. At the time, Wilson and I were still working crazy long hours. Jeff, on the other hand felt strongly that he didn't want to become one of those corporate

workaholics who puts in 70 hours a week, has no life and eventually dies of a heart attack from the stress. This situation of Jeff leaving work on time while Wilson and I worked late into the night created some feelings of resentment. Why were Wilson and I working so hard and Jeff gets to leave at the normal time? We needed a solution that we all agreed was fair. We decided that the partners could earn overtime pay just like an employee, equal to 1.5 times our normal hourly wage. In this way, Wilson and I could earn some extra money for those long hours we were working. Jeff agreed, since the rules applied to him too. If he decided to work late, he could also earn the extra income. Wilson and I felt this was fair: our resentment was gone, problem solved. You too may need to come up with creative solutions to ensure that all the partners feel like things are fair.

Taking the time before you legally form a partnership to hash out all these expectations is a great exercise to help prevent future conflict and one last test to see if you and your partner are a good fit for each other.

Managing creative people really is like herding cats. It is nearly impossible without bribes and drugs.

— DAVID GENSLER, THE KDU

It's all about us. Much of my management approach is derived from the paradigm through which I view my position. As "president'" of Go Media, I don't see myself above everyone else, though typically, that's how society seems to see a "president." Instead, I tend to think of my position as one part of a system. It's unique, it's absolutely critical, but it's not necessarily more important than any other part. Imagine an engine. It has many parts. Some are bigger, some are smaller. Some move fast and some don't move at all. But it takes all the parts working together to make the engine run. Remove almost any part from an engine and the whole thing becomes worthless. Can an engine run without pistons? No. Can it run without spark plugs? No. Is a piston more or less important than a spark plug? That can be debated. What is clear is that you need both the piston and the spark plug for the system to work. Similarly, Go Media has many different parts and we need them all to work together for us to achieve success. Will a design firm that has no sales team work? Will a design firm with an amazing sales team, amazing marketing manager, amazing project manager, but no designers work? You can see my point.

My job (as it relates to management) is not to boss anyone around. It's more about making sure all the parts of the engine (all the employees and partners of the company) understand how the engine works, what aspects of their roles are critical, what gauges we're going to use to evaluate their performance, etc. In some cases I might even be considered the designer of this "engine." I believe I need these parts, I think they should go together like this, and here's what I expect will happen. But the truth is that it's really a team effort. I need all my employees to take ownership of their role, understand how it fits into the overall system and make improvements. I will never have as much information about any person's job as they will. After all, they spend all day doing it. I might only be focused on their role 10% of the time or less. Just imagine if you had an engine where every part had a brain and could give you feedback and make suggestions on how you could improve them. Not only that, but the purpose of this engine is to provide great service to your clients. So, your clients are also major contributors to the design of your "engine."

With this paradigm in mind—that we're all equally valuable parts working toward a common goal, here are a few things that come from that:

Transparency: In order for everyone to help, everyone must understand what's going on. This means educating and sharing with your staff. It means taking the time to explain what the reasoning is behind your decisions. This type of management takes more work. It would certainly be easier for me to keep my team in the dark and just give instruction with no explanation: "Bob, do THIS. Why? You don't need to know—just do it." This type of management works so long as I'm brilliant, know exactly what I need everyone to do and keep a very close eye on them. But it will never work as well as having every employee know why they're doing what they do and how they fit into the whole. At Go Media we involve our staff in many of our decisions. We have an "open book" policy with our financials, for instance. Anyone at any time can go into our

books and see exactly where every dollar goes. We distribute a monthly report to the staff that shares all the metrics of each of our firm's parts. On an annual basis we review the previous year's performance and I present a growth plan for the coming year. On a quarterly basis we review our company goals, as well as personal goals and make adjustments as necessary. And on an almost daily basis we're having discussions with each other about operations, strategy, financials, relationships, etc. The point is, our firm is highly communicative and transparent. I don't want a bunch of employees who are followers or "yes men." I need a team of equals working together.

> I want to hire a group of dedicated, professional, passionate individuals who are able and willing to do whatever it takes for the company. In this way, we can remove barriers, encourage openness and have a self-sustaining network of productivity without constant supervision or oversight.

JOSE VASQUÉZ, QUÉZ MEDIA MARKETING

Having praised the importance of teamwork, and including your staff on decision making, let me toss in one small disclaimer. Go Media used to be too democratic. We included the staff on too many decisions. We were wasting too much time debating the pros and cons of various options. Instead of making smart decisions, we were experiencing "groupthink." We were making decisions that were least offensive to the group, but they lacked strong direction. There were too many cooks in the kitchen as they say. Sometimes the right decision is going to offend a few in the group. In the last few years, we've pulled back on including the staff on decision making. Everyone is absolutely still involved in lots of decisions about the company. But now the partners are a bit more selective about when to include the staff. And in some cases we've

even given the staff more power. For some aspects of our business, we've handed off the power and responsibility and told the staff: "This piece is yours. You own it. Its success is riding on your shoulders. You don't need to ask us for permission to do something. In fact, we don't want you to pull together a committee every time you need to make a decision. That takes too much time. We trust you. Use your own judgement." The goal is to cut down on the amount of time we spend thinking and increase the time we spend doing. Let me reiterate that this is what Go Media needed to do because we were overthinking some things.

Shared success. If your concept is: "we're all part of a team working together to achieve a goal," your employees have to believe beyond a shadow of a doubt that they too will get rewarded when the company does well. Otherwise, why do they care if the engine runs well. Imagine this scenario: a group of employees buy in to their boss' plan. They work really hard and contribute ideas to improve the company. The company doubles its annual sales projections, posting massive profits. Then the employees get no bonuses and their raises only match the inflation rate. What do you suppose will happen the following year? At Go Media, we work hard to try and keep the connection between our success and our profits as visceral as possible. In 2007, when things really took off for Go Media, we started giving bonuses to the staff. We gave a bonus to every single employee, $500 a month for the entire year. It was the right thing to do. The success we had was absolutely a group effort. They could see and hear the success we were having. They earned that money, so we shared it with them. We may have had less money in our bank accounts, but let me tell you about the loyalty we experienced due to this type of approach: Go Media experienced almost no turnover in our firm from 2007 through 2011. At least, nobody left us. Unfortunately, we did have to lay off a few people during the economic downturn in 2009. This lack of turnover probably saves us thousands, if not tens of thousands of dollars that would have been wasted hiring and training new staff.

Hard work. I once heard that a company's employees will only work as hard as their boss. The boss sets the standard to which everyone else lives up. I'm not sure if this is true or not, but I have heard many stories from friends who left companies because their bosses were lazy bums who took frequent golfing trips during the work day and overpaid themselves. In a scenario like this, the staff begins to resent their boss and will fight their natural instincts to work hard in order to hurt the company. So, for better or worse, as a manager or owner, never forget that YOU ARE A ROLE MODEL. Your staff is watching you like a hawk: actions absolutely are more powerful than words. What you say is fine, but make sure you're busting your butt for the company and that everyone knows it.

> I want to hire a group of dedicated, professional, passionate individuals who are able and willing to do whatever it takes for the company. In this way, we can remove barriers, encourage openness and have a self-sustaining network of productivity without constant supervision or oversight.

JOSE VASQUÉZ, QUÉZ MEDIA MARKETING

Trust. This management paradigm only works if you trust your employees and each of your employees trust each other. As soon as you lose trust, this management model starts to fall apart. If I, as president, tell my employees "this is a team effort," then micromanage them, what do you think they will believe—what I say or what I do? Here's a hint: actions speak louder than words. And if my salesperson doesn't trust my project manager, so the salesperson starts managing projects, how satisfied will my project manager be? If my salesperson is managing projects, who's selling?

Fortunately, in my experience, trusting people brings out their best. It's one of the major benefits to my model of management. I get this aspect

of my management style from my parents. When I was a young teen-ager, all my friends' parents gave them strict lists of rules, like: you must be home by dark; my parents were far more flexible. They wouldn't tell me I couldn't stay out late. They would say: You can stay out as late as you want, you just need to make sure to keep us informed about where you are and what you're doing. They treated me with trust and respect. They expected me to act like a responsible adult and because they gave me that freedom, I honored them by acting that way (most of the time). If you assume that your staff is a group of children and treat them like children, eventually they're going to start acting like children. Do the opposite. Expect greatness from them and give them the tools and free-dom to achieve it.

> ## DO YOU HAVE ANY STORIES OR WORDS OF WISDOM ON MANAGEMENT?
>
> Trust the team you have put in place and let them do their jobs. Have an open-door policy so employees feel comfortable in sharing thoughts, ideas or concerns. Be proactive with compensation and make it so no employee ever has to ask for a raise. Don't sugarcoat bad situations - be open and honest with your team and make sure everyone feels they are part of a solution.

PHIL WILSON, FINE CITIZENS

Running your company like this really cuts down on the number of rules you have to impose. It creates an atmosphere that is a bit looser. While I think this works for most people, I will admit that there are certain people who thrive in extremely autocratic environments. Perhaps you as a leader are even more comfortable being autocratic than democratic. This touches on a point I made early in the book, that the way I man-

age may not work for you or your employees. Give some employees too much rope and they'll hang themselves with it. I've had a few of them. Without close oversight they goofed off until I had to fire them. I will speak momentarily on finding your own managerial voice.

Punishment is not about me versus you. While I would say that my staff is amazingly well-behaved, focused, and hardworking, there are problems from time to time. With the team concept, having a discussion about poor performance is not about me as a boss coming down on them as an employee; it's certainly not personal. I'm communicating on a higher level. We're talking about principles, actions and company-wide consequences. When one employee doesn't do their job well, everyone suffers. Having this perspective takes a certain weight off my shoulders. I'm not speaking to them because I'm worried about personally losing money, I'm coming to them as a representative of the entire team, concerned about everyone's well-being.

As part of this, I do adhere to common management tactics like seeking to understand first, and bookending any criticism with praise. Since I trust and respect my staff, if they're performing poorly, my first interaction with them is about gaining an understanding. That conversation might start something like this: "Hey Bob, normally you're one of our very best employees. Our clients love you and you do great design work. But in the past few weeks I've noticed that you're coming in late, you leave early, you look really tired all the time and yesterday you snapped at a customer. That's just not like you. What's going on?"

Also, it's important to let your staff "save face." You never want to punish a staff member in a public way. Employees want to contribute. They want to be good employees. They're proud. Most humans are. If they're performing poorly, they usually know it. And once they realize you know it too, they're typically going to fix the problem. But if you humiliate

them in front of others, then you're going to lose the trust between you and them. They're going to resent you for it. Trust me, they'll find a way to even the score—by slacking off, doing a bad job or undermining your authority with other staff members.

> People like feedback, they like to know when they're doing good work and they like to be recognized for it. That doesn't mean a pay raise every other month, but a bottle of wine, an unexpected day off or a team lunch every now and then can really bond a team together.

CHRIS HARRISON, HARRISON & CO

Judge your employees' actions with their body of work in mind. Early on in my career as a manager I had an incident with a great employee. At the time, Go Media was in a rough financial place. I was extremely stressed out. Although this particular employee was normally an extremely focused and hard-working person, he just happened to be having a lively conversation with another employee that day. Unfortunately for us, we were also crammed in a very small office space, so their chatter was right in my ear. In a moment of frustration, I spun around and laid into him. I let him know in a not-so-nice way that we were in bad shape financially and he should be quiet and get back to work. Later I heard from other staff that he was visibly shaken from my little snap at him. I was wrong. He didn't deserve that. He showed up on time every day. He worked extremely hard. Your staff needs time to be able to blow off some steam and have a little fun from time to time; my mistake was that I was making a judgement about a single moment in time without considering the history of the employee. If he was unproductive and spent too much time most days talking to other employees, then I would have been justified in letting him know to shut his mouth and get back to work. But

that was absolutely not the case. I should have let it slide. Even if I had justification for talking to him, I shouldn't have done it in a public way. Before I talk to any employee about poor performance, I will ask myself questions like: "Is this normal for them? Is this a recurring problem or a one-time incident? How is it affecting their job? Does it really matter? Am I just in a bad mood today?"

Make good on your promises. This is basic life skills 101. Say what you mean and you do what you say. Trust and respect is built on following through with your promises. This applies to the good as well as the bad. If you set up rules and consequences, but fail to enforce those rules, then you're going to lose respect. And if you promise a bonus but don't give it, good luck rallying an employee's support the next time you need them to pitch in. If you promise something, but fail to deliver, then you need to make sure you explain the reason immediately and apologize. In 2009 when the economy tanked, so did Go Media's bank accounts. We had no back-up plan. In addition to laying people off, we couldn't afford raises or holiday bonuses. We explained the situation to the staff, apologized, and laid out our plan to make it up to them. Once our bank accounts got healthy, we explained that we would give them a belated holiday bonus and their raise. We even promised to reimburse them the amount of money they would have been paid as if the raise had been given on the first of the year. By the end of 2010, we had delivered on all those promises.

Finding your own voice. Dameon Guess is one of the owner of Jakprints, a great printing company located in downtown Cleveland, Ohio. I've known him for years as we've built our businesses side-by-side. Dameon is a ball of energy. When I first met him I thought: "Is this for real? Is this guy on drugs? Who has this much energy?" Let me assure you: it's 100% natural. He talks a mile a minute, he thinks a mile a minute, and he'll run up to you, throw his arms around you and give you a big hug without a second thought. I love his personality. He's very successful.

He's a great manager, and I'm nothing like him. I am far more quiet. I'm not very physical. I don't hug my employees or my clients. Although Dameon and I are not similar in many ways—including how we manage, we are both very successful. There are many different ways to manage. So, don't find one role model and put a ton of pressure on yourself to be like "that guy." You need to have many different role models and take what you see in each with a grain of salt. Pick the styles and tactics you are comfortable with and find your own voice.

How do you find your own voice? It's in you. It will emerge sooner or later. Time and repetition are certainly a big part of that. You'll do something, reflect on it, realize you could have done it better and next time that problem crops up you handle it differently. Go Media's newer employees get the benefit of a seasoned management team. While trial and error will be fundamental, I also suggest that you enhance experiential learning with a little education. There are many good books on management. I know that Dameon and his partner Jacob took management classes at a local college. They praised the benefits of going back to school. If you have partners in your firm it's also helpful to be able to point out each other's flaws. This can be hard. Nobody likes to be told that they're doing something wrong. But if you're each committed to improvement in your business and in yourselves, you'll do it. Recently, one of my partners and I gave one another some feedback after a sales call with a client. I pointed out that Wilson's answers felt a bit long to me. He has a tendency to be very technical and this can lead to long explanations that go beyond the point of the question. He noticed that I was saying "uh" and "um" a lot. I tend to do that when I'm either nervous or ill-prepared for an important call or presentation. He said we don't sound confident when I'm pausing and stammering. I agreed. Even more recently, one of our employees told all three partners that we were being too harsh with the new staff members. We were making them feel bad. Can you imagine it? An employee telling their bosses to be nicer to the

Limited Brands

Corporate website for Limited Brands

new staff? It happened because the management voice at Go Media is that we're all equal parts of a team working together. If the staff is messing up, the partners need to let them know. And if the partners are messing up, the staff needs to let us know. We wrote a letter to the staff explaining our recent stress, apologized, told them we loved them all and that we thought everyone was doing a great job. You catch more flies with honey.

My goals need to be your goals, and your goals need to be my goals. When I am interviewing potential employees, I make a point of explaining to them the aspirations of Go Media. I talk about the type of company we are, and what we want to become. I make sure to detail how they fit into that vision. It's important to me that what I have planned for them fits with their own goals. I'm not idealistic in this conversation, it's very pragmatic. I recognize that some employees don't see themselves staying at Go Media for the rest of their lives. For some young designers, their time at Go Media might simply be a stepping stone to a larger agency in a bigger city. Or perhaps they want to learn how we run our company so they can eventually leave us to open a competing firm. I accept that. I want my employees to be able to get out of Go Media what they need to achieve their life goals. If a potential designer said to me: "I really want to open my own firm in three years. While I work for you, will you also teach me how you run your firm?" I would say yes, absolutely.

When you've aligned your needs and goals with those of your employees, it's a partnership. They will work harder for you when they know you're working hard for them. And when they realize that you're helping them achieve their life ambitions, it amplifies how much they appreciate you. I would rather be transparent with my staff in this way than have them pretending to be a Go Media "lifer", only to have them leave unexpectedly. At least if I know they're going to leave I can do better succession planning. Two weeks is simply not enough notice to find, hire and train

a suitable replacement. When I am having these practical talks with potential employees sometimes I have to break down their "I'm interviewing for a job mentality." I'll ask: "What are your dreams?" They'll respond: "To work for Go Media!" I'll say: "Really? When you were little you dreamed of working at Go Media? You want to work for Go Media for the rest of your life? Heck, I'm not sure I really want to work at Go Media the rest of my life. What are your REAL life dreams?" Eventually they will tell you what they're after. I've had people tell me some crazy things. "I want to be a zoologist." "Really?" I'll ask. "Why are you applying for a design position?" In a case like this, giving this person a job does not align in any way with their goals—other than providing a paycheck, which is what I'm trying to avoid. However, if they tell me: "I want to work for Pentagram's New York office, and I thought three years at Go Media would look good on my resume." I'm cool with that. This applicant's motives are aligned with mine. They need a beautiful portfolio to get a job at Pentagram and I need them to make beautiful designs for my clients. It's a symbiotic relationship.

I do ask for a two-year commitment from every employee to whom I'm offering a permanent position. In my experience, two years is a worthwhile timeframe to justify looking for and training a new employee. If they only think they're going to be around for a year, I'll probably pass. Now, two years may seem like a fairly short commitment time period, but I am also banking on the fact that people tend to settle in to a place and stay longer than they expect. In my experience this is absolutely true. And who knows, they might even fall in love with Go Media and stay forever. It could happen.

To reinforce the idea of shared goals, Go Media requires each employee to set both personal and professional goals. We combine those with our company goals, print them up and hang them on the wall in our office. Every quarter we review those goals, check off the items we've accom-

plished and add new goals. It's important that the staff feels that their personal life goals are of equal importance as our company goals.

> ## HOW DO YOU HANDLE TROUBLE EMPLOYEES?
>
> ## We fire them.

ALEX WIER, WIER / STEWART

Don't train your staff! When I started Go Media I had in my mind the idea that I could create good employees through proper management and training. I thought that people were clay, and I had the skills to mold them into the type of employees I wanted. I'm a good teacher, an excellent communicator, a skilled designer—I had all the skills I needed my employees to have. So when I hired I was mostly looking for intelligence and a good attitude. While those are important traits for an employee, I've learned over the years that it's a misconception that you can create good employees through management and training. What I've experienced—and later read in books—is that employees are who they are. If someone works slowly, they work slowly. It's very hard to take someone who naturally works slowly and "train" them into a fast worker. Some employees require constant supervision and become easily distracted any time their workload gets slow. Others seem to naturally stay focused. They're task masters who work rapidly and come to your desk asking for more work as soon as they're slow.

The point is that bad employees are not the result of bad management. If you recognize someone in your company who's a below-average employee, you shouldn't waste any time trying to "fix" them. You shouldn't

blame yourself. You need to blame them. You need to fire them and get new people into your company. Good employees require very little management at all. When you have a staff of good employees, your company seems to run itself. It feels effortless. Your staff is smart, they're using their brain, being proactive and staying on task. I can remember the first time I got a few good employees on my staff. It felt like: "Wow. So THIS is how it's supposed to go. This is GREAT!"

Start strict. It's much easier to give employees more freedom and responsibility than it is to take it away. For this reason, I highly recommend that when you bring in new employees you start out more strict and more demanding than you think you need to settle into naturally. Lay down the rules thick and heavy early on, then ease up over time as they prove themselves to be responsible and productive.

Push—a little. Humans are lazy. There, I've said it. Generally speaking, people don't push themselves to their maximum potential. They stay within their comfort zone. That's fine. I do believe in balance. I don't want to work myself or my staff into an early grave. But I also want to achieve great things—and so does most everyone else. In addition to letting your staff work within their comfort zone a good amount of the time, you also need to know when to push them. I tend to push my staff on projects I'm excited about. These are typically projects for larger companies that would look amazing in our portfolio. I'll give them a heads-up at the start of the project: "Make this your best work ever. This one is going in the portfolio!" At the first critique, I might be a little rough. Where normally I might hold back on something that I see as "OK", but not "great", in these instances, I'll give them my honest opinion: "I think you can do better." Of course, I'll also throw in my design ideas as well. I do believe that rounds of criticism and refinement will make the designs better (even if some people don't enjoy the process—myself included).

Dealing with a rush. As a general rule, we try to schedule our projects out in such a way that the staff can get it done during regular work hours. However, there are times when we've got a crushing deadlines that requires overtime or weekend hours. In these instances we do a couple of things. First, we try to make it more of a fun experience. We'll order pizza, crank up the music and try to keep the atmosphere a bit more like a college late-night cram session than a pressure-filled work deadline. Also, we make sure that the staff knows that they can either cash in their OT as additional payroll or use the extra hours they worked to take some time off. They can use those OT hours however they choose so long as we don't miss any client deadlines. This is a great incentive because they can take long weekends or take an entire week off if they choose. It works out best for Go Media if they use their OT for days off vs. extra payroll. The OT costs us 1.5 times their normal payroll hours, but giving them days off costs us nothing extra.

DO YOU SHARE YOUR FINANCIALS WITH YOUR STAFF?

60% YES

40% NO

It's very important to respect the art of business as much as you respect art itself.
— JULIA BRIGGS, BLUE STAR DESIGN

GENERAL STRATEGY:

Business systems are any predefined process you utilize to run your business or execute your work. For instance, McDonald's has a step-by-step process they've developed to make a cheeseburger. It explains exactly what temperature the grill should be, there are specs for the baker on how to make the buns, there is a specific order in which the ingredients of the cheeseburger should be stacked (two all-beef patties, special sauce, lettuce, cheese, pickles, onions on a sesame seed bun!), they've even made a special gun that shoots out a very specific amount of ketchup. This is a business system. It ensures that every McDonald's cheeseburger is identical across the country and around the world. It makes it easier for the employees, it ensures a standard quality, it adds efficiency to the kitchen and it makes the company more profitable. Every business has systems—whether you realize it or not—even the kids selling lemonade down the street have systems. The real question is not whether you need systems, but how many do you have, how complex are they and when do you implement them?

I've always been a big fan of business systems. I'm not sure why. Companies like Mcdonalds have always impressed me with how perfectly

organized and efficient they are. I suppose I've always felt it was part and parcel of what makes up a business, and I've always loved business. I like to look at the work my company does and ask: "How can we streamline this? How can we better organize this process we go through? How can I ensure that we don't make mistakes while becoming more efficient, and better! I've also more recently learned that it's your company's systems that have a big impact on the value of your company. If you have a business that has a bunch of people in it who each know how to do their job, that's great. But if you sell your company, what exactly is being bought? If your company is a cement company, well, the buyer is getting a big manufacturing plant, probably some real estate, a fleet of trucks AND your employees. But if you're a design firm and someone buys your company, what exactly are they getting? If your company runs so well because all your employees know how to do their jobs, then the purchaser of your company is really only buying your people. And what happens if those employees quit? Then they've only bought a room full of computers. That's why business systems are important to the value of your company. An employee can quit, but a business system stays with the company. That's why McDonalds can lose an employee and their company doesn't skip a beat—because they have amazing business systems.

Metrics and Dashboards. When you drive your car down the street, how do you know how fast you're going? You look at your dashboard—a collection of gauges that give you the most important pieces of information you need while driving your car. The speedometer tells you how fast you're going. The odometer tells you how far you've gone. The gas gauge tells you how much fuel you have left. These readings such as miles per hour, fullness of your gas tank and total miles are known as "metrics." Can you imagine driving your car without a dashboard? It's certainly possible. But you might get a speeding ticket, run out of gas or burn your engine up because you didn't change the oil on time.

Running your design firm without metrics and a dashboard is very much like driving a car without one. It's possible, but sooner or later you're going to get yourself into trouble. Not only will metrics and a dashboard keep you out of trouble, they'll also let you know when you're doing well, when you need to hire more staff or when you deserve a bonus! Tracking your metrics over time will also give you valuable information that will drive your decision-making. Imagine if you started tracking the realized rate of all your design projects. And through this tracking you learned that your realized rate on branding projects is $200/hour, but your realized rate on web projects was $75/hour. What might you conclude with this information? Maybe you want to sell more branding work. Or, maybe you realize that you're overestimating your branding work and under estimating the workload for website development. The point is, you can't make informed decisions about your company if you don't have the data to base decisions on. This data comes from your metrics and dashboards.

To start, you must consider what the key measurable components of your business are and you have to start tracking them. You'll need a system for recording all this data. While it's important to do this tracking, as always, I believe in a balance. If you're a small firm and spending a full day every week on your metrics, that's too much time. If possible, you should try to keep your work load on this minimal. If this is all new to you, I suggest starting very small and slowly adding metrics as you grow. At Go Media, the data recording that goes into our metrics is running every day. Employees are logging hours, invoices are being made in Quick-Books, sales leads come in through our website, etc. But we only gather this data and reflect on it once a month. We have a spreadsheet where we drop the data at the conclusion of each month. This way we can look back at the month-by-month performance of our company.

Here is a list of some of the metrics we track, how we track them and what's important about them:

Bank balance: this is one you probably already track. It's as simple as looking at your bank statement. Cash is your lifeblood, so this is very similar to your car's fuel gauge. When this runs out, your company stops running. Never run out of gas (money)!

Sales: this is the monthly total of cash in the door. We use our bank statement for this one too. Go Media runs our books on a cash-basis accounting method: we only count actual dollars in and out the door as real. With accrual accounting, you get to count an open invoice as income and unpaid bills as expenses. Accrual-basis accounting is critical for companies that have inventory. For service-based businesses like graphic design, I much prefer the cash-based accounting method. It's simpler, for one, and your P&L statement is very closely matched with your cash flow statement. With accrual accounting it's possible to look like you're doing great financially on your P&L, but your bank accounts is empty.

Expenses: again, this is real basic stuff. We pull this number off our bank statement: dollars out the door. While this is a true reflection of all your expenses each month, sometimes you are making investments in your company, like buying new computers, software or a sign for your build-ing. Because these one-time purchases can skew your monthly expenses up, I suggest you also know your monthly operating costs. Your operat-ing costs are all your fixed expenses: how much it would take to run your company if you only spent the absolute minimum amount of money. This would include things like rent, utilities, payroll, etc., no improve-ments, no growth, just covering the basics.

Net profit/loss: sales minus expenses. Did we lose money or make money this past month?

Leads: how many new inquires did we get? It's also critical that you track where these leads are coming from. We ALWAYS ask our customers how

they found out about us. It helps us make decisions about where to invest our advertising dollars. Most of our leads come from a contact form on our website, so we just count up those e-mails at the end of the month.

Proposals sent: we track both the number of proposals we send out and the total dollar amount. Over time we've been able to calculate our "close rate." For this we keep a spreadsheet. We just jot down the client name and proposal value when we send it out. Then we total it up at the end of the month.

Hours networking: this is a metric specific to the sales team. I've learned over the years how important it is to get out from behind your desk. You have to knock on doors, attend events and shake hands. There is nothing as powerful as getting to know your customers in person. For this metric, I have my sales staff log their time in Proof Lab, then we tally it at the end of the month.

Stress level: how are we feeling? Don't forget that you are not a machine. Keeping track of your team's stress levels will let you know in advance if someone needs help. An employee might not tell you that they need help, but if you ask them once a month, "How stressed are you," they'll let you know. It's like the thermostat on your car engine—don't run too hot or you might blow a gasket! Ever have an angry employee storm out of the office? That's a breakdown you cannot afford. For this metric, we ask people to rate their stress level: calm, average or stressed. If they're stressed, I'll ask them what's going on and how can I help.

Web traffic: we keep an eye on all the website traffic to our different properties. For this we use Google Analytics.

Project realized rate: your realized rate is the hourly amount you actually earn on a project. Calculating this is very simple. It's the amount paid divided by hours worked. Ideally your realized rate is the same as the

JULY 6, 2013
ALPINE VALLEY MUSIC THEATRE
EAST TROY, WI

DAVE
MATTHEWS
BAND

shop

All Build a Dream products are trademarked, patent pending.

Playhouses

○ Snack Shack™
○ Cosmic Cruiser™
○ Imagine Wagon™
○ Dream Machine™

Pop N' Play Series

○ Pop N' Play Kitchen™
○ Pop N' Play Castle™

Stickers

○ Create a Dream Snack Set
○ Create a Dream Vehicle Set

○ Return Policy
○ Limited Warranty

Create a Dream Snack Set
$19.99

Create a Dream Vehicle Set
$19.99

Pop N' Play Kitchen™
$49.95

Snack Shack™
$59.95

rate you bill. We bill $100 per hour. If we estimate a project will take five hours and we complete the work in five hours, and if we get paid $500. The realized rate would be $500 divided by five hours or $100/hour (our billing rate). Of course, this rarely happens so cleanly. Typically projects run over budget. We might quote five hours, but in reality we might work seven. If the client isn't willing to pay for the extra two hours we need to work, we might eat those hours. In that case our realized rate would be $500 divided by seven hours or $71/hour. It's important to keep track of your realized rate. Look for trends. Some clients might be problem clients. Some project types might be misquoted regularly. Use that knowledge to make changes in how you run your company. To track this number we use Proof Lab for tracking our time and QuickBooks to track payments.

Estimation accuracy: estimate accuracy is closely related to project realized rate. Except in this case we are only looking at hours. Did the hours estimated for the project match the hours projected? To calculate this, we divide the hours estimated by the hours worked. For instance, if we estimated 100 hours for a project and it only took us 50 hours, we'll know our accuracy was 200%. That means our estimate was double what it should be. While this may be good for our bank accounts in this case, it is also an indication that the sales team did a poor job estimating. Poor estimating can lead to losing work because your rates are inflated. Or it can lead to losses because you're underbidding the work. Your goal should be to estimate as closely to 100% accurate as possible. Being in the 90% accurate range I would consider good. 80% is acceptable. Anything in the 70s or below is bad. And anything in the 50s or lower is absolutely unacceptable. Your business will fail quickly if your estimating is this far off.

Those are the primary dashboard metrics that Go Media tracks on a monthly basis. We keep track of these metrics in spreadsheets so we can see our performance over time. The more information you gather over

time on your company, the more informed your decisions will be. And as I stress over and over, you need to be making decisions based on knowledge. You need to gather your facts, gather your customer feedback, gather staff input and then decide how to move your company forward. Your dashboards are an important part of that.

The project zip-line. I wanted Go Media to have systems. Early on in the company I decided to build a project management system. I had an invoice for each project which I typed up in QuickBooks. I often times had additional information on my projects that I kept in a folder (yes, a physical cardboard folder). Sometimes a client would bring me some photographs or additional resources for the project. I recalled from my days working at Kinko's that they had these project envelopes where they kept the client's original files. These project envelopes also had the project instruction form on the outside. It kept everything neatly in one place. I really liked that concept, so I decided to do something similar. I ordered a bunch of 16x20-inch reusable clear plastic envelopes. I could put all the information about each project into this envelope and hang it from a wire which I ran across our office (at the time our office was a dining room of an old duplex we rented). The "line" was a big industrial steel cable that I mounted to the walls. It was total overkill. I got the "line" idea from an old fashioned restaurant where the line cooks would hang the order slip in a row above the grill. The cooks would prepare each meal, pull the slip down and move on to the next slip. I guess I was seeing design work as a production line like an assembly plant.

Here's what happened: it failed. First, there were only two of us in the company at the time. Which meant that half the time I was spending typing up project descriptions just for myself. Second, that typing up the project descriptions for Wilson when he was sitting two feet away from me was a little silly. I could simply spin my chair around and tell him. Also, design projects don't always go in chronological order. It's

not like I could finish a project and remove it from the line and then work on the next project in a set order. The order of the envelopes was inconsequential. If I had managed the line, constantly reordering the projects so it made some sense, it would have been a colossal waste of time. At any given moment we had 10—20 projects that were in some state of completion. What I realized fairly quick was that my project zip-line was taking more time and energy than it was returning in value. We were too small and had too few projects to need a project management system; I could keep everything in my head and nothing was more efficient than that back then.

HOW DO YOU DELIVER PROOFS AND RECEIVE FEEDBACK FROM YOUR CLIENTS?

Almost always in person. We prefer to not deliver creative materials electronically. But, we will follow-up a creative presentation with a post to our project collaboration portal. Then, the client can respond with feedback right on that portal so everything is documented.

PHIL WILSON, FINE CITIZENS

So what did I learn? First, that systems from other companies or industries will not necessarily work for your company. Second, don't be afraid to evaluate your systems. If they're not working, throw them out and come up with something better. Also, some systems require that your company is bigger to be of use. When Go Media reached five employees, I realized that I was desperate for a project management system. So we developed Proof Lab, which was a huge success, but it wasn't until we got bigger that it made sense for us. Your business systems will grow with your company. When you're small you won't need many, but as you grow you'll realize that you need more. In my experience, most systems

are born out of a mistake. Something goes wrong, people are angry and you're trying to figure out how to avoid a repeat of that mistake.

> We use Streamtime for project management—it manages proposals and invoices, work plans and time sheets, as well as CRM data. We also have very in-depth project processes. The processes are continually being refined but are comprised of timelines, work plans and checklists to help ensure we stay on time and within budget. Creative work can easily go beyond project scope parameters so these tools help us stay on task.

RACHEL DOWNEY, STUDIO GRAPHIQUE, INC.

Proof Lab. A couple of years after the zip-line concept failed, we had grown our company to five employees and realized that we were in need of a real project management system. Having verbal conversations and exchanging e-mails was simply not going to give us the reliability we required to manage all our projects. We did extensive research to find an adequate web-based project management system. After about two weeks of looking we just weren't happy with anything we found. We decided to build our own system. I won't attempt to cover the many trials and tribulations that come with building a complex web-based app in this book. I just want to cover project management software in general. I would not recommend that anyone else undertake the challenge of building their own PM software. It took us years and tens of thousands of dollars. Today there are many more project management options out there—including Proof Lab, which you can subscribe to for a low monthly fee.

Here are the basic functions of Proof Lab that I would recommend for your project management needs. Each project is given a name and a number. That project number carries over into the project folder on our server as well as the file naming system we use. We are able to create

individual tasks with specific deadlines within each project. Staff members can be added to either the project or individual tasks. Employees with tasks are allowed to log their work time. Designers can post proofs and upload files to projects. Clients can also log in to Proof Lab to see all their projects, review details, post messages, add comments, review proofs, supply feedback, etc. I'm not necessarily recommending that you use Proof Lab; there are many PM options out there. This is just the one that we use.

Recently we've realized that Proof Lab comes up short when it comes to long-term resource allocation planning. Unfortunately Proof Lab does not have a calendar component to it yet. So Go Media has recently started using Smartsheet.com to fill that gap. We also use Basecamp for some projects. It would be nice if all the functionality of these different platforms were combined into a single app. As of yet, we have not discovered the Holy Grail of project management software. I encourage you to explore the many options and pick one; be prepared for a learning curve. Quality project management software is complex. It's going to take some time to learn and fully adopt. Once it's in place and running smoothly, you'll wonder how you survived without it.

File organizing and naming conventions. (Reprinted from the GoMediaZine)
Organize your design files—OR ELSE! Design file names and folder structure are a key ingredient to your success as a graphic designer.

Here's a scenario: a client calls you because he just picked up the presentation your firm designed from the local Kinko's and they've found some typos. Also, they've decided to change some images. They have their meeting in one hour and they need you to make changes and e-mail over the revised presentation. They'll need fifteen minutes to print it and fifteen minutes to get to the meeting. That leaves you thirty minutes to make the changes—no problem!

But wait! The designer who put this presentation together is home sick. Again, no problem! These are simple changes, you're a capable designer. This should be no problem at all. But when you sit down to open the presentation you realize you're in big trouble. There is no clear folder structure. There are six different versions of what you THINK is the presentation.

Content files, images, design files and the presentation files are all mixed up in one huge messy folder. Which file was approved? What file was sent to the printer? You start opening the latest files hoping that one of them is the approved version of the presentation. When you open the latest files, images are missing and you don't have the proper fonts installed on your computer! Panic starts to set in as you rush over to your fellow designer's computer.

It's been fifteen minutes already and you're still trying to make heads or tails of all the files. When you fail to deliver the revised presentation on time your client drops you. Your business goes bankrupt and your girlfriend leaves you. Within six months you're addicted to heroin and living on the streets.

DON'T LET THIS HAPPEN TO YOU.

This is just one scenario where having an organized file structure is important to your career as a graphic designer. Has this happened to you yet? If it hasn't, just wait, it WILL! I'm afraid no diet, exercise or drug can possibly prevent this from happening to you. No, what you need is a file naming and folder structuring system!

For starters, all of Go Media's design project files are held on a single server we affectionately call "The Beast" (the actual name has been changed to protect the innocent—us). On the Beast we have a folder called Clients. This folder has exactly what you would expect—a long

SEPT 00, 2013 **CHICAGO IL**

DITKA DASH

RACE INFO SWAG REGISTER CONTACT

The inaugural DITKA DASH, a 5k run is going down September 00, 2013 and you're invited! Come run like Mike with your very own set of Aviators and Mustache, and celebrate this Chicago icon.

REGISTER NOW!

RACE INFO
MORE ABOUT THE RACE

SWAG
BUY DITKA DASH GEAR!

REGISTER
RUN IN THE RACE!

list of folders with names like Nike, American Greetings and Lincoln Electric. Pretty simple so far, right?

Within each client folder we have a folder for each project that we do for them. An individual project would be something like a logo design, website design or brochure design. Now, if a client orders a full stationery set like business cards, letterhead and envelopes, we will typically put this together into one project. Each project folder is named with the project number and the project name.

For instance, a project folder might be named: "3186_business_stationary". Now, you'll notice that I used underscores instead of spaces in the name of that folder. It's not necessary in this case, but all folders that will be put on the web and all file names put on the web cannot have spaces. So I find it's a good habit to get into, using underscores instead of spaces. Let's take a quick look at what our folder structure looks like so far:

Sometimes a client's folder will include a folder or two that are not related specifically to a project. For instance, you may acquire a client that

already has all their branding done. You'll be using that branding for a variety of their projects, so you won't want to hide those branding assets inside a specific project folder. In this case you'll want to have a folder inside the client's folder named something like "Branding" or "Assets."

Another example is our client Lincoln Electric. We design welding helmets for them. They have about four different models of helmet we've built templates for. These templates are used for all their projects, not just one. We have a "Helmet Templates" folder in their root client folder for easy access. I start the names of these non-project folders with an underscore. This ensures that they will stay at the top of the list of folders for easy access. Also, you'll notice that the project numbers being at the front of the project folder names also has a beneficial side effect; it keeps them in chronological order. Let's look at that client folder again:

As mentioned previously, Go Media uses a project management software that we developed internally called Proof Lab. Proof Lab is where we derive our project number. You may have your own project management systems. Whatever you use, you'll need to establish a numbering system for your projects. It's important that the naming conventions and numbers on your folders coincide with what's in your company's project management system, whether that's Proof Lab or something else. Here is a screen shot from inside Proof Lab:

At Go Media, we try to match the project number and the project name exactly between the Proof Lab and our folder structure. This just makes good sense. Still easy enough so far, right? Now is where things start to get complex: the individual project folder structure. It will be easiest if I just show you first, and then explain after. So here ya go:

This is the extent of the folder structure we used for many years. Here is a quick breakdown of what the folders are. The "Ai" folder is filled with Adobe Illustrator files; "Fnl" contains all final approved files. In most cases these are the print-ready files for all print projects. "Ind" is InDesign files. When it comes to any software, you could have an associated folder with that software. What I'm showing here is just our bread-and-butter software. But if we had a project in PowerPoint, for instance, we would also have a "PP" folder in there. "Mgmnt" is all files related to managing the project. This might include things like a timeline, the project proposal or a nondisclosure agreement. "Prf" is where we save our proofs. "Psd" is Photoshop files. "Rsc" is resources. Resources are where we keep anything we may need on the project like images, content, logos, etc. And "Web" is, well, web. This web folder has always had sub-folders, but I won't go into that now.

This folder structure served us well for many years. But when our projects grew in size, we realized there were still some problems. We were confusing which files were old and which files were approved. We were mixing up client content files with previous outdated content. And, we didn't even have any file naming conventions. So, each designer would name their project files differently, which invariably lead to confusion.

Let's start first with that—the naming convention for the files. Here's a breakdown of our current system:

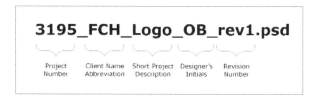

3195_FCH_Logo_OB_rev1.psd

| Project Number | Client Name Abbreviation | Short Project Description | Designer's Initials | Revision Number |

And now let's look at our expanded project folder:

```
▲  The Beast
   ▲  Clients
      ▲  Angelos_Pizza
         ▲  2345_website_design
            ▲  Ai
                  _Old
            ▲  Fnl
                  Ai
                  Content
                  Image
                  Ind
                  Prf
                  Print
                  Psd
            ▲  Ind
                  _Old
            ▲  Mgmnt
                  _Old
                  Feedback
                  Proposal
                  Site Map
                  Wire Frames
            ▲  Prf
                  Rd1
                  Rd2
                  Rd3
                  Psd
            ▲  Rsc
                  Content
                  Images
            ▲  Web
                  _Old
                  Axs
                  Flash
                  HTML
                  Live
                  Stage
```

Whoa!—I know. It IS a beast isn't it? Well, it only looks this big and complicated because I've got every folder expanded. Also, this file structure assumes a fairly large project with lots of different software being used. Obviously, you will only create the folder structure that you're going to need.

All of the "_Old" folders you see are like mini trash cans. When we're on version 8 of a design and the folder is looking cluttered, we like to move versions 1–7 into the "_Old" folder. We don't like to delete them because you never know when a client will suddenly ask for something they saw two weeks ago. The "Fnl" folder stands for Final. Basically, every proof, design file, piece of content, etc., that is approved by the client gets moved into this folder. There is essentially a mirror copy of the folder structure within the "Fnl" folder. The Print folder within the "Fnl" folder is where we save our print-ready files.

The file structure within "Mgmnt" is self-explanatory. In the proofs folder, you'll notice that we break the proofs down into rounds (Rd1, Rd2, Rd3). It's just easier to find the proofs you're looking for when you have them broken down in this way. Another folder that we sometimes put into the "Prf" folder is a "Crit" folder. The "Crit" stands for critique. This folder holds proofs that we're going to do an internal critique on before we show the client. That "Psd" folder should have an "_Old" folder in it—sorry, missed that one. The "Rsc" folder is for Resources. Resources are generally broken down into content and images.

Other random items can just go into the root "Rsc" folder. Within the Web folder, the "Axs" folder is a place for all login credentials or access details; this is convenient when you're trying to keep track of stage or testing site details, client accounts, etc. "Flash" is all source and SWF output for Adobe Flash files. "HTML" is a folder for all static markup; clean, without CMS implementation. "Live" is a folder for all final web files for

the live site, possibly including database backups. "Stage" is a working copy of a site after static HTML has been integrated into a CMS.

Again, this folder structure is fairly large, and you would normally only create the folder structure that you're going to need. For instance, a business card design project's folder structure would look something more like this:

In some instances you need even less. But in our experience, you never know when a design project is going to spiral up in size, so we like to start with a little overkill on the organization so it's there for us when we need it.

I am anticipating another question: "This seems like a great system for client work, but what about Go Media internal work?" Well, we've learned that we need to treat our own internal projects just like client projects. We actually have "Go Media" as a client in the "Client" folder. And all internal work is put in the Proof Lab and given a project number—just like our client projects. This is really the only way to keep it all organized.

Once you have these naming conventions and folder structures in place, you will quickly find they become second nature. Your brain will work more efficiently, your company will work more efficiently, and you can spend the money you save with this efficiency on a Proof Lab account—which will result in even GREATER efficiency, more savings, your company will get out of bankruptcy, your girlfriend will come back to you, and you'll kick that nasty heroin addiction. Congratulations—your design files and your life are now organized!

Business Services. Business services are people or companies that you pay to help you run your company. It might include accountants, lawyer, payroll, consultants, SEO specialists, lead brokers, etc.

General Strategy. When I started Go Media, I tried to do absolutely everything myself. I tried to set up my business' legal structure, run my payroll, do my taxes, market, sell—everything. I did this partially because I enjoyed "running" my business. I wanted to learn all the details of running a company. I also did everything myself because I was broke and business services cost money. While you do have to pay for almost all business services, I've learned over the years that it costs you more in opportunity costs to run everything yourself than it does to pay professionals to do it for you. Obviously, individuals or companies that are selling business services are highly specialized at what they do and have become extremely efficient. They can do the work ten times faster and better than you. While you do have to pay them, you're freeing up your own time to work on your business and make money!

I do encourage you to hire professionals to help you build your company. But obviously, when you're getting started you don't have a lot of money to spend. You're going to have to choose wisely who you spend your money on.

Bookkeeping. Bookkeeping is probably one of the most important things you'll need to do as a freelancer. It doesn't have to dominate or control your life, but you do need to make sure you get a system down and follow it. If you don't have a history or passion for keeping good track of your money, then I suggest that you work with an accountant or bookkeeper. Now, as we mentioned in the general strategy, if you're small or just getting started, you don't want to go out and hire the biggest accounting firm in your town. An individual or small company is probably all you need. I would suggest meeting with at least three different accountants, explain your situation, explain your limited budget and see what they say. A decent accountant should be able to give you some basic pointers, suggest software and then let you handle the day-to-day invoicing and bill paying. Then you would send them a copy of your books quarterly, biannually or in some cases just annually. They would then identify anything that needs fixed, answer your questions, and prepare your annual tax returns.

I know that some small companies will hire a part-time bookkeeper to come in and handle the day-to-day transactions. At Go Media we have an office manager who handles all our bookkeeping. It's not quite a full-time job for her, but I would say she spends a good 20hours/week on the books on average.

Payroll. Unfortunately, the federal and state governments make paying your appropriate taxes a total pain in the butt. In the first few years of Go Media I was doing my best to "run" Go Media's payroll. I had lists of agencies and login info for government websites and tax due dates, and equations for calculating taxes due. I would spend about a week's worth of time totaling numbers, calculating what we owed and paying our payroll and company taxes. And when I wasn't working on it I was definitely worrying about it because it was such a complicated mess. Some agencies you have to pay monthly, others quarterly, others biannu-

ally. It was confusing as hell. The first couple of years I missed things and we ended up owing a ton of money at the end of the year. I got better, but I was still spending a ton of time working on it. Finally, when I was referred to Go Media's current accountant he was like: "What are you doing wasting all your time trying to run your own payroll? That's what a payroll service is for. You should be spending your time running your company—not calculating social security taxes twice a month!" He was absolutely correct.

Payroll companies take care of all this work for you. And since it's all they do, they are extremely efficient. I don't think anyone even really does anything. They have software that knows exactly how to run your payroll and pay all your taxes automatically. So it's really quite cheap compared to the amount of time I was putting into it.

When I finally handed off that responsibility, it was like a massive weight had been lifted from my shoulders. Suddenly I didn't need to worry about it any more. I knew it was being handled professionally. Being worry-free was worth the cost alone. And the price was so cheap that I could earn what it was costing in half of a day. When you consider that I had been wasting a week of each month on it—you can begin to see how economical hiring a payroll service is.

Economies of Scale. One thing you'll learn about business services is that there are efficiencies as you grow bigger. Your payroll processing fee for one employee (you) might be $60 a month ($60 per employee). But when you add a second employee, your payroll processing fee won't double. It might not change at all or it might only go up marginally— say $70 a month ($35 per employee). The bigger you get, the more efficient your business services will get. I'm not suggesting you grow solely for the advantage of economy of scale alone. Obviously, your decision to hire new employees should be justified by your workload. But economy

of scale is a nice perk when it happens.

Network like hell…everybody knows someone who knows someone who knows someone.

— JEN LOMBARDI, KIWI CREATIVE

General thoughts/strategies. Marketing is a tough nut to crack. I'm not going to lie. Some days it feels like you're just pouring time and money into it and not getting a return. I've heard that a 1% response rate on an ad is a good rate of return. Most times 1% feels like an unattainable dream—my return feels more like .0001%. But despite the feeling that you're wasting your time and money, you're not. You absolutely must have a system for your marketing. Just like your sales process, if you let this part of your company go stagnant when you're busy, you'll soon find yourself out of leads. No leads, no work. No work, no money. No money, no business. So whatever your marketing strategy is, start by making sure you have one. And make sure it keeps going even when you're busy.

Another thought to keep in mind about marketing is that it's cumulative. That P.R. campaign you ran may not return any leads, but it still gets your name in front of people. Sometimes a potential client needs to see your name two or three times before they decide to contact you. Each touchpoint with a client builds on the collective memory of your audience until they reach a tipping point.

You're not Nike. It's easy to be seduced by mega-sized marketing campaigns in traditional media by companies like Nike. Who doesn't feel inspired when dramatic music accompanies a TV commercial showing an athlete in super-slow motion hitting a home run. Or who doesn't want to buy Irish Spring soap when they see a red-haired vixen showering in a waterfall? We all want to be Victoria's Secret, Puma or Polo, but we're not. Forget about it. You need to get those grandiose marketing ideas out of your head. They'll only cloud your marketing judgment. Lifestyle marketing on an international scale to a consumer is not what you should be doing.

Generally speaking, I'm not a big fan of what would be known as traditional marketing. Running a television ad or placing print ads in a magazines is not only lazy, it's expensive. What I prefer is something completely unique. It's a new and creative way to get in touch with potential clients. What is it exactly? I don't know. That's for you to figure out. If I had to put a label on it, I would call it guerrilla marketing. It's when you use your brain and your resources to come up with something fun and different. Guerrilla marketing can be less expensive and more effective. It does take considerably more work to execute, but if you're a startup, you probably have more time than you do cash, so it's a good approach. Let me give you one example of guerrilla marketing Go Media does.

On the Map. For years, Go Media used to throw an open house. Once a year we would open our offices up to the public and throw a party. We posted examples of our work all over the office, supplied free food, free beverages and played hip music. We marketed the event with press releases, through our social media channels and with flyers all over town. The plan for how this would market Go Media to potential clients was simple. We believed that throwing a party in our offices would attract lots of people (which it did). Those people would gain awareness of our firm and either hire us directly or refer business to us. Our open house

parties were a huge success in terms of attendance, praise and fun. But where they failed was in generating us business. The problem was that we weren't attracting potential clients. The people attending our open house parties were mostly our family, friends and fans. Those people already knew about our firm. Showing them our work was a waste of time.

After realizing this, the staff had a brainstorming session to figure out how we could make the businesses we wanted to work with show up at our annual open house. The brilliant idea that came out of that brainstorming session was that Go Media's open house shouldn't be about Go Media. It should be about the companies that we want to work with! What business could refuse an invitation to a party—FOR THEM!? I know what you're thinking: "Bill, that's crazy: how could you possibly throw a party for someone else?" Here's how it works:

Go Media decided to promote the amazing and creative things that happen around our city. We selected a number of businesses that we would be excited to work with, who also share our passion for creativity. We went to them and said something along the lines of: "You've been selected to be featured on a new website and event we're throwing. It's called "On The Map Cleveland." We're going to bring our professional video team out to produce a three-to-five-minute video vignette about your company. Think of it as a teaser trailer for your business. We're then going to promote it on our website and at our event. You'll be featured on an interactive map so people can find you. The whole thing will be promoted to all of Cleveland as the go-to resource for learning about what a great city we live in." Now, what kind of business owner would turn down this opportunity? I can tell you that none ever have. Of course, they are all very excited to be featured! We hired a group of young, cheap, but talented video producers to shoot and edit the vignettes. As part of their payment, we promoted them as well. We also invited our featured businesses to set up tables at our annual premier event to help sell their companies.

We're entering our third year of the event and the results have been tremendous. For starters, the composition of our parties has changed dramatically. We still get all of our own family, friends and fans, but we also now get the family, friends and fans of our featured businesses. The attendance has grown to the point that we're starting to discuss moving the premier party to a new, bigger venue. The event has enhanced our reputation as a company that is extremely proud of our city and willing to give back to our community. When I'm on sales calls, I will include the fact that we help promote Cleveland businesses as part of my sales pitch. We've had Cleveland organizations like the Greater Cleveland Partnership, and The Council of Smaller Enterprises .

Family and Friends. Some of your first customers should be your family and friends. There is no shame in selling to the people you already know. And in those early days you need to be as efficient as possible. If you're opening a new business, you should probably start by telling your spouse: "Guess what dear? Have you heard? I'm starting a company! You may have noticed that I don't leave the house for work anymore. Would you please tell everyone you know that I'm available to design their new logo or website?" Then call your siblings, tell your parents, tell your friends, etc. It seems obvious to me, but some people ignore this group because it feels like charity. "I own a business! Who are my clients? Well, let's see…my dad, my sister, my best friend's brother…" I say bravo to anyone working with their family and friends. If that's not macho enough for you, pretend you're in the mob. Working with your family will feel much cooler in that context. "Yeah, I did a job for my brother."

Find a vehicle for promotions. Another great guerrilla marketing tactic is to find a vehicle for promoting your business. Specifically, look for opportunities that provide you with some form of publicity. Let me give you a couple of examples. The first time I considered this idea was when I learned about Norman Rockwell. He is on my top five list of favor-

ite artists. His ability to communicate personalities, emotions, and a complete story in a single painting is simply amazing. While Rockwell's fame is much deserved, I don't believe he would be nearly as famous if it weren't for *The Saturday Evening Post*. Rockwell was working as a freelance illustrator when the Post came to him for some art. Most likely, their deal was a basic work-for-hire contract where Rockwell was paid for his work. Soon, his work was gracing the cover of the magazine. In time, The Saturday Evening Post didn't seem complete unless it featured a Norman Rockwell painting on its cover. Over 47 years, The Saturday evening Post would feature 322 of his paintings. While he was probably paid for each one, I would argue that the real value he received from his work was that fame that the Post's national distribution brought him.

Another example of someone using a vehicle for promotions is a local Cleveland artist by the name of Derek Hess. His story is that he started working for a local bar/rock venue named The Euclid Tavern. It's an old bar steeped in Rock 'n' Roll history. Derek started by booking bands there, but soon was also illustrating flyers and gig posters for the shows, too. A great byproduct of doing promotional work like that is that the pieces you design will get printed and distributed all over your city. Soon, Hess's exposure led him to his manager and national recognition. Today several of his pieces are part of the permanent collection at the Louvre Museum in Paris.

It was with these two examples in mind that I started Go Media's first real marketing campaign. There is another great rock venue in Cleveland called The Grog Shop. In 1999, I went to the owner with a proposition. I told her I'd design free flyers and gig posters. In return, I get to include my company information on each and if anyone asks, she's paying me. She would also be responsible for printing and distribution, which she already did anyway. Of course, she accepted. Who could turn down free design services? I would then labor for two to three days drawing a sin-

gle black-and-white flyer for her. For me, it was simultaneously a passion project and marketing endeavor. That's one nice thing about doing work for free—the client can't complain. I got to draw whatever I wanted, she got amazing free designs and I got promotion. The response was immediate. I got two or three project leads when that first flyer hit the street. I maintained that campaign for about a year. After that I was too busy to be working for free. I still have some of those original customers.

> **Work your networks: for me, over 75% of new business is from a referral source. The people you already know are likely to be the connection between you and you next new client.**

CHRIS HARRISON, HARRISON & CO

Networking. Getting your butt out of your chair, walking out of your studio and engaging the "real world" is among the most successful ways to generate new business. Over the years, as I've kept my eye on other successful design firm owners, I've noticed that all of them are very active in the community. Unfortunately, I think most designers are more comfortable sitting at their desks working than they are in a crowd of people. That's certainly true for me. My happy place is being zoned-out, working on a highly detailed illustration. Having to go out to events, shake people's hands and talk about my business is not my most comfortable thing, but it works. And because it works, I know I have to do it. I keep track of how many hours I spend networking each month. I have a goal of four hours a month: I need to get out of the office at least once a week. The entire sales team also has to log at least four hours each month networking.

There are networking organizations you can join where the networking process is very formalized. Everyone in the group has to be a business owner. At each meeting you get to pitch your company and generally there is only one member per service type, so that members are not competing with each other. That's fine, I'm not very picky about how or where I network. In my opinion it doesn't matter. So long as you're getting out into your community and are meeting new people you'll generate business. Invariably, what you do will come up during a casual conversation and new business will often be the result. Sometimes, being in a non-networking setting can be an advantage. In those situations, you won't be competing with other businesses that are also networking. Where you network will also communicate something positive about you. For instance, if you volunteer at a charity organization, you'll likely run across many smart, professional people. They'll likely have jobs at businesses that would benefit from your services. The fact that they met you while volunteering at a charity event will communicate a common interest in helping others.

Some other activities I would consider quality networking activities include, but are not limited to: bowling with a group of friends who are designers and developers; being a member of street or neighborhood organization; attending Chamber of Commerce events; volunteering for just about anything; joining a running group; participating in neighborhood cleanups; acting as an advisor to a new business incubator; attending continuing education classes and joining young professional organizations. As you can see, it doesn't really matter what you do. The goal is to get out from behind your desk and meet new people. You'll have to look for opportunities in your city. Choose activities that you're genuinely passionate about. If you're faking it just to sell business, you'll eventually hate it so much that you'll stop doing it. If you're excited about what you're doing, that will shine through and you're more likely to meet people with shared interests.

BLUE STAR STUDIOS

Knock on doors. When Go Media was in about its seventh year in business, we met these two kids. They were still in college, but we realized they were selling TONS of website designs—far more than us. And these guys were working part-time out of their dorm room! We asked: "How are you selling so much?" Their answer was a slap in the face because it was so simple. They told us they just walk around the neighborhood, walk into businesses, ask to talk to the owner and pitch their services. That's it. Just walk in the door and sell. It's rare these days that salespeople make their first contact by walking in the door and saying "hello." Business owners have gotten so good at ignoring e-mails, mailings and ads that they're difficult to reach. Your conversion rate is much higher if you pick up the phone. It's even higher if you walk in their front door. There is one additional recommendation that I would add to this approach—only talk to the owner. Selling the secretary won't get you anywhere—trust me. It's the owner or no one.

Content Marketing. If you just crawled out from underneath a rock, you may not be familiar with content marketing. Otherwise, the concept is familiar. It's fairly straightforward: you produce content (images, articles, tutorials, videos, etc.) which you put online (mostly) to attract viewers that eventually turns into business. Here's a specific example: a few years back, Go Media volunteered to redesign the Cleveland Marathon's line of apparel. It was a marketing strategy. We were employing the idea I mentioned above about finding a promotion vehicle. The Cleveland Marathon is a huge event with many large corporate sponsors and advertising. We were given sponsorship of the event, and we hoped our designs would lead to more work. Unfortunately, we didn't land any work directly through the event itself, but we did land work by doing some content marketing. After the event was done, I wrote a long article on the GoMediaZine about my experience. Not only did I work on some of the designs for the Cleveland Marathon, I ran it too! I posted lots of images of the work we did, and a few of me staggering across the finish

line. A short while after I posted this article, we received work from both the Washington D.C. Marathon and the San Francisco Marathon. When asked how they found out about Go Media, and both referenced the article I had written. There probably weren't a lot of websites that featured content about the search term: "Marathon Apparel Design." Fortunately, Go Media's did.

> ## Have a website that's easy to navigate with a contact form; people are usually too lazy to pick up the phone.
>
> **JEN LOMBARDI, KIWI CREATIVE**

I won't even try to go into all the details this subject deserves. Content marketing is a huge subject that I cannot begin to cover fully in this book. I will share with you a few tidbits of wisdom I've gained over the years.

Your blog is not an ego trip. Your customers don't care about your company softball team. They don't care about some new service you're offering. And they really don't care about awards you've won. Think about it: would you go out of your way to read an article on your printer's website about them recently winning an award? Heck no. What kind of articles on your printer's website would interest you, a designer? How about: "Make Money by Brokering Printing." or "Faster File Prep for Printing." or "Five Tips to Save Money on Your Printing." Why do you care about these subjects? Because they help you run your company and help you make more money. Similarly, you need to get into the head of your client. What do they care about? How about: "Five Keys to a Winning Newsletter." or "Designing Landing Pages that Convert!" or "Top Ten

Web Marketing Mistakes." These are not articles about you, they're articles for your customers. I've heard the 90% number floated around when it comes to how much of your content should be client-focused, versus how much should be focused on your interests—10%. I don't have any hard data to back that up, but it sounds about right to me. You need to keep the frequency of your self-promotions and marketing extremely low in your content feed. Focus on your customer's needs!

Your content is your brand. Everything you put out into the world reflects on your company. Your content is no exception. Recently, Go Media hired a full-time social media manager. She keeps all our social media streams full of fresh, quality content. Recently she posted a short business-related article. The copy was good, but instead of working with a designer to produce some cool imagery, she simply grabbed some generic stock business images. It was the boring, dated stuff we've all seen a million times—boss hovering over shoulder of employee at a desk pointing at some document, two racially ambiguous hands shaking, diverse office staff smiling. It was stuff that might work for some clients, but the moment I saw it, I thought: "Whoa. That's not Go Media!" I told her that I would rather us post random artwork completely unrelated to the topic than post generic images on our blog. You must carefully consider what you post online. If you hire a content factory that hammers out bland articles that you marry with boring images, that's what people are going to think about your firm's design. You don't need to be a literary master to communicate knowledge and passion. Hopefully, you will find this book to be a good example of that.

Doing free work. One thing Go Media has tried regularly over the years is doing free work. Our thought is that if we do some work for free, they'll see how great we are and decide that they need to pay us. In truth, it doesn't work. Once you've established in a potential customer's brain that you're the "free" company, it's extremely difficult to rebrand yourself as

the $100/hour company. I've done work for nearly-free for years, only to have the client leave me and start paying someone an outrageous amount. I'm like: "WTF!? Where was that money these last two years?" and "Why the heck would you want to pay someone four times as much as I'm charging for work that isn't better?" This is another example of how you price yourself having a big impact on how customers value you.

While I don't condone doing free work for a client in hopes of landing that person as a client, I would strongly condone doing free work for other reasons. If, for instance, you're trying to break into a new industry such as film, they like to see examples of similar work. If you don't have any work for a particular industry in your portfolio, one way to get some in there is to volunteer to do some work for free. I will suggest that you not do the free work for the company you're hoping to land as a client. Instead, pick some other smaller company you don't care as much about. Another scenario where I encourage designers to work for free is when they're relatively young and have little or no "real world" experience. Recent college grads are perfect examples of designers who just need to get out there and do it—even if it's for free.

Working on Spec. I would like to differentiate Go Media's attempts to land clients by working for free and the concept of "working on spec." In the above scenario, Go Media was hand-picking clients we wanted to work with and then went to them with an offer. This is different than a client coming to us and asking us to work on spec. For those of you unfamiliar with "working on spec," it's when a client comes to you and says: "Show me something and I'll buy it if I like it." Go Media does not typically work on spec. In my experience, clients that ask you to work on spec are not trustworthy. If they ask you to work for free, they obviously don't have much respect for you or your work. And as I've discussed in other sections of this book, miserly people will rarely change their spots and suddenly start paying you lots of money. In either case (working for free or on spec),

our experience has been that turning those people into quality paying customers has been around zero. Don't do it: you're wasting your time.

An exception would be very large, well-funded companies that have outlined a formal contract to be won. For instance, when Nike wants to hire a new advertising firm, they will outline their needs, put a dollar amount on the advertising budget and invite select marketing firms to present their ideas. In a case like that, the competing advertising firms will absolutely do tons of work mocking up ads, even producing TV commercials to help sell their ideas. Technically, this is work on spec. If they don't land the contract, they don't get paid a dime. Similarly, Go Media was recently asked to do a presentation in hopes of landing a contract to develop ten property websites for a large real estate company. As part of our pitch, we mocked up several different homepage designs to help sell our ideas. In a case like this, I knew this would be a massive project with a potential massive payout. In my estimation, it was well worth the time. We ending up winning the contract and learned afterward that we were the only firm that did mock-ups. But this was the exception to the rule. Generally, I would advise young designers and small firms to avoid doing work on spec.

Pay-per-click. Search engines like Bing, Google and Yahoo! offer pay-per-click advertising. I like to think of it as the modern-day Yellow Pages.

People non longer find businesses in a book, they jump on the search engines! Obviously, you're best off if you can drive traffic with natural search results. That's free. But landing on the first page for the search term "Website Design" is nearly impossible. Even hitting that first page for something more targeted like "Web Design Cleveland" can be difficult. That's when the pay-per-click option becomes the solution. Go Media has a consistent budget for pay-per-click marketing. It's not huge, but it's running 24/7/365. Our pay-per-click is very focused. We have a specific list of keywords and we only pay for regional searches (within Ohio). We also keep it on a budget. Once our money is spent each month, the pay-per-click turns off until the following month.

Referrals and repeat customers. If someone asked me what my #1 source of work was, I would answer without hesitation that it's referrals and repeat customers. When you're considering how to market to new customers, it's important to understand that your existing customers represent your greatest opportunity for more work. Obviously, this starts with you doing an amazing job for your customers. Don't think of your work as just a job. Think of it as a marketing opportunity. Don't just give them a design, give them a d-e-s-i-g-n e-x-p-e-r-i-e-n-c-e! Treat them like royalty, go above and beyond, deliver the final product with flair! And while you're taking them through the design experience, you or your salesperson should continue to market and sell them. "Did you know we also design banners, logos and billboards?" When you near the completion of their project, you should be asking: "Hey Bob, your new restaurant sign is almost done, how do you plan on promoting your restaurant? How about we design you some die-cut flyers in the same shape as your sign! That will really grab people's attention and familiarize them with your new signage. I know a distribution guy who can pass your flyers out all over town." Then a month after their project is done, you should be checking in: "What's been the response to your new sign Bob? I drive past it regularly and it looks fantastic when it's lit up at night." Note: I

try very hard to not be a pushy salesperson. Sometimes it's best to check in without a sales pitch. If you contact your customer with some positive feedback, inquiring about the success of something you worked on with them or in a support capacity still has a sales effect on the customer. They are reminded of you, they certainly remember your services and having you on the phone makes placing their next order that much easier. "While I've got you on the phone, Bill…"

Speaking. If you tell someone something on a sales call, you're just a salesperson with self-interest in mind. But if you write an article or speak at an event, you're a trusted expert! Potential clients are naturally skeptical of anything a salesperson tells them during a sales call. For this reason, it's great if you can meet new clients under a different paradigm. Writing content on your blog is one way, another is speaking. The

> All of our leads come from referrals or from the speaking and writing we do. We run our own series of workshops called "Build Responsively" and I speak at conferences throughout the year.
>
> **BEN CALLAHAN, SPARKBOX**

partners and sales staff at Go Media regularly give talks on areas of our expertise—what we do professionally. We give talks on branding, social media, web development and promotions, just to name a few. Getting speaking gigs is much easier than you might imagine. I started speaking because I was invited by a high school teacher—who was also one of our clients— to talk to her class about what I did professionally. Later, I was asked to talk about branding to a group of startups in a new business

incubator. I have also applied to be a speaker. Some events want you to fill out an application and submit an outline, PowerPoint presentation and handouts of your talk. I would suggest starting with the school kids. It will help you get comfortable talking in front of a group. After that I would recommend going to your local Chamber of Commerce. Let them know you would be happy to help the businesses in their organization by holding workshops on whatever you do. Obviously, the content must fit the needs of the audience. If your design firm only designs Rock 'n' Roll apparel, then you might not have much to contribute to the businesses that belong to the Chamber of Commerce. Instead, you might want to go to a local recording studio and propose that you give a talk to their artists on "Maximizing your Merch Sales!" It's a win-win-win. The bands get a valuable education on how to sell more merch. The owner of the recording studio gives a free value-add to his customers. And you get access to potential new customers. This paradigm is a powerful sales tool. If you own a band and you're trying to decide who to hire to design your merch, and you just got a 30-minute lecture from a guy on how to maximize your sales, do you think he might be a good candidate? You bet your ass he would be.

Once you've done a few speaking engagements, you'll develop a reputation and soon organizations will start coming to you. As it can take a long time to put together a "talk" I like to reuse my material. Hey, why reinvent the wheel every time? That's too much work. I worked with Jackie Bebenroth of Muse Content Group to put together an "Art and Copy" talk about branding. I spoke on the visual side of branding; she talked about the copy side of branding. We put in a fair amount of work building nice handouts, a well-designed PowerPoint and I wore an orange leisure suit, wig and gold necklace as part of the talk. We've used the same material with four other talks so far. Each time we get more comfortable with the material and add something to it.

> As a total marketing/communications firm, we practice what we preach by using multiple media to promote our brand. We use traditional methods like outbound marketing, direct mail, and telemarketing, but we also use inbound tactics like content marketing and SEO. We always track the results of our campaigns so we understand what worked and what didn't and can be better for the next effort.

JOSE VASQUÉZ, QUÉZ MEDIA MARKETING

Tracking performance (ROI). An essential piece of your marketing strategy needs to be tracking the performance of your various marketing efforts. Go Media mostly accomplishes this by simply asking our leads as they come in: "How did you hear about Go Media?" We keep a Google Docs spreadsheet of everyone's answers. Of course, web analytics are always advisable. Building in systems that will help track leads like: "Bring this flyer in for 20% off" or "Tell 'em Bill sent you for 10% off!" is fine. You don't need to get too fancy. Just know from where your customers come and make adjustments to your marketing accordingly.

DO YOU HAVE A BLOG?

100%
YES

Everyone [in the company] is a sales person. We always want to be suggesting new ways for a client to improve their business; it doesn't matter who that advice comes from.

— JEN LOMBARDI, KIWI CREATIVE

KEYS TO LANDING PROJECTS AND STAYING PROFITABLE.

Build a strong sales team—or at least set aside an allocation of time and resources for sales. This might well be the most important aspect of your company. Selling is the lifeblood of your organization. In the words of a trusted business advisor: "Nothing happens until you sell something." If you're just starting out, then you are probably the salesperson. That's not only normal, it's good. If you can't sell your services, then how can you train someone else to do it? The owners of a company should be able to do most of the critical tasks in their organization. The better you know your own company inside and out, the better you'll be able to run it. One of the most critical parts of your company is sales, so it makes sense that you should be on the front lines—at least while you're starting up.

Many successful companies are started by sales people. And many companies that struggle are started by people who perform the service their company sells—like a graphic designer starting a design firm. Of course, a graphic designer starting a design firm seems like the most natural thing in the world. Why is it that they struggle in business? Because

given the option between selling and designing, the designer is going to design. It's who they are and what they love. If the owner of the company is focused on designing, then who's selling? And if nobody is selling, the company is going to struggle. Conversely, if the owner is a salesperson, they're going to be focused on sales. And while the quality of their design might not be as good as the firm whose owner is a designer, guess what—sales trump quality every day. To put it another way, a poor design team that has a great sales team will outperform (in terms of revenue) a fantastic team of designers who have a poor sales team. I don't want to diminish the importance of your firm doing amazing design work. What I am impressing upon you is the critical importance of your sales team and or sales system.

WERE THERE ANY KEYS TO THE GROWTH OF YOUR BUSINESS?

Hiring a business development staff person. I didn't have enough time to juggle everything in the studio AND keep a full pipeline of prospects, so I decided that having a dedicated (sales) person to take care of prospecting was the best way to ensure continued growth.

JEN LOMBARDI, KIWI CREATIVE

Avoid the chug-chug effect. For years, Go Media didn't have a dedicated sales team. First, all sales were handled by me. Later I added our project manager, Heather, to my sales "team." This was a part-time sales team at best. I had many other responsibilities on my plate other than sales. In particular, I was an active member of the design team. Heather also had many other responsibilities, including managing the ongoing design projects we had. As you might imagine, when we got very busy with design projects, we stopped selling. What happened when we stopped selling? We got slow, and what happened? We started selling again. It

produced what I call a "chug-chug effect." Much like a steam train trying to get moving, we would have a surge of energy, then stall. This would happen over and over: surge, stall, surge, stall.

Have a measurable, repeatable sales processes that runs regardless of how busy you get. How do you avoid the chug-chug? It's simple. Your sales efforts must continue, uninterrupted, despite how busy you are with design work. One approach would be to pick one day each week that is your sales day. That's fine so long as you honor that schedule. In my case it was nearly impossible. I have a bad habit focusing on what's urgent rather than on what's important. My scheduled sales time went right out the window when there was the pressure of a looming design deadline. For Go Media, we weren't able to overcome our chug-chug effect until we hired a dedicated salesperson. When you have a staff member whose only job is to follow up with and land clients, it's much easier for them to stay focused. Being slammed with design work doesn't affect your salesperson. It's even easier when you base their pay on sales commission. Currently, Go Media has two sales people and myself. The two sales people are commission only. I think the ratio of 10–20% of your company efforts being focused on sales is a realistic proportion. So if you have a ten person design firm, you'll need two–three of them focused on sales in order to keep everyone else busy.

Sales cycle: your sales cycle is the step-by-step process by which you sell your services. Go Media's sales cycle looks something like this:

> **Initial contact:** this may be an e-mail we receive through our website, a phone call or a personal meeting.
>
> **Preliminary need identification:** this is a very short conversation to get a rough sense of what the client needs.
>
> **Prospect qualification:** before investing any further time or energy,

we like to have a frank discussion about typical costs associated with our services. We may skip this step if the client appears to be very large. Obviously, if Coca-Cola knocks on your door you don't have to worry about them having enough money to afford your services. But when a local teenager starting a clothing line gives you a call, it's helpful to discuss ballpark costs as soon as possible.

Discovery meeting: assuming that the potential client is qualified, we'll have an extended conference call or meeting to discuss all the details of the project. We have a written list of questions we ask every client during our discovery meeting.

Proposal: a written document outlining all the services to be done, cost estimates and terms & conditions.

Negotiation: when necessary, we may rework aspects of the proposal to meet the client's budget.

Closing/deposit: once an agreement is met the client makes a deposit.

Dance a jig: for larger projects, we take a moment and celebrate our success.

What to do when your client cannot afford your proposed rate? Wouldn't it be great if every client immediately accepted every proposal we write or estimate for them? It sure would. But obviously, that's not realistic. Selling your design services will frequently require a fair amount of creative problem solving. You could consider this negotiating, but I don't like to think of it that way. Negotiating has a slightly negative connotation to it. When I'm working with a client to make a deal, I don't want to inject any negativity into the conversation. It's not personal. I'm not upset that they may not be able to afford me, and they should not be offended

CHRIS HARRISON, HARRISON & CO

that I've asked for more money than they have a budget for. We're not hard-nosed businesspeople out for each other's throats. We're just two people trying to see if we can make a mutually beneficial deal. Hopefully, it's the start of a beautiful relationship, so you want to be friendly. If a client asks you why it costs so much, you should take the time to explain the details of the work you do and the situation you're in as a business owner. They should understand that your design rates are not financing trips to Vegas, even if they are.

What are the next steps after a client tells you "no" and their primary reasoning is that they cannot afford your rates?

Offer a discount: Certainly, you can offer them a discount. I think anything up to 20% is a reasonable amount to take off your bill. This assumes you're starting with at least a 40% profit margin on your quote. Here are a few points to note about lowering your rates to secure a customer. First, it's rather difficult to raise your rates on a customer once you've established a billing rate. So be prepared to sell this client at a reduced rate moving forward. Second, clients that negotiate hard are typically more picky about their designs. They're clearly trying to get the very best value from you, so it makes sense that they would be more difficult during the design process.

JOHNS HOPKINS
BLOOMBERG
SCHOOL *of* PUBLIC HEALTH

PROSPECTIVE STUDENTS CURRENT STUDENTS FACULTY & STAFF JHSPH ALUMNI PUBLIC HEALTH PROFESSIONALS

Protecting Health, Saving Lives—Millions at a Time

Contraception saves the lives of mothers worldwide

Researchers at the Bloomberg School show that using contraception prevents more than 272,000 maternal deaths every year—with the potential to prevent more.

READ THIS STORY LEARN MORE ABOUT REPRODUCTIVE HEALTH

 Join the Conversation #familyplanning

DEPARTMENT HIGHLIGHTS

MOLECULAR
MICROBIOLOGY &
IMMUNOLOGY

VISIT DEPARTMENT

RELATED ARTICLES

Science of the Sexes
There are important differences
between the sexes...

MASTER OF PUBLIC HEALTH

Find out what distinguishes the Hopkins MPH program.
MORE ABOUT MPH

ONLINE LEARNING & COURSES
LEARN MORE

Scale back the proposed work. It's surprising that this works, but it absolutely does. Instead of offering a discount, you can simply suggest that the project be scaled back so that it meets their budget. It's easy to make a suggestion about what can be taken off to get the project on-budget.

Break the project into phases: similar to scaling a project back but worded differently is breaking a project up into phases. By describing it in this way, the customer feels like they will eventually get everything they want and allows them to get the ball rolling with their available budget. The thought is that they will be able to secure more funding as you work through the first phase of the project.

Offer a payment plan: this can be a little risky, particularly if you're going to give them their design files. However, if the project is something like a website and you are in control of the hosting, then you can definitely offer a payment plan. If they stop paying, you simply pull down their website. If you are going to offer a payment plan, I highly recommend you get a credit card from them and make sure they understand that you'll be running their payments automatically each month. I'll typically offer a payment plan for projects over $3K. I'll give a customer from 3–12 months to pay it off. We decide on the terms in advance and put that into an agreement they sign. If you offer a payment plan, then give the customer their files and expect them to write you a check every month—you're setting yourself up for failure. Try to maintain a tight control.

Ask for concessions: if you're going to give a discount to get your price on-budget, then you should ask for concessions from the client. A good things to ask for is an extended deadline. This is good because it gives you the ability to fill in your slow times with these lesser-paying projects. You can also ask them to handle some aspect of the workload. If you're building a website with a CMS, you could ask them to populate their own content. Or if a design requires research, you could ask them to do

that part. Each situation is unique, so be creative in trying to figure out how you can lighten your workload.

Barter: if your client has anything they can do for you, or if they have anything they can give you, definitely look into bartering. Go Media is always looking for a good barter. The only word of caution is to keep in mind the cash flow you need to stay in business. If you barter too much, you may be getting good value, but be short of the cash you need to pay your bills.

Find another, more affordable, solution for your client. What's the old saying? There are 100 ways to skin a cat? (Sorry to any cat lovers out there). The point being that there are many different ways to solve your client's design problems. A good case study is with web development. Go Media's fully-customized web development process costs a lot of money. We were pricing ourselves out of many potential customers' budgets. As a different solution, we developed a few proprietary WordPress templates we can use to quickly build a website. The customer is obviously limited on what they can get, but it's still an alternate solution that satisfies many clients' needs. We've had tremendous success by using prebuilt solutions to serve the our clients' needs when they have tight budgets.

KEYS TO WRITING SUCCESSFUL DESIGN PROPOSALS.

Writing a proposal to land a design project can be intimidating. If feels like a project you might have had in high school. As a designer, writing may not be your forte. But with a solid plan of attack, you can make proposal writing fast and easy. First, let's take a look at the common elements in Go Media's design proposals:

Title Page: a very simple page that has the title of the project, the name of the client, the date and information on who prepared the proposal.

Cover Letter: a friendly letter that thanks the client for the opportunity, expresses your enthusiasm and gives the customer a little sizzle. When

I say sizzle, what I mean is I give the client a little taste of the creativity that they can expect if they hire us. This is typically in the form of written ideas about the project. It only takes a sentence or two to paint a picture in the client's mind.

HOW DO YOU WRITE A SUCCESSFUL PROPOSAL?

Personalize it to the exact questions that are being asked. That doesn't mean you can NEVER copy/paste, but don't just give the same generic crap to everyone.

JEN LOMBARDI, KIWI CREATIVE

Overview and Key Requirements: where you state the current situation and the list of design requirements—the problem as it was presented to you by the client.

Our Solution: a simple overview of what you're going to provide in design services that solve the client's problem.

Our Process: where you explain how you will go about your work. What is unique about how you produce designs.

Cost Estimate: a line-item list of costs associated with the project.

Additional Recommendations. You've got a fish on the line. Here's your opportunity to up-sell additional services. Other than what they've asked for, what else can you sell them? Make recommendations based on the needs you've identified.

Our Work: samples of your design work that relate to the project you're proposing.

Testimonials: one of the most powerful forms of advertising yourself. Let your potential customer see how much your current customers love you. And don't feel the need to wait around for customers to compliment you. If you have good relationships with your customers, you can call or write them and ask for a testimonial. That's right! ASK FOR TESTIMO-NIALS. You can even write your own testimonials and then ask your clients to sign off on them.

Terms and Conditions: how do you bill? What happens if there are changes outside the scope of the project? What happens if the client disappears for three months? What happens if the client is not happy with your work? Is there a guarantee or warranty on your work? Who owns the rights to original artwork?

OTHER KEYS TO WRITING WINNING PROPOSALS:

Regurgitate back exactly what your clients tell you. Writing a good proposal starts with listening. Ask lots of questions and listen carefully; your potential client is going to tell you exactly what they want to read in your proposal. Your first job is to listen and write down everything they say. Then you're going to write that back to them in your proposal. If a client says: "We want a highly interactive website." In your proposal you should say: "Our solution for you is a highly interactive website. We're going to make your website interactive by using lots of JavaScript. Your customer experience is going to be the most interactive in your industry."

You're still going to be selling them on your particular solution, but you also want to be fulfilling their desires and expectations. The only way you can do that is by discovering what those desires and expectations are.

Create templates and refine your message. When you sit down to write your first proposal, think of building a template. You're not going to want to write every proposal from scratch. Try to keep most of the sections generic enough so that you can reuse them with other clients. At Go Media, we have several different proposal templates done in advance. We only have to write a few small sections in order to create a long, beautiful proposal. The sections we create from scratch each time are the cover letter, the overview and requirements, our solution and the cost estimate. That's about it—four sections. When you think of it in these terms, your proposal creation process becomes less intimidating.

Showing samples: less is more. When you're showing potential customers samples, only show them three to five samples of your very best work. A client will always look for your worst work and assume that's what their design will look like. The less samples you show the better.

Give options. If there are a few different ways you can approach a client's needs with differing costs, don't be afraid to give your client some options. Of course, you're always going to want to start high and work your way down.

DO YOU HAVE ANY WORDS OF WISDOM ON WRITING A SUCCESSFUL PROPOSAL?

Never assume anything; make sure the client knows you have done your homework and include as much detail specific to their project as possible. Also, try to always include ideas in addition to the standard proposal content.

PHIL WILSON, FINE CITIZENS

Design your proposal. You can file this under the "duh" category. As an owner of a design firm, I get resumes constantly from young designers looking for a job. What's shocking to me is that these resumes are frequently Word templates, complete with black-and-white Times New Roman type. They spent no time on designing their own resume. It's as if there is a perception of designers that business documents must follow some boring format. It's not true! Your business documents are a representation of you! They should embody all the skills you have as a designer. This includes your proposals. So take the time to make sure that the design of your proposal will sell your potential client as strongly as the content within it. Your proposal is your portfolio! Make sure it looks amazing!

Customize the design for your client. Go Media's proposal has a bit of a fancy title page. It includes a number of images and blocks of solid colors. Of course, the base template is Go Media's brand color scheme, but

HARRISON & CO

for larger proposals, we will swap out the colors and images to match the client's brand. In some cases we invest quite a bit of time and effort to make our proposal look like THEIR proposal. I will go onto their website, download their newsletters, extract their photos, copy their logo and pepper it throughout the proposal. It's amazing how impactful delivering a custom proposal can be. The client feels like: "They just 'get' us." Well, that's because you do—you've done your research and taken the time and effort to infuse it into their proposal.

Give them a few exciting ideas. It's a well-known fact that people buy on impulse. There is a lot of emotion involved in why people buy. One way to sell a client is to get them excited. This can be easily accomplished by sharing a few of your ideas with a client. This should be done in just a sentence or two. Describe something exciting you want to do with your client's design. It helps if you are genuinely excited about a client's project. Then all you need to do is share a little of that enthusiasm. It doesn't really matter how likely it is that you'll use the idea. Obviously, you're in the brainstorming phase of the project, so let those cool ideas fly. A clever idea can make the difference between you and your competitor.

Ask for a budget upfront. Nothing's more frustrating than spending several days preparing a proposal for a complicated website development worth over $50,000 only to find out that the client has a $500 budget. I like to start talking money very early in the conversation with a client. Nothing is gained from playing coy and trying to sneak your price up on them. What can be gained from "talking turkey" early on is huge. On web development projects in particular, there are many features, functionality and approaches to building a website that will be heavily impacted by what the client can afford. I want to know upfront exactly what I have to work with before I start formulating a solution for them. If a client is willing to give you a budget it will also help with your approach to the negotiation, if that becomes necessary.

So how EXACTLY do you get that budget? You ask—almost immediately. If a client calls me, I'll ask during that first conversation. It's a qualifier: "Who are you? What do you need done? What's your budget?" If they can answer those questions to my satisfaction, I'll move on to setting up a discovery call where I can get significantly more details about their project. If they ask me why I need a budget, I'm candid: "It takes significant time for us to prepare proposals. I don't want to waste your time or mine. So I like to make sure that we're a good fit for each other. Also, it can impact my approach to your project." On our contact form on our website, it asks for a budget; if I'm replying to an e-mail, I'll ask if they have a budget.

Don't underbid the project. Another critical reason for asking for a budget is making sure that you're not underbidding the project. Believe it or not, underbidding the project can be as big of a reason why you might not land a project as overbidding. By significantly underbidding a project, you're communicating a number of things to the client: "We're not worth much." "We don't understand the scope of the project." "We're amateurs." From personal experience, I can say that I have passed on hiring some companies because their price was too low. It scared me. I wasn't sure if I could trust them. As you work with bigger and bigger clients, you'll realize how important your price is. I suggest that you want to be in the middle or high range when compared to your competition. You don't want to be the cheapest vendor. Nobody wants to hire the guy who is at the bottom of the barrel. They're more likely to try and work with the highest priced person and negotiate their rate down to that of choosing the cheap guy! They want to work with the expensive firm because the price impacts the client's perception of your worth.

Extracting a budget from your client. It's a commonly held belief that giving a vendor your budget upfront is a fool's approach. Because of this, many clients will play dumb when you ask them for a budget. That's fine.

Don't be a jerk. It's still important to have a money conversation early on. You need to qualify your clients before you spend a minute working on a proposal for them. In those cases where a client doesn't give me a budget, I'll give them my ballpark pricing. This starts with me asking enough questions to get a general sense of their project. Then I might say something along the lines of: "OK, Bob, this sounds like a fairly typical website design: Homepage with slideshow, About, Services, Contact Us and the whole site to be responsive, correct? Great. Obviously, we're going to need to get into the nitty-gritty details about your website in order for us to provide you with an accurate time and cost estimate. However, just so I can make sure our firm will be a good fit for you, my very rough estimation on a website like this will probably be somewhere between $15K and $30K. Does that sound reasonable to you? I just want to make sure we're not wasting each other's time."

This approach works almost every time. If this ballpark is significantly more than they were expecting, they're going to let you know. They might say something like: "Whoa. OK. Yeah, I was hoping to get a website built for about $2K." Well, there ya go—you just got their budget! It's funny how they will suddenly give you their budget after they said they didn't have one. Or they might say something like: "Well, that's a little higher than I was expecting, but I think we can get something done." I would interpret that to mean that their budget probably starts lower than my range, but definitely is within the lower part of my range. Maybe their budget was $12K to $17K. Of course, if they say that they're comfortable with the range, I will proceed. If the client falls out of their chair and/or faints, I know I need to adjust the options I offer. Hopefully, I do have a solution for them if they cannot afford me. My follow-up with a client whose budget was well below my range might sound something like this: "OK Bob, I certainly understand you're on a tight budget. Many clients don't fully understand the work that goes into building a website. We have a few options here. I have a prebuilt website

template that can be customized for you at a fraction of the full cost. Or we could break your website development into phases and just scale back the project scope of the first phase so we're within your budget. If that doesn't work, I know a few freelancers you can talk to. How would you like to proceed?" Obviously, this is just one possible response.

You don't want to be thinking of solutions and writing proposals in the dark. Get that financial conversation going early. It's perfectly OK to talk money. Just make sure you do it in a very friendly way. Take the time to explain that you have website options that range from $10K to $100K, and you just need to know what's going to be a realistic range. You're still going to do your due diligence and present a complete solution and pricing upfront before they will have to make a decision. There will still be an opportunity for them to negotiate with you if they feel the need.

KEYS TO NEGOTIATING:

Negotiate hard, but nicely. Just because you're being nice, doesn't mean you're being a "softy." You can and should be a sweetheart while asking for the moon. Research shows that most people don't ask for enough when they're negotiating. You can always come down on what you're asking for, but if you start too low you can never go any higher. Your opening bid should probably be a bit out of your comfort zone. If you think you'll get the amount you're asking for, you're probably starting too low. Of course, you also don't want to make your number so large that a potential client is either insulted or so blown away that they don't even bother entering into a negotiation. Having said that, just remember that most people start too low.

Never insult or demean the person with whom you're negotiating. Some people think that belittling the person or product you're negotiating for is a good tactic. If, for instance, you're trying to buy a used car from someone.

If you think this that being insulting or demeaning an effective strategy, you might say something like: "You want $5,000 for this piece of crap car? Look at how ugly it is. There are rust holes all over it. The engine is underpowered. And, quite frankly—it smells bad!" Can you imagine why this might be a bad negotiating tactic? When you insult someone, they don't like you; if they don't like you, they are less likely to make concessions on price. Their response to this type of negotiating tactic would probably be something like: "F*@!% YOU BUDDY. If it's such a piece of crap, why are you even trying to buy it?"

A better approach might be: "This car is really great. It's exactly what I'm looking for. And you're a very handsome and reasonable person. I trust that you took great care of this car. I would really like to buy it today. Unfortunately, I simply cannot afford the $5,000 you're asking. Quite frankly, I'm embarrassed to tell you what I have to spend on it. I don't want to insult you, but would you take $3,000 for this car?"

In this alternate approach, you are making the person like you. They want to help you. You're not acting pushy or insulting. This doesn't mean that you can't point out the flaws or concerns you have when you're negotiating. It's just important that you're not insulting them in the process. Giving a reason for your position is a powerful psychological tool.

Give them a reason. When negotiating, you should always give a reason for what you're asking. Scientists did an experiment to see how frequently people would let someone cut in line at a bank. In the first test, the person asking to cut in line didn't give any reason, they simply walked up and said: "Can I cut in front of you?" As you might imagine, the percentage of people who let the cutter into line was very low. Then they replicated the study, except this time they gave the cutter a reason for why they should be let in line. The results were dramatically better. The funny thing they discovered was that it didn't really even matter how good the reason was.

DO YOU HAVE ANY THOUGHTS ON EFFECTIVE NEGOTIATING?

Silence. If you're on the phone with a client, going over some decisions about a project, silence on your end will generally get them chatting away, eventually blurting out an agreeable number or solution.
— MIKE DAVIS, BURLESQUE OF NORTH AMERICA

It should always be a win-win. A win for all involved.
— JULIA BRIGGS, BLUE STAR DESIGN

If they want you to cut costs, cut deliverables.
— TRACEY HALVORSEN, FASTSPOT

Always understand your worth before negotiating and be prepared to decline a project if the client starts to take advantage of you. If you set the precedent that you're easily manipulated at the start of a relationship, it will be difficult to get out of that mode later.
— PHIL WILSON, FINE CITIZENS

Even if the cutter simply said: "Can I cut in front of you, because I really want to," their success rate was far better than not giving any reason. Any reason is better than nothing. I'm sure you can think of many reasons why a client should pay you more, or why you should pay less for your next car.

It never hurts to ask. Asking for extras is never a bad thing. If I'm negotiating the cost of a website with a client, it never hurts to ask questions like: "Are you willing to extend the deadline by an extra month?" or "Is your team willing to populate the content on the website?" You never know what's important to a client. While their budget might be lower than you'd like, they may be able to help you in other ways.

Prepare, prepare, prepare. There is no better way to guarantee a successful negotiation than to properly prepare. Do your research in advance. Think about what you're going to ask for or offer before you walk in the door. Have a list of extras in mind. Get to know the person you'll be negotiating with. What's important to them? Know your walk-away price. Know what items you're willing to compromise on. Sit down and take the time to think through everything before you start a negotiation. You'll feel calmer and less likely to make a bad deal.

Know your walk-away price. As mentioned above, a part of preparation is knowing your walk-away price. What can you afford. Or if you're negotiating the price of a project, how low are you willing to go before the project isn't profitable for you. A big part of this is knowing your alternatives.

Know your alternatives. The more alternatives you research, the better you'll be able to determine your walk-away price. Let's pretend for a moment that all the air on the planet is gone. Humans must buy their air in tanks from a company to survive. Also, there is only one company on the planet that sells it. What are your alternatives? Can you go without air? No. You have no alternatives. Well, you do have one alternative: death. But assuming you want to live, you'll pay anything they ask. But no alternatives is not normal. You typically do have alternatives. In lieu of buying a new car, you can always keep your current car. Or you can buy a car from another car dealership. You could also decide to not have a car and ride the bus instead. This is where the research comes into play. What are the pros and cons of riding the bus? What are the pros and cons of a Chevy Volt vs. a Toyota Camry?

If we relate this to a design situation such as negotiating the price of a project, do you have alternatives? Let's say a client is low-balling you on a project. Do you have to take their business? Not necessarily. You might

have other projects you can work on. You can certainly choose to wait for a client that's willing to pay more. This is why marketing and lining up as many potential projects as possible is so important. The more alternatives you have, the better negotiating position you'll be in. Alternatives are exactly why our responsive pricing system works the way it does. As our work dries up, our alternatives shrink, our negotiating position weakens and we need to offer more discounts.

Alternatives are not the same as negotiated alternatives. It's common practice when shopping for something that you "get three quotes." Let's say I need to hire a photographer for a project. I contact three photographers and describe the project. They each send me a cost estimate for their services. Let's say one estimates $10,000 one is $8,000 and one is $6,000. Perhaps in this scenario you would really prefer to work with the photographer that is asking for $10,000. Going into that negotiation you know that your alternatives are $8,000 and $6,000, correct? Wrong. Are $8,000 and $6,000 as low as those other photographers will go? You should engage each of them in a negotiation prior to your negotiatiing with the guy who's asking for $10,000. After a negotiation, you may learn that the guy who asked for $6,000 is actually willing to do the work for $2,000. And the guy who asked for $8,000 will do the work for $7,000. Now, do you know your alternatives when going into the negotiation with the guy asking for $10,000? Yes. Your alternatives are $7,000 and $2,000. It takes a little extra work, but it's worth it. You never know what's possible until you ask. Sometimes the highest priced person is willing to negotiate the most, whereas the guy who's low-balling you might not negotiate at all. Negotiate every alternative.

Present alternate but equivalent offers. One time a print shop asked Go Media to design a new website for them. The price we quoted for the site they wanted was $20,000, but they told us that their budget was only $10,000. How do you suppose we closed this deal without sacri-

ficing anything? In this particular case, we asked the print shop if they could pay us $10,000 in cash and then give us $10,000 in printing credit with their company. They quickly agreed to this offer. For us, it was just as valuable. We buy printing all the time, so we quickly recouped that $10,000. For them, they already had paper and ink in stock. So, paying us with a printing credit didn't cost them any cash. This is an example of us making an alternate but equivalent offer.

Ask questions. How can you get to know what the person you're negotiating with really wants? How can you get to know on which items they'll be willing to compromise? How can you get to know what's most important to them? What magical power will allow you to peer into their brain? Questions. Ask them. If they're smart, they'll answer truthfully. Communicating well during a negotiation will benefit both parties. Remember, you don't have to be a secretive jerk to be a good negotiator. Be friendly, ask lots of questions, propose alternatives and try to give them what they want—while also getting what you want!

WHAT PERCENTAGE OF YOUR COMPANY IS FOCUSED ON SELLING?

Positivity is absolutely the most important characteristic to success. Enthusiasm for all you do is crucial.

— ALEX WIER, WIER / STEWART

Building a business can be a slow, painful process. Even after you've figured out most things and your company has settled into a nice groove, look out—you're going to experience growing pains. Let's imagine that you start your company all by yourself. It's just you working away as a freelancer. Over some time, you'll figure out everything you need to be a successful one-person design firm. Once you've figured all that out, you'll probably start to have a little success. You'll build up a surplus of money or work and the crazy thought will creep into your head: "I can make more money if I hire someone!" That may very well be true. It might be the right decision to add an employee to your small company. What you need to realize is that by adding another designer to your organization you have fundamentally changed your company, and your job along with it. By adding a new employee, you may have to spend more time selling. You may need to change your work hours to accommodate their schedule. You may need to write company policies like: "Proper attire required when meeting with clients" (Hey, I don't know who you're hiring).

A business will go through these pains as it grows. I see a company's growth as a set of stairs or a series of hockey sticks.

If you're familiar at all with business concepts, then you've probably heard of the "hockey stick." The idea is that businesses growth—when charted in a line graph, looks like a hockey stick laying horizontally with the blade pointing up. The concept is that when businesses get started there is a long period of little to no growth. I like to think of this phase of the business as the learning phase. You're eliminating the bugs, discovering what works, building your client base, perfecting your messaging, etc. Then, when you've gotten your business all figured out, growth hits. You'll find that when things take off, it can happen very rapidly. This is the sudden upward movement of your hockey stick. This is a great feeling when things suddenly take off.

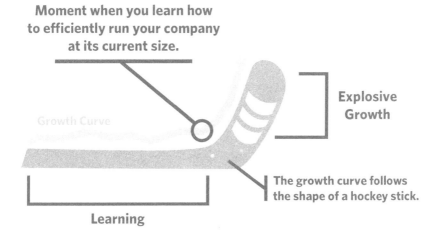

Classic "Hockey Stick" Growth Curve

Moment when you learn how to efficiently run your company at its current size.

Growth Curve

Explosive Growth

The growth curve follows the shape of a hockey stick.

Learning

But with growth comes change. And with change comes a new set of challenges to be overcome and lessons to be learned. When I got started I could design super cheap. I was living in my dad's house. I had virtually no overhead. I could sell my services based on my time alone. As I became very busy I increased my rates. And by increasing my rates I

lost a lot of my customers. Since I lost my customers I had to go find new customers, except this time I couldn't sell on price alone (because I wasn't dirt cheap any more). I needed an online portfolio to show off my work. Once I built that, I got busy again, so, again I raised my rates. And again I lost some of my customers and had to figure out how to find new customers willing to pay more. This time I needed to design a brochure and write an explanation of the value of my design process.

I've found that because growth brings change, your business will plateau after a growth spurt. You'll then need learn how to operate your business successfully at its new size. Once you've done that, you'll experience another growth spurt—and a whole new set of growing pains. The result is the stairsteps, or series of hockey sticks mentioned earlier.

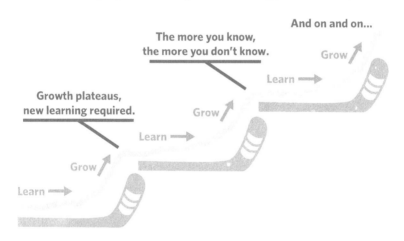

Series of Hockey Sticks
(My experience with growth over a long period of time.)

And on and on...

The more you know,
the more you don't know.

Grow

Learn

Growth plateaus,
new learning required.

Grow

Learn

Grow

Learn

Here are some common growing pains that I experienced building Go Media and the things I did to solve each one:

Too much work on your plate. As your business grows, the list of things that need to get done grows. With each passing day, your schedule becomes

fuller and fuller until you either have a heart attack or some items start to slip through the cracks. The solution is simple. You need to learn to delegate. If you're planning to really build your company, you're going to have to realize you can't do it all on your own. I'm a doer, and a bit of a control freak. This is the case for most entrepreneurs. So like me, you may find that you have a hard time handing off parts of your job. I learned, just as you will, that there are only so many hours in a day. If you don't learn how to delegate parts of your job, then it won't ever get done.

> I don't think we were well prepared for the rapid growth we experienced. We didn't have a good solid foundation to manage it. Everything from the financials to human resources really threw me for a loop. It was amazing and frightening and exhausting all at once. I've since been working on developing systems and operations that allow us to grow without so much effort involved. So the next time around, I can enjoy it.

JULIA BRIGGS, BLUE STAR DESIGN

If your plan is to build a design firm, there is a simple fact that you're going to have to accept. You can't do it all by yourself. You're going to need to need help. Could Walt Disney have built Disney World by himself? Could he design the buildings, pour the cement and paint them? If he had tried to do it on his own, Disney World wouldn't exist today. The same is true of your business. You have to get comfortable with the fact that you're going to be giving up control. I know this is difficult for many young entrepreneurs. I think we're all control freaks by nature. Unfortunately, there are only so many hours in a day. You can't do it all by yourself. Part of becoming a good delegator is learning to trust your partners and employees. I don't mean half-trust them. I don't mean giving them a job and then standing over their shoulder constantly pointing out ways you'd do it differently. This type of approach will only lead to frustra-

tion and poor work. You need to clearly communicate the goals of their job or the project, then let them be. They may not always do it how you would, but that's not a bad thing. Frequently my partners or staff will do something far better than what I had in mind. That's what makes your company great. Instead of having one entrepreneur and a bunch of sheep following you around, waiting for your next order, you'll have a whole flock of entrepreneurs coming up with ideas and getting things done.

I remember one of the very first tasks I delegated. At the time I was running a one-man company. I used to deliver the printing for my client: driving down to the printer, picking up the boxes of flyers, then driving across town and drop them off. I probably spent two–three hours making the round trip. It struck me one day—what the heck am I doing? Now, I did have an ulterior motive in those early days. I wanted to steal a few copies of my printed designs before they were delivered to my clients. But eventually I was just acting as a delivery service. I wasn't even charging for it. I just thought of it as good service. When I finally realized what a terrible use of my time it was, I asked the print shop to provide the delivery, or I told my client to pick of their stuff at the printers.

Part of delegating is recognizing your unique value to your company. I was a graphic designer. That's where my value lay. A delivery service could easily replace the time I was wasting driving all over town. It's what they do and they're far more efficient at it than I was. A similar thing happened when we hired a payroll company. I had been wasting days every month tabulating payroll and paying all the appropriate taxes. The cost/benefit analysis was simple: my time was worth way more than what the payroll company charged. My unique value to Go Media was NOT my ability to calculate payroll and pay taxes.

Sometimes there are aspects of your job you love, but are not the best use of your time. It can be really hard to let go of those. At the end of 2012,

I realized that Go Media was suffering because I was wearing too many hats. I was the president, doing sales, producing products for the Arsenal and working on client design projects to name a few. But I wasn't doing any of the jobs very well; I was spreading myself too thin. The company needed a president who was 100% focused on managing the different aspects of our company. Our staff needed guidance and leadership. I had to make a choice: either step down as president and find someone who can do that job or give up working as a designer on client projects. There simply weren't enough hours in the day to do both jobs. It's a weird thing after having built a design firm on my skills as a graphic artists to now find myself not a designer any more. Today, my skills as a manager and salesperson are more valuable to the company than my skills as a designer. We have other amazing artists stepping in to fill my shoes. Fortunately for me, I also really love running Go Media. If I didn't enjoy the business end of running a business so much, I would have hired a CEO.

> The amount of time it takes to administrate the business end is, I think, always larger than anyone expects. Especially a designer. Success begets greater complexity, as well. So, as you grow and get bigger and better clients and more people, you have to stay focused on management and you end up designing less and directing more.

ALEX WIER, WIER / STEWART

Of course, I didn't have to delegate my design work. I could have remained a designer. What you choose to delegate is up to you. You simply have to recognize when you don't have enough time to do all the work that's on your plate and give a portion of it to someone else.

Unhappiness with your job. There have been many times when I've found myself absolutely miserable while running my company. Sometimes it

was due to a difficult customer. Sometimes it was a trouble employee, or a lack of money. Many of these moments of misery were a direct result of growth. Here's the greatest part of running your own company—you get to make a change when you feel miserable. It's not always easy, but the power is in your hands. If you're not happy to start each day of work, take some time to sit down and identify what exactly is bothering you. Once you've identified the problem, you'll want to create a plan for how you're going to deal with it. In the case of annoying customers, I don't like to burn bridges and I don't like to leave anyone hanging, so I won't just quit on them mid-project. I think that would be bad form and bad for my karma. However, it doesn't mean that I need to take on their next job. You can use any excuse you want. One I've used regularly is that Go Media is booked with work for the next six months. Or you can simply triple your rates. A massive increase in design rates will scare off most customers. Another great example are the problems I had early on giving my clients payment terms and then stressing out constantly about getting paid. I simply decided to change the way I ran my business. By requiring deposits upfront, I haven't worried about getting paid a single day since then. Unhappy in your business? Identify the problem and make a change. The process isn't always easy, but it is within your control.

Becoming a manager. When I started Go Media I was a graphic designer. I spent the vast majority of every day drawing or designing. I knew how to do that. I'd spent my life honing those skills. I had only limited experience being a manager. But as Go Media grew, my responsibilities as a manager continued to grow, and quite frankly I was not confident or comfortable in my role as a manager. I wish I had an easy answer for how to become a great manager, but I don't. In my experience it just takes time and repetition to get better. Reading books on the subject certainly helps. And finding your personal voice is critical. Don't try to manage like someone else. We are all unique and we must be true to ourselves. There is more than one way to effectively manage, so figure out

PRESENTED IN

HD

ALFRED HITCHCOCK SERIES

Cedar Lee Theatre presents for the first time in HD, The Alfred Hitchcock Series. Admission to each film will be $5. Patrons may also buy an $8 ticket for the double-feature on Saturday afternoon. A $30 series pass can be purchased at the Cedar Lee Theatre box office and will be valid for one admission to each of the eight films. Single tickets can be purchased at the Cedar lee Theatre box office and online at clevelandcinemas.com. Double feature and series passes are on sale at the Cedar Lee Theatre box office only.

CEDAR LEE THEATRE, 2163 Lee Road Cleveland Heights, OH 44118
Showtime Information: 440-564-2030 WWW.CLEVELANDCINEMAS.COM

TORN CURTAIN	REAR WINDOW	FRENZY	PSYCHO	THE TROUBLE WITH HARRY	VERTIGO	TOPAZ	THE BIRDS
April 4th, 2 PM	April 4th, 4.30 PM	April 11th, 2 PM	April 11th, 4.30 PM	April 18th, 2 PM	April 18th, 4.30 PM	April 25th, 2 PM	April 25th, 4.30 PM
April 8th, 7 PM	April 7th, 7 PM	April 15th, 7 PM	April 14th, 7 PM	April 22nd, 7 PM	April 21st, 7 PM	April 29th, 7 PM	April 28th, 7 PM

what works for you and stick with it. Most important—give it time, lots and lots of time.

Hiring bad employees: it's inevitable that you're going to hire a few employees who turn out to be a bad fit with your company. Your employees are your company. If your employees are bad, your business will suffer. You need to get bad employees out of your company as quickly as possible. It's painful to do, but it's imperative for your success.

Inexperienced employees: when you hire new employees, it may take about a year before they stop asking you questions all day long and making lots of mistakes. This can significantly hurt your business, but it's a fact of growth. New employees need to learn and that takes time. You can teach them about the way you run your company, but most lessons require personal experience.

IT. When your company is just you, there are no networks to establish and no server to maintain. As you grow past three employees, you're going to want to have all the computers in your office networked to a server where all the company's files are maintained. I highly recommend finding a small IT company or an individual who can help you with this. It's mostly an upfront cost to get everything set up, and barring massive growth, you'll usually be good with just an annual checkup. In my case, I had a good friend who was an IT professional who was willing to do the work on trade for design services.

Project management: one of the most important things you'll need to address as you grow is how you manage your projects. After having interviewed a number of large and successful design companies I am shocked at how archaic their project management systems are. Some firms have a secretary with an Excel spreadsheet keeping track of what their company is working on. I would recommend any of a number of web-based

project management software systems. Of course, Go Media has Proof Lab. There is definitely a learning curve. But once you do learn it, it's like a computer—you can't live without it.

Your office space. It's likely that you'll start your business out of your house or apartment. About the time you reach four staff members, you're going to feel like you need more space. At one point, I was at 12 employees and still working out of my house. Then again, I didn't have a wife, children or a social life to speak of. The business was my life. To move the office from my house, we bought a warehouse and rehabilitated the third floor, building a luxurious office space. In retrospect, I would not recommend this. At least not until you are so financially profitable that buying a building makes absolute sense. Particularly in the first five to ten years of your business, owning a building is a headache you really don't need to deal with. Instead, look for a nice business office and sign a lease. When you own your own building and the roof leaks, you lose multiple days of work calling roofers, getting quotes, overseeing the work, etc. When you're leasing and your roof springs a leak, you make one short phone call to the leasing company and then you go back to work. Unless land ownership is a part of your overall business strategy, you shouldn't waste your time purchasing and maintaining an office building.

Your internet connection: your bandwidth needs will be growing rapidly as your company grows. Generally, internet service prices are dropping as technology gets better. Most internet service providers will try to get you to sign a long-term contract (three or more years). I recommend that you only sign a one-year contract and don't extend it until you've been with a provider for two years and are fully satisfied with their service. Only then should you sign a long-term contract to get better savings. It's likely that within those first two years you'll find a new company that offers more for less money.

Phone Systems. This is another one of those areas where you're going to need to work with a professional. As with any investment you're going to make in your company, I recommend talking to at least three different vendors and getting quotes. Go Media started with one domestic phone line. It was just a normal house line. There were four receivers around the office (my house). We used this single domestic line until we had 12 employees! This gives you some sense of how frugal I was with Go Media's money. When the phone would ring, someone would answer it, then yell across the room, or down the stairs to whomever the call was for. There were no extensions or transfers, just: "Excuse me, I'm on the line!" When we moved into our new building, the former company had left an old phone system behind, which we hooked back up and started using. Eventually it died and we updated to a VoIP Trixbox system. It was not the very latest equipment, but it got the job done. In my experience, you really don't want to be on the cutting edge of technology for your company. When you buy the latest and greatest of everything you're spending two or three times as much. Quite frankly, the neat new feature on the latest version of something is typically not worth the added cost. When it comes to buying a phone system, IT equipment, or other office technology, I suggest buying the system that is two to four years old. Another huge advantage to buying equipment that has been out on the market for several years is that it has been well tested. If there are any major flaws in the system they will be well documented.

Lulls. You may recall earlier in the book I talked a bit about the emotional implications of running your own company. You get a big check; you're king of the world. You're running low on money and you're pond scum. It's something that comes with the job. One thing I learned early on in my business was to stay tuned in to my emotions and use them as an early warning system. Even before I would realize intellectually that my work load was lightening, I would feel it. I think we all feel better when we're wanted—when people are clamoring for our time. When I was

getting slow, the phone wasn't quite ringing so often. The e-mails weren't piled up. I wasn't getting feedback. So I felt a little sad. Why doesn't anyone like me? I didn't actually think that, but there was definitely an emotional drop-off. At first, I didn't associate it with anything other than just being in a bad mood, but later I realized: "Hey! It's getting slow."

> Be prepared to ride the waves. Owning a company is like riding a roller coaster. There will be lots of work and then there will be no work. Lots of money and then no money. So plan and strategize accordingly. Put money back to cover you when you are at bottom of that hill.

ALEX WIER, WIER / STEWART

Once I realized how to better recognize that work was getting slow, I knew it was time to shift gears. When I was slammed with client work, I didn't really have time to work on marketing, bookkeeping or improving my company systems. Those items would drop off my to-do list radar. As it got slower, I would work longer on my client projects. But that really wasn't smart. I needed to fill up my to-do list with Go Media work. At first it took awhile to recognize the pattern and know how to quickly shift gears, but the more I did it, the better I got at it. When your business slows down—add to your to-do list. You can work on a marketing flyer, interview potential lawyers, get caught up on your bookkeeping or countless other tasks that you could do to improve your business. If you own a business, there is never really a shortage of work to be done. You just need to make it a priority and recognize when you have a little time to spare so you can switch gears. One good rule of thumb is to keep a list of internal work that you need to get done. Having a list accomplishes three things. First, it's a place to write down good ideas while they're fresh in your mind so you don't forget them. Second, having the list re-

duces stress when you don't have time to work on them. Most important, it makes switching gears much easier. You don't have to think up what else you can be spending your time on—the list is right there waiting for you.

Burnout. Building a business requires massive amounts of focus and energy. It's perfectly natural to have moments where you feel absolutely fried. You won't feel motivated to lift a single finger. Finding ways to motivate yourself are key in business and in life. Here is a list of motivators I've used to keep myself productive:

Start with the low fruit. It's always easiest to start with simple tasks and build up to larger ones. So as you look over your list of everything you need to do, pick something simple to get the ball rolling.

Make checklists. I'm not sure why exactly, but checklists have always been a motivator for me. Perhaps it's because I can see a well-defined list of the things I need to get done. Or perhaps it's the visceral satisfaction of crossing items off my list after I'm done. Whatever it is, I believe in lists.

Break down your large to-do items into smaller tasks. Sometimes when I'm having a difficult time getting started on a particular project, it's because the project is large with lots of work required to finish it. The size of the project alone is what's intimidating. "Well, I know I'll never be able to finish that project today—so why start? That won't be very rewarding." But any large project can be broken down into smaller steps—baby steps. Focus on one of the baby steps and give yourself a reward when you've finished it.

Make a game out of it. This works particularly well when faced with boring repetitive work. How many widgets can you design in an hour?

Make a story out of it. If the context of your project is boring, then you need to use your imagination! Imagine for a moment that your logo design project is not for the local private school, but for a covert military organization. This shift in perspective can really boost your enthusiasm. Also, it can push your design to a higher standard.

Find Inspiration. Read a book, talk to other entrepreneurs, or browse the web. Do whatever it takes to reignite the fire in your belly. When illustrating was the focus of my business, I would drive to the local comic book shop to get inspired. These days it's a good business biography that inspires me the most.

Do Nothing. When nothing else is working, I will turn to this technique. Now, I know this might seem contrary to what you're hoping to accomplish, but let me explain. Sometimes if I'm having a really hard time focusing and working hard, I just don't. I just stop. I'll take a nap, watch TV, go for a walk or browse the web. In my experience, if I just let myself take a little break, my motivation will come back on its own. It's only when I try to force myself to work hard when I'm not in the mood that I feel really bad.

Set a time limit. Before you try the "Do Nothing" technique, try giving yourself a short-term goal. Like: work hard for one hour. Sometimes you just need to get the ball rolling and before you know it, three hours will have passed. So, pick something manageable—maybe even break it down to 15 minutes. I'm going to sit and write my book for 15 minutes (yes, I'm using this technique right now)!

Projects that are too big. How big is too big a project? Well, this seems like a silly question, right? You're eager to quickly grow your company. "There is no such thing as too big, too fast" you say. But before you say "yes" to that mega-project for Disney, consider this.

In 2008, Go Media landed a huge project. It was massive—at least ten times bigger than anything we had ever dealt with before. The client seemed reputable, gave us a monstrous deposit, and we were happy to have the work. The project was so big that we hired five new employees and all but shut down work for our other clients. The entire (now almost double-sized staff) was working on this single project. It felt exhilarating to be so busy with such a big project. It felt successful to have just hired so many new staff members. We thought landing this massive project was a good thing.

> Owning a design firm is like a roller coaster. You've got a have the stomach for it. It is thrilling, scary, exciting and sometimes your gum falls out of your mouth. Crazy pictures are going to be taken with your mouth open making crazy faces. But, if you realize that when you strap yourself in, you'll have a great ride.

CHAD CHEEK, ELEPHANT IN THE ROOM

What we didn't know was that the client was a crook. We didn't know that he preyed on small design firms. Later we discovered how he had ripped off two design firms before he hired us. He would overload a small firm with a lot of work. At first he would act cool and supportive, but as the project got closer to completion, he would slowly increase the pressure, change deadlines and generally become a total jerk. As the project ended, he complained that the work was shoddy, refused to pay and even threatened to sue. He had obviously done this many times before and knew that a small design firm would not have the resources to fight a protracted court battle. Even if we had taken him to court, it would be difficult for us to collect what he owed. The net result was that we had just worked our butts off with an expanded staff for six months

and we didn't collect a single dime of profit. 100% of the deposit we had been given was paid to offshore programmers. Not only that, but we had done no work for other clients, so there was literally no income for six months. It was a disaster of the largest order.

> It's incredibly gratifying seeing your agency grow and thrive, so the stress becomes worth it when you see milestones being met, and success happening.

TRACEY HALVORSEN, FASTSPOT

In our case, we were extremely lucky. At the time, we had massive cash reserves in our bank. Otherwise our company would have had to declare bankruptcy. We would have been out of business. When all of this happened, I had a long talk with our accountant who gave us a sage piece of advice: "Don't take on projects larger than 10% of your previous year's total sales. Or at the very least, be very wary of projects that big."

Understand that when you take on projects larger than that, you are forced to change your company in a fundamental way. Consider these things before you take that giant project. A single huge project is not necessarily going to turn into a sustainable flow of work. What happens to your newly-expanded company when that huge project is over? If this one project is so large that your firm has to put everything else on hold, how will that affect your company? How will your other clients feel about being ignored for six months or more? How will you get new customers if you're too busy to keep up with your marketing and proposal writing? If you clear your work schedule to handle one major project,

what happens if they suddenly and unexpectedly cancel the project? If you've hired new specialized staff for a single project, what are you going to do with them after the project? If you have to buy special equipment to work on a single project, will you have a use for it after the project is complete? What are your opportunity costs? What other things could you be working on instead of this project?

The emotional roller coaster. When I first started my business, it was an emotional roller coaster. Primarily, my emotions swung dramatically due to fluctuations in my cash flow. I, like you, was someone who spent the vast majority of their life working for companies that would give me a regular paycheck. I always knew well in advance what to expect. I work X hours, I collect Y dollars. Even with my previous entrepreneurial experience, I wasn't prepared for the emotional swings that come with being self-employed full-time. When money is low and you don't have any new projects in the "pipe" it can be pretty scary. If you've gone two weeks with no new sales, it's not difficult to imagine two months with no sales. And if you're starting your business without a lot of savings in the bank, then two months without sales puts you out of business. I can remember one year in particular, very early on, when I was living off credit cards. There were no less than six times that year that I started looking for a job. I would work on my resume and start scanning the classifieds. Then, just before I would apply for a job, my phone would ring and I would have a new project. I was still in business, but when you are cash-poor it can be incredibly depressing.

Conversely, when you finish up a big project or land a new client and a large check hits your bank accounts, it's exhilarating. You feel strong, confident and, well, brilliant. You only regret that you didn't start your business years ago. It's only a matter of time before you'll be hobnobbing with the likes of Donald Trump and Bill Gates. You are THE MAN.

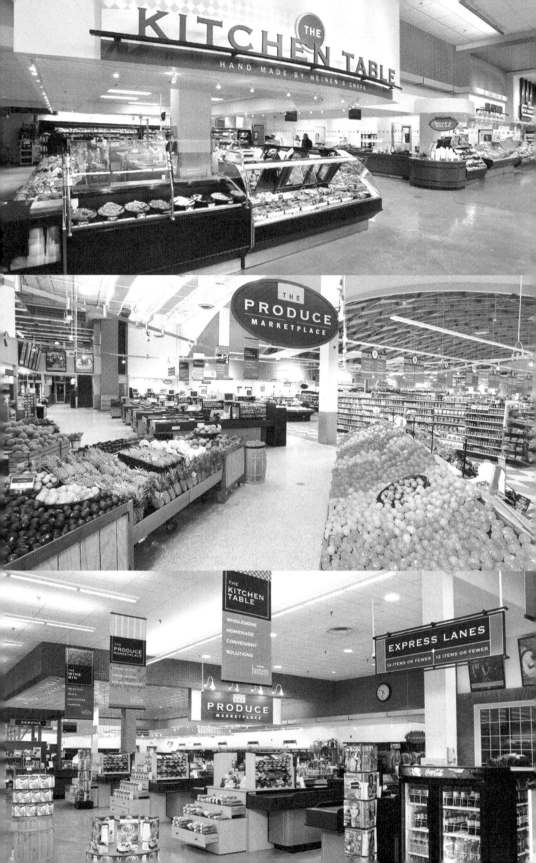

Everyone has different things that are going to stress them out about running their own business. I think money is a common one. For me, money is definitely an emotional trigger that can be both good and bad. When you own your own business, there are going to be massive fluctuations in cash flow as compared to a paycheck. When you land or finish a big project, you'll probably get a large infusion of capital. And with that infusion of cash, you'll probably feel like a million bucks! You'll also have long stretches of time where you have little to no money coming in. Even when you have enough cash reserves to keep your business running, it can be stressful and emotionally draining to be "slow." I can recall days where I was so depressed from work being slow and low on cash that I would go to bed in the middle of the afternoon and cry. The feeling is something akin to: "Nobody likes me and I'm broke. Life sucks."

> We've overcome the overhead dilemma by maintaining flexible lines of credit, and have pursued a risky strategy to aggressively increase capacity so we always stay moving. Different strategies work for different managerial styles. Experiment and adjust with what works best for your firm.

JOSE VASQUÉZ, QUÉZ MEDIA MARKETING

Here's the good news: you'll get used to it. There are only so many ups and downs you'll go through before your emotions become numb to realities of business. You learn to understand that there are going to be good times and bad. And you build emotional safety nets to help you deal with the ups and downs. For me, one mental trick I was taught by a seasoned business professional was to think of my cash flow as a river. I don't know how I was visualizing it before he told me that and I can't even explain why that helped me, but it did. I literally imagined a pristine river flowing through the woods. It's always there. It's always flowing. Some days it may be low, other days it may be high, but it's there.

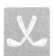

Dealing with financial ebbs and flows. Any business is going to experience ebbs and flows of cash. The stress results when you have an ebb and no financial safety net to keep your business running smoothly. If you have a series of safety nets in place to handle the slow times, it will feel much less stressful when you experience them. Instead of thinking: "We're running low on cash. We better land a project this week or else we won't have enough to make payroll." You'll be able to think: "We're running low on cash. If we don't land a project this week I'll have to pull some money from our line of credit."

Feeling stress when your income is not covering your expenses is a good thing. If you didn't feel stress about your cash flow, then you'd quickly rack up debt and get yourself into a bad situation. So it's important to feel concern when you have to rely on your financial safety nets. But at least it gives you time to "right the ship."

Build a cash reserve. Your first line of defense against a cash flow ebb is your savings in your bank. I suggest that you try to keep three months worth of operating expenses in your bank at all times. If your monthly overhead and payroll adds up to $20K, you should try to maintain $60K in your bank account at all times. This cash reserve will take care of most of your company's ebbs and flows.

Set up a line of credit. These are not either/or safety nets. Don't think that just because you have a cash reserve in your savings account that you don't need a line of credit. You should get both! The more financial resources you have, the stronger your company will be. A line of credit should cost you little to nothing while you're not using it. It's OK to set this up and let it sit. A line of credit is very much like a credit card. The primary difference is that it's for a much larger amount and you don't use a card. Go Media can access its line of credit through our bank's website. We can simply log in and transfer money from our line of credit into

our bank accounts. Only after we've moved the money over do we start paying interest. But since this is a business line of credit as opposed to a credit card, the interest rate is less than half of a typical credit card's.

One key to setting up your line of credit is that you have to set it up when your business is strong. If you wait until you're out of cash and desperate, the banks are going to look at your situation and think: "We're not loaning this guy any money! He's broke and his business is failing." It's ironic that the banks only want to lend you money when you have plenty of it, but those are the facts. So when times are good and your business is booming, make it a priority to go set up a line of credit with your bank. They won't take your line of credit away when your business goes through a rough patch. Having that line of credit you set up in the good times will be there waiting for you when you need it.

Get commitments from family and friends. It never hurts to know if family and friends will be there for you when the chips are down. It's also important to know how much money you can count on. So without being pushy, ask your family and friends if they might be available to give you a loan if times got tough in your business. If so, how much would they be comfortable lending, under what terms and for how long? Having this conversation well beforehand helps put them at ease, so when you do come asking for a loan, the concept is already familiar to them. Also, it lets you know where you stand before you get yourself into a crisis. If you survey your family and friends, and they all say: "Sorry, I can't lend you a dime," at least you know in advance to not count on them.

If you do need to borrow money from your family and friends, you should make sure to communicate to them clearly why you are going through a rough patch, what your plan is to correct the problems and when they can expect their money back.

Use credit cards. Now obviously, this is the very last place you want to get a loan, except maybe from a loan shark. But it's not much better. The interest rates are outrageous. But let's face it—if your options are paying a bad interest rate or going out of business, I'd opt to stay in business.

Dealing with a shortage of cash. I like to call it "righting the ship." During the growth of your business, you're going to have moments when you suddenly run low on cash. It can be a panic-inducing moment when you realize you don't have enough money in the bank to cover payroll or pay your electric bill. Here are a few thoughts on what to do when faced with this situation.

Don't panic. Much of the rest of this section is about making changes to your company to fix things. But I want to stress that your FIRST thought should be: don't panic. Just because you're having a dry spell does not mean that you're doing anything wrong. You may just be between checks, or had some unexpected expenses or maybe are just having a slow period. It happens. There aren't always clear explanations as to why you have a slow month or a busy month. It's just the winds of fate. So it's important to not make changes too fast. If you fire off half your staff every time you have a slow week, obviously you'll be causing yourself more headaches than the layoffs are worth. Because as soon as you land a new project you'll be desperately trying to hire those employees back, or worse,forced to find new employees.

One big part of a business' success is consistency and dependability. It takes a long time to build your network and customer awareness. You can't go changing all the time. If you believe in your business model, then stick with it—even when you're having a bad stretch. I can say from my experience that I've had many slow stretches that made me question my business. But we stuck with what we were doing and things turned around. So, your very first thought, before you do anything else should be: "don't panic."

Cut back unnecessary spending: (no OT). File this one under the "O" for Obvious. Take a moment to review everything you're currently spending money on, and cut back on non-critical items. Items like a marketing budget can be a difficult item to decide whether to cut. On one hand it's an outflow of cash. On the other hand, it's what might help you land that next project. I recommend that you continue to keep your marketing going until you're truly dead broke and looking at missing payroll.

Delay payments to vendors. I've found that our vendors are easy to talk to and sympathetic to a slowdown in business. If you have a good relationship with your vendors, you can ask them to extend you some credit or extend your payment terms. For instance: you may have bills due in 30 days, but you can call them and ask them to give you 90 days or more to make payments. This obviously works best with vendors you've worked with for awhile. A good example for us is our printer, Jakprints. We've been working with those guys for years. They know and trust us. So when times have gotten very tough, I can call them and ask for an extension of our terms. They know we will pay them back as soon as we get our money right, and they have the incentive of keeping us as clients. We do this with as many vendors as possible. We'll review all our bills and slow our payments and much as possible.

Call in IOUs: conversely, you may have clients that owe you money. Don't be afraid to call in that money. Sometimes clients are delaying payments for reasons completely unrelated to financial constraints. Maybe some clients only pay their bills once a month as a matter of routine, and would be happy to cut you a check if you needed it.

Land that next project—or call existing customers: another item to file under Obvious is to go land your next project. One little trick I've used with great success is to call my past clients, explain that I am a little slow and ask them if they had any work for me. This technique has worked

so well, I've landed some fairly large projects using it. I think clients frequently have ideas for design projects in mind and just haven't been given the right cue that would trigger a purchase. A simple phone call from you can be that cue to buy!

Take stock in your company (What are you doing wrong?). I know I said not to panic and to not make hasty changes to the structure of your company. However, if you've run out of money or had a prolonged dry spell, it is a logical time to evaluate your business and make the necessary changes. But I wouldn't really change much if the trend you're seeing is three months or less. But if your slow trend is six months or more, you may be doing something seriously wrong. Between those time frames, you'll have to trust yourself to know when to start to question your systems.

Also, sometimes it doesn't take a major change to have a dramatic shift in your business. It may be the way you lay out your proposals. It may be a slight shift in your pricing. It may be having another employee get involved in the sales process. Don't assume that you need to make a dramatic shift in your company to turn things around. The devil is in the details.

A great example of a period of self-evaluation took place at Go Media in 2009. For five months straight, Go Media posted large losses. Our bank accounts dissolved from a two-month surplus to not having enough money to make our payroll. We didn't have a line of credit set up with our bank. The owners had scant savings and had not talked to our families about loans. We were forced to lay off four staff members to get our finances in order. It really shook up ownership and made us question how we were running our business. We certainly felt like we were busy. I knew everyone was working hard, but when I took a closer look, the problem was obvious. I was working on redesigning our web-based project management software, Proof Lab. Our plan was to release it as a "Software-As-A-Service." It would be a product for future profit, but at

> I've never heard of anyone who died from a graphic design-related incident. Graphic design is important, to the client (because they are paying for it) and to me (it's how I feed my kids)...but it is never a matter of life and death. An idea is not worth killing yourself over, it is not worth working through the night on, it is not worth arguing with the client over. A mistake (in graphic design) will not physically harm anyone. Chill out. In the grand scheme of life, love and death, graphic design does not register. Have fun with it, enjoy the creativity, but don't make yourself ill for it.

CHRIS HARRISON, HARRISON & CO

the moment it was taking up all of my time. Jeff and Adam (one of our favorite employees) were working on redesigning our website. Wilson and most of the development team was working on Go Gallery—another web-based property we intended to sell to the designer market. Almost the entire staff was working on nonpaying projects. Obviously, somebody needed to be bringing in cash while the rest of us worked on "research and development" projects. We decided on a company policy that we could only afford to work on one major future endeavor at a time. So we put our website and Go Gallery on hold and refocused our energies on design sales. We concentrated all our R&D efforts on Proof Lab and stuck with it until it went live. In this case, a little self-reflection and analysis was very useful.

Layoffs. The very last thing you'll want to do to "right the ship" would be to lay off employees. Assuming your business is losing money, you probably don't have enough paying work for your staff. If your staff is slammed with paying work and you're still losing money, then you're either paying your staff too much or you're not charging enough money; perhaps it's a little bit of both. In any case, laying off employees is a dramatic but

effective way to get your cash flow quickly in line. As a design firm, the vast majority of your overhead is your staff. Less staff = less payroll. It's simple. But by reducing the size of your company, you're also reducing its capacity to do money-making work. Much like cutting your advertising budget, firing your staff is a double-edged sword. If you do cut your staff, then suddenly need them, it's going to be that much more work for you to find and hire a new employee to replace the staff you laid off. So this is really a last line of defense to get your company's expenses in line.

Q. Can you think of any keys to good customer retention?
A. Be honest. Be fair. Do good work. I really think it's that simple.
<div align="right">— BEN CALLAHAN, SPARKBOX</div>

I will say honestly that I don't feel like I have a ton of tricks or slick insights when it comes to customer retention. The things I explain in this section are common sense. But I can also say that sometimes we forget the basics when we're caught up in the day-to-day operations of running a design firm, so it never hurts to review.

Take good care of your clients. No amount of holiday cards, phone calls, discounts or anything else will make up for poor service. When a client brings you a project, you need to treat them like royalty. Be nice and supportive. Hit your deadlines. Do amazing design work. Stay on budget. Follow through. Say thank you when they pay. Give them legendary service with a smile on your face. If you do this, you've at least ensured that they'll trust you for future projects.

You can only make a first impression once. How you perform on the very first project is absolutely critical. More specifically, your first set of proofs will establish in the mind of your customer whether they can relax and trust you to do great work, or if they're going to have to look at everything you do with a critical eye. If you're working with a new client, the first project is the most critical time in that relationship.

> We were taught the importance of design early on. We also were taught that it was never too late to throw away a presentation and start over. That has stuck with me—it is a way of life in my agency 33 years later.

NORTY COHEN, MOOSYLVANIA

A few years ago, Go Media built a true sales team. Previously, our project manager and I were handling the sales. One advantage of having me, a designer, and the project manager doing the sales was that there was rarely a miscommunication between the salesperson and the designers. If I sold the job, I would certainly remember what I had told the customer. So I would make sure that what I designed fit what I had promised them. But when our new sales team started selling, there were more layers between the person who was telling the client what to expect and the person doing the work. The result was a breakdown in communication. In one particular incident, the client was told that there would be three designers working on their project. Also, the client had specifically asked that there not be a moon in the logo. Can you imagine how the customer felt when they got a set of logos from us, all designed by one designer and all containing a moon? Obviously, they were very upset. Having messed up that first set of proofs, Go Media was labeled in their mind as a disorganized company that listens poorly. Overcoming an established perception in the customer's mind is always very difficult. Once the customer has lost faith in you, they become very skeptical of all the work you do. It impacts how much they like your designs. They're frustrated and disappointed and they'll show you by being extremely picky.

If this same mistake was made after a few projects were completed successfully, I'm willing to bet the customer would be far more forgiving. They might even make a joke: "Earth to Bill, did you black out during our last conversation?"

Under-promise. Over-deliver. If you think delivering what you promise makes a good impression, just wait till you see how your customers respond when you give them a little bit more. I don't suggest that you give away free design services. You don't want your customer to devalue your primary service. But what if you did a little research to help your customer solve a problem. "Hey Bob, remember that issue you were telling me about with your printer? Well, I did a little research and found another printer in your neighborhood that can do the job for less money." Or maybe you help by consulting a little on their marketing strategy. Or perhaps their son is thinking of going into graphic design and you offer to give him a tour of your office and show him what it's like to be a designer. These types of add-ons can build an amazing bond between you and your client.

> ## CAN YOU THINK OF ANY KEYS TO GOOD CUSTOMER RETENTION?
>
> Throw in freebies whenever you can. Customers will always remember it.
> — MIKE DAVIS, BURLESQUE OF NORTH AMERICA
>
> Under-promise, over-deliver. Be consistent. Be fair, open and transparent. And, always treat the clients with respect.
> — PHIL WILSON, FINE CITIZENS

While giving a little extra is fantastic, I think it's more likely that most young designers simply over-promise. I understand being in that position of selling. You're desperate to land a project. Before you know it, you're promising all sorts of crazy things: "What's that? You need the entire website built by the end of the week? You got it. And it needs to

GO MEDIA

I COMMAND THEE...

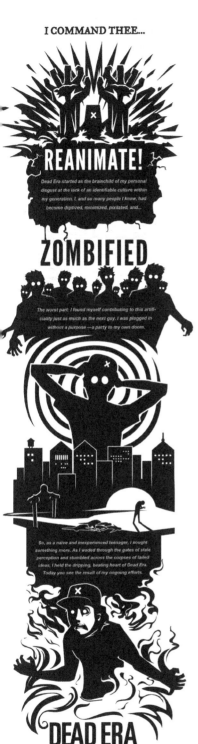

REANIMATE!

Dead Era started as the brainchild of my personal disgust at the lack of an identifiable culture within my generation. I, and so many people I know, had become digitized, minimized, pixilated, and...

ZOMBIFIED

The worst part: I found myself contributing to this artificiality just as much as the next guy. I was plugged in without a purpose —a party to my own doom.

So, as a naïve and inexperienced teenager, I sought something more. As I waded through the gates of stale perception and stumbled across the corpses of failed ideas, I held the dripping, beating heart of Dead Era. Today you see the result of my ongoing efforts.

DEAD ERA

The Mission: To restore the culture that technology has been steadily usurping. The medium of this restoration: ass-kicking apparel sure to reanimate even the deadest souls. And, an infectious blog beckoned to bring clarity to all of the pixilation.

DEAD✖ERA

BLOG · **SHOP** · OUR STORY · *contact*

➡ **ALL** *GUYS GIRLS ACCESSORIES* ⬅

THE WINNERS *circle*

Ikat Summer Rose

Textile printing is the process of applying colour to fabric in definite patterns or designs. In properly printed fabrics the colour is bonded with the fiber, so as to resist washing and friction. Textile printing is related to dyeing but, whereas in dyeing proper the whole fabric is uniformly covered with one colour, in printing one or more colours are applied to it in certain parts only, and in sharply defined patterns.

Camelia

be in 3D? Well, I've never even heard of a 3D website, but I'll do it! Oh, and it needs to dispense golden eggs? Uhhh… OK, we'll do it." It's really easy to over-promise, but failing to deliver on those promises will absolutely kill the relationship. The goal is to build long-term relationships. You have to give your clients realistic expectations. If anything, you need to lower your clients' expectations so they'll be happy with what you deliver. That means giving realistic timelines, real costs, and a true sense of your design abilities. If a client shows me some amazing illustration in a style I'm not good at, I'll tell them straight: "That's an awesome illustration, but that's not my style. Let me show you some of my work because I want to make sure you'll be happy with it. Otherwise, I suggest you get in touch with the artist who made that." And of course, I may pitch them a little on why my style kicks ass, but in general, I make sure they know what they'll be getting from Go Media.

> We use old-fashioned handwritten thank-you notes, and follow up whenever possible to generate feelings of warmth. We genuinely care about our clients. By sincerely investing in your clients, you become their reliable, trusted business partner, and can build a long-term professional relationship.

JOSE VASQUÉZ, QUÉZ MEDIA MARKETING

Be an advisor, not an order taker. If you wait for a customer to call with a project and you give no feedback and make no suggestions, you're an order taker. In the mind of your client you are just a tool, like a hammer or a copy machine. They have one print of a document and they need a copy, so they'll go to the copy machine and make a duplicate. This works fine if your only goal is to fulfill the exact business your clients bring to you on a silver platter, then that's fine. But imagine for a moment if that copy machine could talk. The client walks up, puts their document into

the copier and hits the "Copy" button. But instead of spitting out a copy it says: "Hey Bob! That's a beautiful document you want me to copy. And I certainly can do that for you; I'm very good at it. I do that all day long. But did you know that I am a COLOR copier? Not only that, but I have built-in tools that allow me to convert your spreadsheets into pie charts! Wouldn't a pie chart look more impressive than a list of numbers? I certainly think you would impress the boss with some colorful graphs in your document!" Don't you think that the talking copier would "sell" more copies (services)? Well, you'd be right. That's the difference between an order taker and an advisor. One simply does what he's told. The other is a trusted consultant for their client's business. Being a consultant completely transforms the relationship you have with your customer.

> ## Say "thank you" for their business and let them know how much you mean it.
>
> **CHRIS HARRISON, HARRISON & CO**

Of course, it takes more work to be an advisor than an order taker. You certainly can't just upsell your client on a bunch of services they don't need. You have to get to know them, understand their business and know which services you can provide that make sense for them.

Stay in touch. This is one of the simplest and yet most powerful ways to generate ongoing business. Just stay in touch. It's so simple. Don't pester, don't annoy, just make sure you stay on your customer's mind. Make sure they know that you're ready and eager to help them with their design needs. When I've gotten busy over the years, it's easy to let this slide. It's

amazing to me that when I take the time to get back in touch with a customer they often have work for me. Here's a typical scenario.

I've been out of touch with a client for a year or more when I happen to see that a band we both like is coming to town. I think of them and send out a quick e-mail. "Hey Bob, I happen to see that Skrillex (a DJ I like) is coming to town, and I just wanted to make sure you know about it. I know you're a fan." Frequently, their response will be something like: "Dude. Already got my tickets. Are you going? Also, I've been meaning to call you. I have a new project I need to get started." Was it a coincidence? Would Bob have called me that week if I hadn't sent him an e-mail? In my experience, no. Even if he had decided to get his get his project started, would he have used Go Media over any other firm? Maybe, maybe not, but by me reaching out to him, I made it convenient for him. He felt a connection with me and he was already writing me back. It was easy for him to go ahead and mention his project.

> ## If you help [your clients] make money, they will love you.
>
> **ALEX WIER, WIER / STEWART**

It doesn't even really matter how or why you stay in touch with your clients, so long as you do it. In my opinion the less salesy the better. A fun little gift during the holidays, lunch "just to catch up," a quarterly mailer showing off your latest projects or a short e-mail are all effective. People have busy lives. If they're running a business, they'll be even busier. If you're waiting around for your customers to think of you, forget about it. That's not their priority—it's yours.

Offer cheaper rates to your best customers. For almost the entire existence of Go Media there was only one pricing model. Our prices were broken down hourly, based on service type. We charged all our customers the same amount less whatever they could negotiate us down on. However, I've recently had a conversation with a good friend of mine who is in upper management at a much larger firm. We were chatting about sales, pricing, customers, etc. when he happened to mention that his company charged their best customers less than new customers. Their strategy was to work on volume rather than price. The concept really struck me. Historically, I'd always been so excited to find a good customer that could pay my retail rates that I joyfully charged them my full prices knowing that they could afford it. But customers like that are hard to come by. And who knows how many projects those customers are not sending me because there are cheaper alternatives. At the time of this writing, Go Media has begun offering our best customers cheaper rates. To qualify, the customer has to have completed enough projects with us that we feel comfortable with the way they work. They can't be a customer that meanders off-scope, push our hours over budget and then complain about additional costs. They have to be easy to work with and they have to pay their bills on time. Also, we have to like them. I can't yet say whether this strategy will work for us, but we're giving it a try. Perhaps in a year or so I'll have more information for you.

CONCLUSION

I'm lucky. I've always known what I wanted to do with my life. When I was 14 years old, I had a clear vision for my future. I wanted to build a studio full of creative people. I imagined us working in a rehabilitated warehouse near the city. We would do inspired work for large companies. People around the world would know about us. Our company culture would be something between Silicon Valley's and Willy Wonka's. "Common folk" would take tours of our office to see the delightful art we were making. The staff would feel fulfilled and want for nothing. I would build the Camelot of art studios.

Today, Go Media is not Camelot, but not too far from that vision I had when I was just a kid. The road to getting here has been bumpy. I can recall working on my resume frequently over the years in anticipation of getting a "real" job. I've been ripped off for hundreds of thousands of dollars. I've had employees drive me into therapy. I've had clients I paid to leave. During those first six years, I probably averaged 70 hours of work per week. I've had to fire and lay off staff. When my favorite employees quit, I felt like I'd been dumped. At the worst of times, I would crawl into my bed and cry.

I hope this book, while pointing out the many struggles a young entrepreneur may face, has inspired you to pursue your dreams. I hope I have provided you with some practical tools. Despite all the challenges I've faced, I still get a thrill from running my own company. While I wish I would have had this book 15 years ago, not having it would not have stopped me from doing it all over again. The rewards of starting your own business will outweigh the pain and suffering. I do have one complaint. Time is flying by too fast. My days and weeks are a blur. I suppose that's what happens when you're doing something you love.

CPSIA information can be obtained at www.ICGtesting.com
Printed in the USA
LVOW01s2027241013

358392LV00004B/5/P